———————— SECOND EDITION

WOMEN ARTISTS IN HISTORY
FROM ANTIQUITY TO THE 20TH CENTURY

Wendy Slatkin

University of Redlands
Redlands, California

PRENTICE HALL
Englewood Cliffs, New Jersey 07632

Library of Congress Cataloging-in-Publication Data

Slatkin, Wendy
 Women artists in history : from antiquity to the 20th century /
Wendy Slatkin.—2nd ed.
 p. cm.
 Includes bibliographical references.
 ISBN 0-13-961830-9
 1. Women artists—Biography. I. Title.
N43.S57 1990
709'.2'2—dc20
[B]

Editorial/production supervision and
 interior design: Patricia V. Amoroso
Cover design: Bruce Kenselaar
Manufacturing buyers: Ray Keating and Mike Woerner

 © 1990, 1985 by Prentice-Hall, Inc.
A Division of Simon & Schuster
Englewood Cliffs, New Jersey 07632

Printed in the United States of America

10 9 8 7 6 5 4 3 2 1

ISBN 0-13-961830-9

PRENTICE-HALL INTERNATIONAL (UK) LIMITED, London
PRENTICE-HALL OF AUSTRALIA PTY. LIMITED, Sydney
PRENTICE-HALL CANADA INC., Toronto
PRENTICE-HALL HISPANOAMERICANA, S.A., Mexico
PRENTICE-HALL OF INDIA PRIVATE LIMITED, New Delhi
PRENTICE-HALL OF JAPAN, INC., Tokyo
SIMON & SCHUSTER ASIA PTE. LTD., Singapore
EDITORA PRENTICE-HALL DO BRASIL, LTDA., Rio de Janeiro

To the past:

GAIL SLATKIN ORNSTEIN

(1944–1982)

And the future:

JOSHUA (9/9/85)

SARA GAIL (12/21/86)

Contents

10 Early Twentieth-Century Artists 127

11 Artists of the Post-World War II Era 155

Preface

Women Artists in History: From Antiquity to the 20th Century provides an introduction to the accomplishments of women artists throughout recorded history. The careers of approximately sixty creators, mostly painters and sculptors, are discussed and illustrated. Since photography is widely accepted, in both academic circles and the culture at large, as art, a group of women vitally important to the history of photography is also included. Finally, the undeniably sophisticated formal and technical products of the medieval embroiderers of *opus anglicanum* and American quiltmakers argued for discussion of their artistic importance.

An understanding of the achievements of these artists is impossible without some information about the cultural milieu in which they lived and worked. Therefore, *Women Artists in History* also includes introductory material for each successive historical epoch, focusing on the social, economic, and demographic factors that have direct bearing on women's potential to become professional artists.

We know that women have been making art since earliest recorded history, and the number of practicing professional women artists has increased steadily since the Renaissance. This growing body of professionals is reflected in the larger number of artists included in this text who lived in the nineteenth and twentieth centuries. This may be explained by concomitant improvements in access to education and more egalitarian legal and economic rights for women. Quite simply, as Western civilization lifted restrictions placed on women, more of them became viable artists.

Most important, each artist's contribution to and position in the history of art is defined. Unlike most published treatments of this topic, I have resisted

the temptation to record women artists of mere competence. The artists se-
lected for discussion in this text have each made a unique, significant contribu-
tion to the history of art and have survived a rigorous selection process,
comparable to the criteria applied to male artists for inclusion in survey texts.
These criteria, discussed in the introduction, include technical or formal inno-
vations, iconographic originality, artistic influence, and status in the contem-
porary culture. The responsibility for these selections is wholly mine. How-
ever, they are not presented with the implicit understanding that they are the
only women artists worthy of attention or wider recognition. The design of
this text as an introduction to the subject necessitated such a rigorous selection
process.

In the interest of comprehensibility, I have tried to organize discussions
This book does not build a case for a specifically "feminine" style in the
visual arts. However, the impact of the marginal position from which all
women operated in their society's structures governing the creation of the
visual arts cannot be underestimated. Whenever possible and valid, I have tried
to indicate the ways in which being a woman affected these creators. Often,
this was manifested in their selection of subject matter.

In the interest of comprehensibility, I have tried to organize discussions
of each artist around the works illustrated in the text. When appropriate, I
draw comparisons with the works of a male colleague whose art may not be
reproduced. Wherever this occurs, the male artist's work is reproduced in any
standard art history survey textbook.

It is sincerely hoped that readers will be stimulated to explore the subject
in greater depth. Therefore, suggestions for further reading are provided in the
annotated bibliography that appears at the end of the text. Instructors may also
find these suggestions helpful, for users of this text will invariably need to
modify and expand its contents to fit their specific purposes.

Inspiration for this text originally came in the spring of 1980 when I was
teaching both a standard art history survey course and a specialized course on
women artists at Rutgers University in Camden, N.J. At that time, I became
acutely aware that there was no extant textbook that bridged the artificial
gender divisions between male and female artists in history; in fact, virtually
no women artists were included in the most widely used survey textbooks.
(Newer editions of such texts are rectifying these earlier omissions.) It there-
fore seemed very clear to me that a textbook correcting this imbalance and
restoring the reputations of the most outstanding women artists was urgently
needed. Fortunately, investigation into the careers of many women artists
already had begun. This book rests on a body of scholarly research, led by the
brilliant efforts of Ann Sutherland Harris and Linda Nochlin, authors of *Wom-
en Artists: 1550–1950*. Their volume was the catalogue for an exhibition that
aroused great excitement as it toured the country in 1976.

Women Artists in History was designed to disseminate much of this exist-
ing scholarship and to educate a broader public to the existence of a group of
outstanding women artists. Envisioned primarily as a supplemental textbook

for college students in introductory art history courses, it should also prove useful to those enrolled in studio art, art appreciation, history of women artists, humanities, and other women's studies courses. Artists and other art professionals may utilize the text to expand their knowledge of the major issues concerning the historical position of women artists. Finally, interested general readers will find *Women Artists in History* accessible and informative.

Many people have contributed to the creation of this book. My students, responsive and enthusiastic, have always encouraged me to write for their needs. Diane Kirkpatrick carefully scrutinized the manuscript, and many of her suggestions have been incorporated into the text. Ruth Butler provided assistance in the final organization of the chapters. Estelle Fuchs contributed to the section on women in prehistory, and Janet Kaplan wrote the text on the Surrealists, improving my comments tremendously. Susan Weiss worked to obtain permissions needed for illustrations, and Patricia Likos contributed moral support and substantive suggestions during the period in which I wrote the text.

At Prentice Hall, Bud Therien's active encouragement, patient guidance, and faith in the project are deeply appreciated. Thanks are also owed to Hilda Tauber, who carefully copyedited the text, and to Chrys Chrzanowski, who transformed my manuscript into the book.

Finally, I wish to acknowledge the contributions of colleagues, friends, and family to the creation of *Women Artists in History*. Virginia Oberlin Steel, John Giannotti, Myra Blubond-Langer, Harvey Lesser, Rita Mae Kelly, and Nancy Gulick have been valued friends and colleagues at Rutgers. I offer heart-felt thanks to my mother and father, Helen and Robert Slatkin, and to my cousin, Kitty Bateman, for their strength, confidence in my abilities, and unfailing love. This above all has sustained me during the years in which I have worked on this book.

Wendy Slatkin

Preface to the Second Edition

It has been a wonderful and gratifying experience to watch *Women Artists in History* find an audience and become adopted as a text in a wide range of college courses across the country. For this new edition, we have taken the opportunity to expand the selection of contemporary artists to give a better appreciation of the immense impact of women artists, especially feminists, on the art world since 1970. Also included are some important creators unfairly omitted in the earlier edition.

Thanks are due my enthusiastic and supportive editor at Prentice Hall, Bud Therien. I also wish to acknowledge the support of Dean Neal Mangham of the Whitehead Center of the University of Redlands, who provided a precious office space. Sandra Richey of the Armacost Library at the University of Redlands was extremely helpful. The input of Howard Smagula and Mary Davis MacNaughton, Curator of Exhibitions at Scripps College, in the early phases of this revision is gratefully acknowledged.

A project of this scope inevitably demands sacrifices from one's family. For his patience and understanding, I wish to thank my husband, Fred Cohen, and to Joshua and Sara, my apologies for my absences.

INTRODUCTION

ART ANd THE POSiTiON
of WOMEN iN SOCiETY

The history of women artists cannot consist simply in the biographical ac-
counts of the achievements of a few exceptional women who changed the
course of art history. It is difficult to appreciate the significance of these impor-
tant individuals without a knowledge of the options available to them in any
given historical epoch or culture. The fundamental roles, restrictions, or liber-
ties permitted to women in their societies is essential information for an under-
standing of the ways in which women could participate in the making of art—
or the ways in which they were excluded from such activities.

In every epoch, demographic factors directly affect women's ability to
engage in productive or creative work. The most basic consideration, of
course, is survival. In some cultures, such as ancient Greece where female
infanticide was routinely practiced, fewer female babies were raised to matu-
rity. Another factor is the age at which a woman is married and the proportion
of women in the population who do marry. When women are married by age
fifteen, they can scarcely have time to acquire any professional skills. The
average number of children a woman bears, the size of her household, and the
nature of her family responsibilities also directly affect the amount of time she
can devote to creative work. A woman who has numerous pregnancies and is
responsible for the care of a large family will certainly have difficulty finding
time to practice a skilled activity like painting. Not surprisingly, the output of
many women artists falls off after marriage. Such factors also affected the life
expectancy of women in the past because women often died in childbirth. As
late as the early 1900s, the painter Paula Modersohn-Becker died prematurely
after the birth of a daughter. To maintain proper perspective, then, in this text
each of the historical epochs is introduced with demographic information. It is

1

not coincidental that the nineteenth century, which witnessed both a decline in the birth rate and an increased proportion of unmarried women, saw a dramatic rise in the number of women artists. As the absolute numbers of practicing women professionals increase, so do the numbers of outstanding women artists who profoundly influence, and at times even change, the course of art history. By the twentieth century, women artists are participating in all major avant-garde movements, not in isolation but in groups.

In addition to marital age, child-rearing activities, and mortality rates, any given society has a set of political, legal, and economic rights and restrictions that directly affect a woman's ability to become a professional artist. Artists are, after all, one category of worker, and professional artists operate to a certain extent like other business or professional persons. To understand the role of women in the arts, it is necessary to know what economic and legal rights women held in their day, for example, whether or not they were legally permitted to practice a trade, become a member of a guild, run a business, sign contracts, appear as a witness in court, etc. Clearly, when women are forbidden such activities, it is difficult for them to become professional artists.

Another economic consideration, the social class to which a woman belonged, directly affected her options. Very often, societies have different sets of expectations and permissible behavior norms for women of different classes. It is often impossible to generalize about the women in a given culture because the class into which a woman is born may be a more significant factor than her sex in determining the possibility for her to become a practicing artist. While painting and drawing have been considered proper accomplishments for women of the upper class since the Middle Ages, gentlewomen were not permitted to practice these arts as serious, professional activities until the twentieth century.

In many cultures throughout history, women of the upper classes were virtually confined to their homes. Only activities related to the needs of the household were considered appropriate. Traditionally, women have been associated with the making of containers, such as baskets and pottery, for household use. Women also have been primarily responsible for the manufacture of textiles for use as clothing and the decoration of these garments, often with embroidery. Domestic activities of this nature are outside the realm of the "fine arts," which are public and professional, and fall more within the category of the "crafts" or the "decorative" or "minor" arts. Art history has traditionally focused exclusively upon the fine arts, i.e., painting, sculpture, and architecture, and has ignored the many creative outlets through which women have expressed their visual sensibilities, such as quilt design, which requires no formal training. One of the concerns of the feminist art movement of the 1970s was the renewed appreciation of women's creativity in craft media, especially the tradition of needlework.

Psychological factors undoubtedly also play a determining role. Every

society projects ideal models for behavior. The social conditioning of women often differs from that of men. Some cultures have demanded that women be demure, self-effacing, docile, and obedient. These behavioral qualities, combined with the socioeconomic restrictions noted earlier, are not likely to encourage the professional excellence and independence needed for a woman to become an outstanding artist.

Furthermore, regardless of whether a woman possesses such characteristics, the practice of the fine arts is dependent on a lengthy period of training to achieve professional competence. In order to understand the role of women artists in art history, it is important to consider the availability of artistic training for young women of talent. Prior to the twentieth century, even the most talented women were handicapped by the inequality of opportunities for professional education. During the late Middle Ages, artists learned their crafts as apprentices and journeymen. Women were not permitted to become apprentices and were thus denied access to training. When art academies took over the role of the education of artists in the seventeenth and eighteenth centuries, women were not allowed to become students at these schools. Not until the late nineteenth century were women permitted to receive comparable artistic training.

Given the problems they encountered in obtaining a complete, professional education, it is not surprising that most women artists before the twentieth century were daughters of artists. Being born into an artist's family gave these women access to training at an early age, an advantage denied to creative or talented women who did not have artists for fathers. However, being trained by one's father was also a handicap to an artist in terms of her ability to develop an original style. All too often, daughters were forced to copy their fathers' compositions, and they were relegated, like the female members of other artisans' households, to the most menial tasks of the studio.

Beginning in the Renaissance, a knowledge of human anatomy was essential for an artist who wished to paint large-scale, multifigured compositions. Since women were explicitly forbidden to study the male nude, they rarely received important commissions. Unable to acquire complete artistic training on a par with men, women artists often settled for mere competence. Insecure with their skills, they rarely felt confident enough to create an innovative style.

The situation of women artists before 1800 has been aptly summed up by Harris:

> By and large, women did not attempt to compete with men for the more prestigious public commissions . . . very few women in any European country attempted large-scale historical or religious compositions until the nineteenth century. Their limited training confined most women to the less valued specialties of portraiture and still life. With very few exceptions, women did not even try landscape painting until the nineteenth century. . . . Thus men not only con-

trolled the most remunerative and most esteemed public commissions as well as landscape, one of the three popular genres, but also had an almost total monopoly over sculpture, architecture, and even printmaking before 1800.[1]

The crucial importance of access to education is underscored by the difference in women's contributions to the field of photography as compared with architecture. Prior to the late nineteenth century, architects were always male. While a few women have acquired the training necessary to become practicing architects in the last hundred years, their achievements are not sufficiently original to warrant detailed discussion in this text. On the other hand, no formal training was required to become a photographer. And, because photography was not originally considered an art form, its technology was equally available to men and women. In chapter ten, we will meet a group of women who are among the most innovative and important photographers since the invention of the medium in the nineteenth century.

The artists selected for detailed discussion in this text are all exceptional. Through a variety of circumstances, these women overcame the obstacles to training and the preconceptions of their cultures to create a body of works that deserve recognition. The women artists included in this text have all made significant contributions to the history of art when judged by the traditional standards used in selecting male artists for such inclusion.

It is important to remember, however, that the vast majority of women artists remain unnamed in this book. This parallels the situation for male artists in introductory texts. Prior to the Renaissance, most artists, male and female, were anonymous. Works were rarely signed and virtually no biographical information on their creators has survived. Beginning in the fifteenth century, the identities of individual artists are preserved, along with more documentation about their lives and careers. Those who are included in the mainstream of art history are the truly extraordinary, singled out for excellence from the majority of practicing artists. That there are fewer women who rank as outstanding reflects the smaller number of practicing female artists in any specific epoch rather than an innately inferior creative capacity in women. This reduced population of practicing women artists is the result, in turn, of those biological and cultural factors noted earlier that limited women's ability to become professional artists.

The achievements of most of the artists discussed in detail in this book were recognized by their contemporaries, and that recognition was preserved throughout the nineteenth century. However, when art history became codified as an academic discipline in the twentieth century, the reputation of these artists became obscured. The making of art, as taught in our universities until quite recently, was identified exclusively with the activities of male artists: ". . . modern art history produces a picture of the history of art from which women are not only absent, but identifies women artists as inevitably and naturally artists of lesser talent and no historical significance."[2]

The absence of women in most traditional accounts of the history of Western art has led to an underlying assumption that women are not capable of excellence in the fine arts simply because they are women. The artists discussed in this text disprove that assumption. They have been selected for detailed discussion because they have made significant contributions to the history of art according to the following criteria:

1. *Stylistic or technical innovation.* A number of artists have developed methods of painting and sculpture that are different from any previous style. These artists usually are members of an avant-garde group. This category applies most frequently for artists living in the late nineteenth and twentieth centuries, when stylistic innovation has been most valued. However, Rosalba Carriera, for example, was a technical innovator in the lower-status categories of miniature painting and pastel portraiture during the eighteenth century.

2. *Compositional or iconographic originality.* Some artists have been singled out because they invented a new format, compositional arrangement, or structure for painting or sculpture. For example, the originality of Clara Peeters lies more in her compositions and the selected viewpoint of her still lives than in her method of paint application. A number of artists have invented new subjects, sometimes based specifically on their experiences as women. Other artists have developed new variations or layers of meaning for subjects regularly depicted by their male colleagues. Judith Leyster, Harriet Hosmer, and Käthe Kollwitz are examples of artists who have created new iconographies based on their personal identities as women.

3. *Influence on other artists.* One standard regularly applied by art historians to evaluate the contribution of an artist to the history of art is the extent to which that artist's imagery or technique influenced the works of other artists. Certain artists, such as Angelica Kauffman and Artemisia Gentileschi, exerted a decisive and widespread influence on the art of their contemporaries.

4. *Recognition within the culture.* Many of the artists to be discussed were widely appreciated during their lifetimes. They received official and critical recognition and occupied positions of prominence in the contemporary culture. Rachel Ruysch, Elisabeth Vigée-Lebrun, and Rosa Bonheur are examples of artists whose careers belong in this category.

These criteria are clearly not mutually exclusive, and some artists to be discussed are noteworthy for more than one of them. Radical feminist art historians have disputed the validity of applying such criteria to women artists. They argue that being a woman artist in a professional arena dominated by male teachers, colleagues, historians, and critics was so extraordinary and discriminatory that women's art cannot fairly be judged by that critical apparatus. Since women were usually denied recognition because of their gender, few women could influence other artists and thus impact on art history. Also, because women suffered from unequal training and the struggle for technical competence was so great, they rarely deviated from conservative, culturally accepted stylistic modes. The radical feminist position does not call for new evaluative criteria, rather the *elimination* of all such criteria as they have been applied to women artists.[3]

A defense of my position is based on the indisputable reality of the male-dominated history of art, both for the women artists under discussion as well as in today's college classrooms. Anguissola communicated with Michelangelo in the sixteenth century; Vigée-Lebrun studied Rubens in the eighteenth century. The great women artists accepted the inequities and struggled to meet the criteria established by male artists. If they recognized and accepted the reality of male-defined standards for excellence, contemporary art historians must as well. Perhaps we should not wonder why so few women managed to meet these criteria, but rather how any women at all surmounted the immense difficulties of patriarchal society to create works that meet such stringent critical standards.

Finally, the all-important question remains to be addressed: To what extent does gender determine the nature of an artist's creative output? The issue continues to be fiercely debated. While few critics and historians accept a fairly narrow set of formal criteria, evolved by critics such as Lucy Lippard in the 1970s, we cannot underestimate the importance of the gender of the artist as a contributing factor in creation.[4] Art is a product of a complex cultural process involving extensive training and molding of vision. The patriarchal culture has controlled that process of art production. For that reason, it is very rare, until contemporary times, to find a distinctly female style in the visual arts.

Women artists, like men artists, create within a given national and period framework. Therefore, it is necessary to view the works in this book within their historical context in the mainstream of art history. Being a woman is merely one factor, among many, that determines what type of art a person will create. It is for this reason that the works of art illustrated in this text display a broad range of styles and subjects, as this is appropriate for works created in different countries and diverse historical epochs.

There seems to be no validity, then, to generalizations about a "feminine" style as opposed to a "masculine" one. In fact, labeling an artist's work "feminine" is often an indirect way of assigning a negative value judgment to that work. "Feminine" art is said to possess "grace" and "delicacy" at the expense of "power" and "strength." "Feminine" artists select intimate domestic subjects, while "masculine" artists depict the heroic actions and events in which men participate. "Feminine" artists work on a small scale, which automatically excludes their works from "significance" in art historical terms. The works of women artists are often considered inferior in quality if they possess the traits that may be characterized by the term "feminine."

However, one would be absolutely mistaken to assume that the fact that an artist was a woman had no bearing on her creative output. Women artists are rarities. Their backgrounds are distinctive from those of male colleagues. The ways they acquired their training, prior to the twentieth century, with a few notable exceptions, was different. The social conditions and milieu in which they exist is clearly distinct. Not surprisingly, we do find that some

women artists select subject matter rarely, if ever, treated by male colleagues, or reinvent subjects that bear the clear marks of a woman's point of view. Whenever possible, works of art that reveal women's values and vision have been selected for discussion and illustration in this text.

Sometimes the differences between male and female artists appear in the pattern of creation, as well as the scope and pace of output. It is essential to realize that women artists, even those of immense talent, operated from a marginal position and were forced to negotiate their careers from a very different place in their culture than their male colleagues.

We can infer some of the prevailing attitudes and inescapable insecurities of the woman artist from Manet's comment to Fantin-Latour in 1868:

> I quite agree with you, the Miles Morisot are charming. Too bad they're not men. All the same, women as they are, they could serve the cause of painting by each marrying an academician, and bringing discord into the camp of the enemy.[5]

Is it so surprising that Berthe Morisot destroyed all but about two dozen works executed before she was thirty and in full possession of her talents? So the answer to the question, "Are women artists different from male artists?" is "yes" and "no."

The author is confident that the use of this book, in conjunction with a mainstream art history survey text, will bring to students a broader, more balanced understanding of the culture of Western civilization. Art history cannot remain unaffected by a full discussion of the social, political, and economic situation of all women, in successive historical epochs, the contribution of these selected creators and the reasons for their exclusion from some texts, and their uniquely female viewpoint in some works. This book adopts that "bolder" route, defined by Norma Broude and Mary Garrard, of centrism, integrating and redefining art history, rather than separatism.[6]

This study is limited to the contributions of women creators in Western civilization. The artistic activities of women in Oriental cultures or African civilizations, for example, fall outside the scope of this discussion. Any generalizations that are made concerning "women artists" must therefore be understood as implicitly confined in this way.

Let us turn, then, to a historical account of women artists in history, leaving behind, as much as possible, any preconceptions we may have about them.

1

From Prehistory
to the Roman Empire

The beginnings of Western civilization do not coincide with the earliest artifacts, the first known works of art, or the survival of written records. The historical era upon which we formulate our understanding of the past is a relatively recent epoch in human history. Thousands of years of social organization preceded the appearance of the already highly evolved civilizations of Sumer and Egypt in the third millennium B.C.

The oldest known works of sculpture are statuettes of obese standing women with enlarged breasts and bellies. The famous *Venus of Willendorf* (Figure 1) is one of many such statuettes that have been discovered across the Eurasian continent. Some of these figures date from the neolithic era (c. 25,000–20,000 B.C.) while others are as "late" as 5000 B.C. The figures are widely regarded as images of a divine Earth Mother.[1] From the evidence of these figures, one may postulate the widespread worship of a mother goddess to ensure fertility.

However, the existence of these objects does not necessarily tell us about the organization of society, the division of labor between the sexes, or the relative status of women and men in communities of the prehistoric past. Nonetheless, from the incontrovertible evidence of these numerous fertility images, one may deduce that "the female body was experienced in its own character as a focus of divine force and a system of rites was dedicated to its mystery."[2]

The survival of these fertility statuettes, as well as mythological references to them, have elicited many speculations about the existence in prehistoric culture of societies organized as matriarchies. There is no consensus among scholars that this was the case. On the contrary, "motherhood has

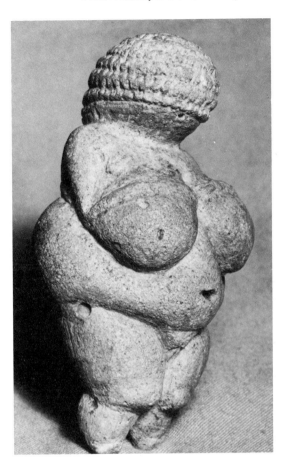

FIGURE 1. *Venus of Willendorf.* c. 30,000–25,000 B.C. Limestone. H.: 4 3/8". Naturhistorisches Museum, Vienna.

often placed abstract *woman* on a pedestal, but it has at the same time left concrete *women* in the home and powerless. Reverence . . . does not necessarily result from, or lead to, the high status or power of the revered object that is symbolically presented."[3] Contemporary anthropologists generally discount any arguments for the widespread existence of matriarchies in prehistory.

That there are biological differences between men and women is clear and undeniable. But biology alone does not determine the roles, activities, and status differences between men and women in any given culture. "The chief importance of biological sex in determining social roles is in providing a universal and obvious division around which other distinctions can be organized."[4] Although every society has some sort of division of tasks by sex, the assignment of any particular task to one sex or the other varies enormously from culture to culture. Biologically determinist theories are an inadequate explanation for the success of male dominance in early civilizations.

In recent years, many anthropologists have accepted the theory that a stage of comparatively egalitarian economic and social organization preceded the patriarchal stratification of classes and cultures of the historic era.[5] It is believed that humanity originally lived in small bands or tribes organized by kinship relations, in which property was owned communally. Archeological evidence of the earliest societies in Europe and the Mediterranean basin supports the theory of egalitarian communism in prehistoric cultures. Danubian I peoples of the third millennium lived in large houses that could contain a clan, rather than a nuclear family. Based on the evidence of paleolithic burials, there were no status differences between the sexes.

In a recently published volume, edited by Stephanie Coontz and Peta Henderson, the origins of male dominance are convincingly connected with the development of patrilocality.[6] When women moved into their husband's kin group, their labor could be effectively exploited for the creation of commodities for exchange. Essays reprinted in this book agree that female subordination established the necessary labor force for the emergence of private property and the state.[7]

In the absence of concrete evidence, it is very difficult to determine the extent of women's participation in craft activity. We simply do not know whether women were responsible for the creation of fertility figurines, the making of clothing, or the fashioning of clay pots or woven baskets. Evidence from the Anatolian settlement of Çatal Hüyük, dating back to the seventh millenium B.C., indicates that this community was "unmistakably matrilineal and matrilocal"[8] and that women participated in food cultivation as well as hunting and gathering. Women made pottery and textiles, operating the oldest known looms. Such evidence is consistent with the activities of women in more modern hunting and gathering cultures. But whether women performed these tasks in all pre historic communities remains purely conjectural.

WOMEN OF EGYPT

A wide range of surviving evidence indicates that Egyptian women enjoyed the same legal rights as men in any given class group.[9] This situation is quite different from the prevailing cultures of Mesopotamia, Greece, or Rome. Women in Egypt could acquire and dispose of property in an independent manner and administrate it freely, without consulting male relatives or spouses. Women were considered responsible for making legal contracts. Women priestesses were not unknown and, except for women of the lowest classes, women could serve in the temple of a divinity. Motherhood appears to have been highly respected, although representations of pregnancy in the visual arts are virtually nonexistent.

Throughout the Pharaonic period, during the Old, Middle, and New Kingdoms, matrilineal order of descent prevailed in the royal Egyptian dynas-

ties. As Nancy Luomala has noted, the throne of the land was inherited by matrilineal descent, through the queen's eldest daughter.[10] The king was the administrator of Egypt, but his power and position derived from his relationship to the queen. When a queen was unmarried, her brother ruled as regent. Therefore, when we see the Queen Khamerernebty II embracing Mycerinus in the famous Old Kingdom sculpture (Figure 2), the gesture should be interpreted as one which confers power and legitimacy to her husband. On occasion, queens ruled independently of male consorts. The most famous female pharaoh is Queen Hatshepsut (1504–1483 B.C.). Her monumental mortuary temple at Deir-el-Bahari is tangible evidence of her power.

Worship of the Great Mother Goddess, in the form of the cow goddess Hathor, whose insignia was a cow-horned headdress, appears on many surviving works such as the Palette of Narmer. The sky-cow goddess was believed to have given birth to the sun, and the queens of Egypt were equated with her powers. Her insignia was the sun disk. Both cow's horns and sun disk are visible in representations of queens' headdresses. One famous example of such

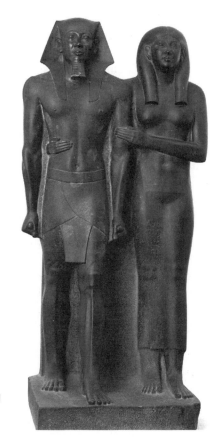

FIGURE 2. *Pair Statue of Mycerinus and His Queen.* Egyptian, Dynasty IV, 2599–2571 B.C., from Giza Schist. H.: 54½″. Courtesy, Museum of Fine Arts, Boston, Harvard University – Museum of Fine Arts Expedition.

a crown is worn by Queen Ankhesenamon on the back of the throne of Tutankhamen. Thus, the status and divine powers of the female members of Egyptian royal families are important components of an accurate interpretation of their depiction in the visual arts.

WOMEN OF THE ANCIENT NEAR EAST

By contrast with Egyptian society, in the contemporary civilization of Sumer, the subordination of women was well under way by the third millennium B.C. In this culture of the "fertile crescent" in the ancient Near East, political power became centralized in the hands of male military leaders, and hierarchical class stratification of the society began. Women were excluded from decision making and became another form of private property. This process is documented by the marriage laws that controlled women's lives to a great extent. Marriages were arranged by parents. The groom paid a "bride's price" to the parents of the bride. Daughters from poor families were sold into marriage or slavery to improve the family's financial situation. After marriage the husband became undisputed head of the family. He could divorce his wife quite easily or sell or pawn her and his children to pay off his debts. While husbands could maintain concubines, a wife's adultery became a crime punishable by death. Children, like wives, were considered property of economic value.[11]

There is no evidence for female infanticide in Mesopotamia because the more children a man possessed, the greater his economic worth became. Abortion was considered a serious crime, and the society encouraged numerous births. A woman who was a mother had higher status and better legal rights than a woman who was not.

Because the main occupation of most women was the bearing and raising of children, the education of daughters focused on instruction in household tasks, which included weaving, needlework, and music making. However, women were not totally excluded from the economy. Wives had the right to use their own dowry after their husband's death. Therefore, some upper-class women were active in business affairs. Such women were literate and signed documents and contracts in their own names. They could buy and sell slaves and other forms of property. Women could act as witnesses in court. A few women were priestesses living in convents and conducting a wide variety of business affairs independently of men.

Lower-class women and female slaves were active in many types of jobs and contributed to the economic development of their societies in the ancient Near East. Women were scribes, midwives, singers, tavern-keepers, and even chemists (thirteenth century B.C.). Records from as early as the third millennium B.C. show that women were brewers, cooks, and agricultural workers, occupations associated with women into the eighteenth century A.D.

As in Çatal Hüyük and Crete, women made pottery. A cylinder seal from the early third millennium B.C. shows women potters making vessels in what appears to be a workshop.[12] Basket plaiting was another craft practiced by women of all classes.

Women predominated in the making of textiles, a laborious and time-consuming activity that could be done in the home and was therefore well suited to women. The fibers of flax, cotton, or wool first had to be cleaned and prepared and spun into thread. Then the thread was woven into cloth. Clothing was often decorated with embroidery. All these tasks were the exclusive concern of women. Female slaves who were skilled weavers were highly valued and in great demand in the ancient Near East. The upper classes purchased fine garments, beautifully decorated. Such items were also economically valuable commodities for export.

The professional activities of women in the Near East were largely confined to women of the artisan and slave classes, who were forced to work for survival. In royal families, women were secluded in harems. Within the harem, women practiced spinning and weaving, as well as embroidery and basket plaiting. But aristocratic women (as in the Middle Ages) performed these tasks for the domestic needs of the household, not as professional skills.

WOMEN OF CRETE

By the third millennium B.C., the Minoan civilization on the island of Crete was a matriarchal theocracy ruled by a queen-priestess. This culture demonstrated a relatively high status for women. Minoan women had access to all professions, including the manufacture of their famous pottery, which was distributed throughout the ancient world. Worship of the Earth Goddess was prevalent. Vincent Scully has convincingly argued that the selection of Minoan palace sites and their architectural orientation were dependent on the relationship of the surrounding landscape to the "body" of the Earth Mother. All Cretan palaces were located in an enclosing valley and oriented to a conical hill and double-peaked or cleft mountain in the distance. The closer cone was perceived as the body of the Great Mother Goddess, and the horns of the more distant mountain created a profile evocative of a pair of horns, raised arms, the *mons Veneris* or a pair of breasts of the Great Goddess.[13] In the courtyard of Knossos, from which Mt. Jouctas is visible, young men and women performed the famous bull dances, seizing the horns sacred to the goddess. Thus, locations of Cretan palaces were determined by their proximity to the center of life and divine powers of the Earth Mother Goddess. The numerous statuettes of snake goddesses, depicting a bare-breasted woman holding snakes in each hand (Figure 3), document female participation as divinity and priestess in Minoan society.

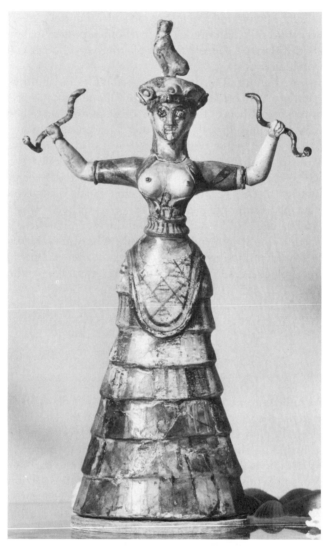

FIGURE 3. Snake Goddess, from the Palace at Knossos. c. 1600 B.C. H.: 13 1/2". Archaeological Museum, Heraklion, Crete. Courtesy Hirmer Verlag München.

WOMEN OF GREECE

The contribution of women to the culture of their society is dependent first and foremost on their survival to maturity. Archeological evidence indicates that the Greeks practiced female infanticide and that males outnumbered females by at least two to one.[14] This smaller proportion of females surviving

infancy extends from the Greek Dark Ages (1100–800 B.C.) through the Classical and Hellenistic periods. By the Hellenistic era (fourth to first centuries B.C.), even fewer children of either sex were raised.

A Greek girl who survived infancy was fed an inferior diet. Girls were married between the ages of twelve and fifteen; men were usually married at thirty. Such young marriages forced women into early pregnancies, further threatening their survival. The shortage of women plus selective rearing also ensured that women would have multiple pregnancies. Many women did not survive the childbearing years, and women's life expectancy was five to ten years shorter than men's. One may conclude that only a fraction of the female population lived long enough to practice any profession without being pregnant or responsible for the care of small children.

As in the ancient Near East, marriage and motherhood were the most widely accepted and expected roles for women to fill in the society. However, the position of wife and mother conferred varying status on women in different periods. The status of some royal women in the Bronze Age, as described in the Homeric epics (c. 1200 B.C.) was very high, and evidence also indicates that women were dominant in the religious sphere.[15] By contrast, the status of Greek women in the culture of the Classical era (fifth century B.C.), especially in Athens, seems to have been very low, and this may be explained by a number of factors. Particularly among the upper classes, a sharp separation existed between the men's public world and the women's domestic one, a situation similar to that in modern capitalist cultures. While men were occupied with running the Athenian democracy and waging almost continual warfare, upper-class women rarely left their homes. They remained in segregated quarters, often on the upper story of town houses. While boys were taught the arts of rhetoric and other intellectual pursuits, girls learned domestic crafts from their mothers. The age discrepancy between husband and wife and the gaps between the education of men and women further intensified the isolation between the sexes in Classical Athens.[16]

Considering the severe restrictions on women's lives, their inability to move freely in society, conduct business, or acquire any type of nondomestic training, it is not surprising to find that no names of important artists have come down to us from the Classical era. Only the poet Sappho (c. 600 B.C.) received high praise from the Greeks: Plato referred to her as the twelfth Muse. Significantly, she came not from Athens or Sparta but from Lesbos, an island whose culture incorporated a high regard for women.

Further evidence of the low status of women is that no statues of female nudes survive from the Classical period. This is consistent with the belief that only the male body could be appreciated as an object of beauty. When female figures were created in sculpture, they were always clothed. Female nudes began to appear in the fourth century, accompanied by a correspondingly improved status for women in the society at large.

The Athenian woman, daughter of a citizen, always had a dowry that

was meant to remain intact when she married. The dowry provided her with some degree of economic security. In the absence of sons, a daughter could legally inherit the family wealth, but the nearest male relative was supposed to marry the heiress. While women could acquire property through their dowries or by inheritance or gift, they had no legal rights. Women could not conduct business or sign contracts for major sums. Furthermore, because few women were literate, it was virtually impossible for women to conduct a business enterprise independently of men.

Greek women of all classes were occupied with the same types of work, mostly centered around the domestic needs of the family. Women cared for young children, nursed the sick, and prepared food. Wealthy women supervised slaves who did these tasks. Poorer women who could not afford to remain at home worked for wages at these jobs. There is evidence that some lower-class women sold retail goods in the marketplace.

Throughout this period in the Greek world, one of the major tasks of women was the weaving of textiles and their decoration. Women of all classes contributed to the making of cloth. Wealthy women and slaves worked in their homes, while poorer women earned wages as wool workers in the cloth industry. Spindles used to spin flax or wool into thread have been found in graves from the Dark Ages, identifying these as burial places of females.

Many female figures, including Helen and Penelope, are occupied with spinning and weaving in the *Iliad* and the *Odyssey*. Penelope, the wife of Odysseus, spends her days weaving a shroud for Laertes, Odysseus's father, and her nights unraveling it to evade her suitors. This is her primary activity and can be taken as an example of the importance of weaving in the life of the Greek upper-class woman. In Athens, a robe (*peplos*) for the cult statue of the goddess Athena was woven every four years. Two young girls selected from among the noble families of Athens would spin the yarn for the cloth. Other women then assisted in the weaving and embroidering of this holy garment. The culmination of the Panathenaic procession was the presentation of the *peplos* to the statue of Athena on the Parthenon, as depicted in the Parthenon frieze. Representations on Greek vases of women spinning or weaving far outnumber the pictures of other crafts. For example, the black-figured painting on a lekythos (Figure 4) illustrates women occupied in a variety of tasks related to the making of cloth.

Textile manufacture was a primary occupation for women in areas of the ancient world outside of Greece. As noted before, women of all classes in the ancient Near East made textiles. Phoenician women were famous for their fine cloths. In the excavations of Troy, many weaving tools have been found.

Women were not only responsible for the manufacture of cloth but also for its decoration. Embroidery was an exclusively female occupation in Greece. In the decoration of textiles, women were the tastemakers of antiquity. Here, they had an outlet for their visual creativity.

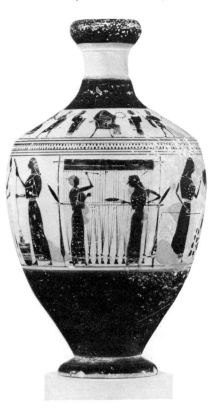

FIGURE 4. ATTRIBUTED TO THE AMASIS PAINTER. *Lekythos.* Women working wool on a loom. H.: 6 3/4". Said to have been found in Attica. The Metropolitan Museum of Art, Fletcher Fund, 1931.

Kate McK. Elderkin has built a convincing case for the influence of textile patterns and decoration on the successive stylistic development of Greek pottery design.[17] She maintains that the geometric style, as seen in the Dipylon pottery vases of the eighth century B.C. (Figure 5), was derived from the ornamental patterns found in Dorian wool fabrics. Not only the specific forms, but also the use of bands, is consistent with the weaving of wool fabrics. Ornamentation in bands is a noteworthy characteristic of Corinthian ware, such as the famous François Vase. In the later Archaic period, i.e., the sixth century B.C., fashions changed and the less decorated linen chiton of the Ionians gained popularity. The painted decoration on pottery subsequently became less ornate, and the influence of weaving became less pronounced in this epoch.

Athena was the patron goddess of both weavers and potters, connecting both of these activities with women, although by the Classical era it was mostly men who made pottery. Some women did continue to practice this craft. A woman is shown decorating a vase on a Greek red-figured hydria from the fifth century B.C. She is depicted in a workshop setting.

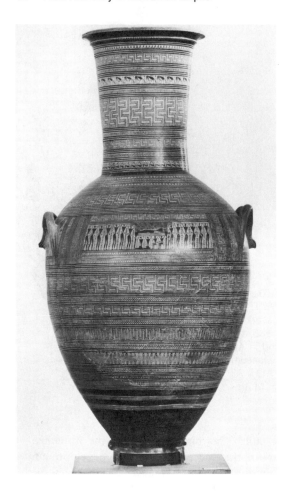

FIGURE 5. Dipylon Amphora (Geometric Style), from the Dipylon Cemetery, Athens. c. 750 B.C. H.: 61". National Archaeological Museum, Athens. Courtesy Hirmer Verlag München.

During the Hellenistic era (fourth to first centuries B.C.), Greek women received a rudimentary education, learning to read and write (except in Athens). In exceptional cases, women could study with a philosopher. By the fourth century B.C., the women of Sparta controlled two-fifths of the land through dowries and inheritance. Since much of the male population was away at war, the Spartan women enjoyed substantial freedom.

An increased status and prestige, at least for royal and upper-class women, can be observed during the Hellenistic era:

> . . . many women wielded power as wives or mothers especially of weak kings and as regents for young sons or absent husbands . . . the competent women visible in Hellenistic courts were one of the positive influences of this period toward increasing the prestige of non-royal but upper-class women.[18]

During this period there were more public decrees honoring the activities of women, a few women even held public office, and nude statues of goddesses proliferated.

While very few artists' names of either sex survive from antiquity, the earliest recorded names of women painters are found in Hellenistic texts. Unfortunately, none of the works of these artists have survived. In 228 B.C., Nealkes of Sicyon had his daughter trained as a painter.[19] Another Greek painter known by name alone was Eirene, daughter of Kratinos, who was famous for painting in the city of Eleusis. Eirene is singled out for special mention in Boccaccio's *Concerning Famous Women*.[20] Boccaccio's treatise, largely dependent on the Roman historian Pliny, is a very important Renaissance source, preserving for his era the names of notable women of antiquity. Boccaccio also mentions Thamyris, or Timarete. This artist's reputation was based on a painting of the goddess Diana, guarded at the sanctuary in Ephesus. It is, of course, possible that women were painters in earlier periods and that their names, like those of their male colleagues, have simply been lost in history. To my knowledge, no evidence of women sculptors or architects in the ancient world has survived.

Long before the appearance of women painters in literary records, women had been credited in legend with the invention of this art. In both Eastern and Western cultures, the origin of the art of painting is attributed to the observation of a shadow and the tracing of that outline. By the time Pliny recorded the legend, the inventor of painting was identified as a woman, i.e., the "Corinthian Maid." The Maid traced her lover's profile on a wall. Subsequently, her father, the potter Butades, built up the work into a sculpture. The Corinthian Maid is often called "Dibutade," i.e., the daughter of Butades. A variation of this legend is recorded by Athenagoras, a Christian Athenian of the second century A.D. The first artist is now called "Core."

The legend of the Corinthian Maid was first widely used as a subject for the visual arts during the era of romantic classicism, in the late eighteenth century A.D. One art historian, Robert Rosenblum, believes that the increased popularity of the story of Dibutade at that time is related to the prominence of contemporary artists such as Angelica Kauffman and Elisabeth Vigée-Lebrun.[21] The careers of these artists will be discussed in chapters six and seven.

The legend of Dibutade and the preservation of the names of these women painters from the past have immense importance for the history of women artists. Despite their limited number, these notable painters served as role models for women artists from the Renaissance through the nineteenth century. Eirene, Timarete, and the other women recorded by Pliny and included in Boccaccio's study were incorporated into many subsequent histories of women artists.[22] Even though their works were lost, their reputations remained alive, preserving the idea that women could become excellent painters.

WOMEN OF ROME

The process of increasing freedom and status for upper-class women, begun in the Hellenistic era, continued into Roman times. Groups of women, such as the Sabines, played an important role in the early history of the Roman Republic. The famous Cornelia, who lived in the second century B.C., was considered a paragon of virtues: "She possessed an excellent Greek education, was a master of rhetoric such as no other woman was and corresponded with philosophers, scientists and distinguished men of affairs."[23] Through her sons, the Gracchi (their father was the tribune Tiberius Sempronius Gracchus), she exerted political influence as well. Cornelia was a model figure not only for subsequent generations of Roman matrons but also for later centuries. (See Kauffman's *Cornelia Pointing to Her Children as Her Treasures,* Figure 28.) As in Sparta, the prolonged absence of men on military campaigns and the administration of a far-flung empire gave upper-class women greater autonomy.

Nevertheless, marriage and motherhood continued to be the main occupation of Roman matrons. The exposure of girl infants and early death in childbearing resulted in fewer women than men in Roman society.[24] During both the Republican era and the Empire, virtually all upper-class women were married. In fact, Augustus made marriage almost compulsory. Girls were married early, between the ages of twelve and fifteen. Motherhood conveyed great status, as well as economic benefits, on women. Unmarried women forfeited their inheritances, and childless women lost half of their inheritances.

While the Roman matron acquired a measure of respect and power inside the home as *mater familias,* the *pater familias,* i.e., the father of the family, retained total control over the female members of his family. He had the literal power of life and death over his daughters and decided on their marriage partners. Legally, women could not control any money or transact business on their own, but in practice women did control and bequeath their wealth. The growing bureaucracy of the Empire served to protect the rights of wives and children. A wife's dowry had to be returned intact if her husband repudiated the marriage.

> The growing custom of marriage *sine manu* enabled a women to remain under the power of her own family rather than being transferred to her husband's on the simple condition that she live for three days of every year in her father's house. By the beginning of the third century, [the Roman jurist] Ulpian said that a woman had to have a tutor to act for her at law, to make contracts, to emancipate slaves or to undertake civil business. But he added that a woman who had borne three children was no longer subject to this regulation. Thus, the Roman woman, entirely powerless within the public structure, could exercise very considerable power in private life as a result of the wealth and property that she might accumulate by herself or through her family.[25]

Upper-class girls were educated by private tutors, but the early age of marriage limited the extent of their education. However, as was also true of

the Renaissance, education and other accomplishments were considered positive attributes for women. Because women were not so completely isolated from male company as in Classical Athens, a woman was expected to be able to converse intelligently with men. Large numbers of upper-class women were interested in literature, and a few were even authors and poets. Numerous orations honoring women have survived, indicating a public approval of notable women.

Spinning and weaving continued to be a major preoccupation of women of all classes:

> The old-fashioned Roman bride wreathed the doorposts of her new home with wool. When Augustus wished to instill respect for old-fashioned virtues among the sophisticated women of his household, he set them to work in wool and wore their homespun results. Many women of the lower classes, slave and freed, were also employed in working wool both at home and in small-scale industrial establishments where working-class men joined women as weavers and weighers of balls of wool to be apportioned to weavers. Spinning, however, continued to be solely women's work.[26]

Lower-class women practiced a number of occupations. In Pompeii, there were women physicians and "commercial entrepreneurs," as well as prostitutes, waitresses, and tradeswomen. Slaves worked as domestics and, as noted above, in the clothing industry. "Freed women and female slaves worked as fishmongers, barley-sellers, silk weavers, lime burners, clothes-menders . . . as midwives and nurses . . . stenographers, singers, and actresses, among other professions."[27]

Iaia of Kyzikos is the only name of a Roman woman artist that has been preserved. According to Pliny, "She painted chiefly portraits of women. . . . No artist worked more rapidly than she did, and her pictures have such merit that they sold for higher prices than those of Sopolis and Dionysios, well-known contemporary painters. . . ."[28]

Considering the wide variety of occupations practiced by Roman women, there may well have been other women painters whose names have not come down through the centuries. At any rate, the fact that Pliny recorded for posterity the names of a handful of women painters is a mark of the increased respect the Romans had for women of talent.

2

The Medieval World

During the long period known as the Middle Ages, women in different socioeconomic classes occupied a wide variety of roles and positions within their diverse cultures. For about a thousand years, from the collapse of the Roman Empire to the beginning of the Renaissance, society moved through a series of political and economic changes that affected the lives of women and the potential for them to act in the world. From the increased number of surviving documents, compared with the ancient world, the clearest picture emerges for women of the upper classes, the land-owning nobility. However, the general tendency, as the Middle Ages progressed, "was toward a lessening of the public activity of women, a lower place in ecclesiastical opinion, fewer roles in guild organizations, and less agricultural administration, if not less agricultural labor."[1]

Most of the works of art that have survived from the Middle Ages are related to the needs of the Church or the religious requirements of the nobility. Whether active in the construction and decoration of churches, the fabrication of magnificent sacramental objects in precious metals, the embroidering of clerical vestments, or the illumination of religious texts, the medieval artist/artisan, male or female, worked most often in anonymity. Where so few male artists are known by name, it is not surprising that the names of only a handful of women artists have survived from this epoch. Nothing, of course, precludes the possibility that more women artists of talent existed but did not sign their works and therefore remain unknown to modern scholars.

Throughout the Middle Ages, it would appear that large families were fairly common. The infant mortality rate remained high, and many women died in childbirth. There is no evidence of infanticide. Earliest statistics, which date from the Carolingian era (ninth century), show that there were fewer

adult females than males. This was the result of women's vulnerability to violence, mortality in childbirth, and lives of hard labor. However, after the thirteenth century, life expectancy was longer for women than for men. Furthermore, during the late Middle Ages, when reliable population statistics are available, there was a surplus of women. We know, for example, that in Bologna in the late fourteenth century, women formed a majority of the population over age fifteen. While many men were killed during the incessant warfare of the epoch, women in cities were protected from attack. Men also died in greater numbers during the plagues that repeatedly decimated the population. In addition to these natural causes for high male mortality, many more men than women took vows of celibacy as monks or clergy. Therefore, a certain proportion of the female population could not find mates. Among the upper classes, unmarried women were sent to convents. Women of the lower classes were always needed as workers, either in the urban shops of their fathers and brothers or as agricultural workers on rural manors.

During the Middle Ages, the situation of women was so intertwined with their class status that it is impossible to make any accurate generalizations about medieval women that cut across class lines. For that reason, the options of the women of the peasantry, the landed nobility, and the craft or artisan class in the towns will be discussed separately.

WOMEN PEASANTS

The largest number of women throughout this epoch belonged to the peasant class living on rural manors. Peasant women were involved in all activities of the manor except plowing. Their major responsibility was the production, preparation, and serving of food. They cooked, ran the dairy, cultivated the gardens, and tended poultry, in addition to performing many agricultural tasks. While aristocratic and upper-middle-class women were often literate, most lower-class women living on manors could not read or write. A peasant woman had practically no legal rights. She was dependent not only on her husband but also on the feudal lord. An old custom known as *ius primae noctis* or *droit du seigneur* entitled the feudal lord to spend the first night with every bride on his land. This right was not always exercised in practice, but it remained for centuries a symbol of the lord's possession of the women of his manor. In Germany a woman of the lower classes could dispose of only very small sums of money, and her husband had sole rights to the dowry.

WOMEN OF THE LANDED NOBILITY

During the early Middle Ages, women were often permitted to inherit land, usually in the absence of a male heir. In an epoch when all wealth was determined by the ownership of land, this gave a select group of women great

power within their society. Beginning in the sixth century, daughters could inherit property, and the laws restricting inheritance rights of women were continually eased. By the mid-eighth century, both legally and in practice, women were often inheriting control over land. In the early Middle Ages, with the exception of the Carolingian period in the ninth century when a centralized government under Charlemagne was established, women often wielded considerable political power through their ownership of property. While the Carolingian system deprived some women of their political influence, it eventually strengthened the position of secular women within the family. Marriage became indissoluble, and this protected women from capricious husbands and ensured their inheritance rights. Following the dissolution of the Carolingian empire, women of these classes benefited directly from the almost unlimited power of the family:

> Since land had become the only source of power, by exercising their property rights . . . a growing number of women appear in the tenth and eleventh centuries as . . . mistresses of landed property and castles with attendant rights of justice and military command, proprietors of churches and participants in both secular and ecclesiastical assemblies.[2]

Because a woman was allowed to bequeath her property as she wished, her position of power was consolidated. Women appear to be most important as landowners and managers when men are absent for extended periods during the frequent wars or the Crusades. By the early twelfth century, Eleanor of Aquitaine controlled a large portion of the lands of southern France, making her the most outstanding and famous example of a powerful female landowner. But there were others, especially in southern France and Spain where women were very prominent as landowners.

During the Middle Ages, marriage continued to be largely a financial and political arrangement. This was especially true in cases of heiresses. Often, women were betrothed and even married while still children. Once a woman was married, her legal rights were restricted. Wives were supposed to be obedient to their husbands. The husband, in turn, functioned as his wife's "guardian" and had to represent his wife in court. Only in the later Middle Ages could women act as witnesses in court. A widow, however, was permitted to act more independently than a wife or daughter. Many widows were named as executrixes in their husband's wills and thereby profited financially from their marriage contracts.

The wife of a nobleman living on a feudal estate was responsible for the smooth running of a large and complex household. Medieval manors were economically self-sufficient; virtually all the necessities of life had to be raised or made on the premises. The noblewoman supervised food preparation and production on the farm and dairy. Some of the cloth used for the household was produced at home, but in the later Middle Ages the expanding cloth industry of the towns provided textiles more cheaply than they could be

produced in the manor. When it was no longer necessary to manufacture cloth on the manors, noblewomen often occupied themselves with embroidery and tapestry production, the most luxurious forms of needlework.

Large families were common among the upper classes, but the responsibilities of motherhood were not as demanding as in later epochs. Infants were ususally turned over to wet nurses. Boys and girls left home at an early age to pursue their educations, and marriage took place at a very early age.

Girls born into noble families were provided with an education that could prepare them for the complex responsibilities of their existence. Some girls were sent to school in nunneries. Here they learned to read, received religious instruction, and were taught the techniques of spinning and needlework. Sometimes girls were also taught how to write and illuminate manuscripts. In addition to this type of education, girls were sent to the courts of great ladies where they could develop manners appropriate to their class. A certain level of intellectual attainment was acceptable for women of this class. They were often expected to be able to sing and to play a musical instrument.

When the lord and husband was in residence, the noblewoman's tasks focused on the domestic management of the estate in her roles as wife and mother. However, when the husband was absent, as was frequently the case during the Crusades and other military expeditions, the duties of the wife expanded dramatically. The medieval lady then took over all aspects of the management of the estate, even defending it from attack if necessary. If the lord was captured, she raised the money for his ransom. In his absence she was his sole representative for all necessary affairs.

The dominant role played by the noblewoman on her estate during her husband's absence is consistent with the activities of some queens who served as regents when their husbands, i.e., the kings, were not in residence at court. For example, Eleanor of Aquitaine was designated regent for Henry II and Matilda was regent for William the Conqueror.

Although not acting specifically as regent, some medieval queens were quite influential. The Carolingian queens of the ninth century were responsible for the distribution of funds from the royal treasury for the salaries of knights. It is likely that the queen also controlled the workshops on the manors, which supplied the funds that she dispensed. The wives of the three Ottonian Emperors in the tenth century used their influence to found convents which, through schools and in other ways, strengthened the dynasty of the emperors.

Not to be overlooked for the history of art, many queens and noblewomen were very active patrons of the arts, commissioning precious objects, books, goldsmith work, embroideries, and so on.

With a few notable exceptions, beginning in the mid-eleventh century the growth of cities and the increasing powers of the Church tended to restrict the wide range of roles that upper-class women had played in the tenth and early eleventh centuries. Compared with the early Middle Ages, women in the twelfth, thirteenth, and fourteenth centuries could not exercise the same range

of power. Professional men took over the administration of their families' estates.

Furthermore, the custom of providing women with a dowry upon marriage rather than a portion of the family's land holdings was becoming more widespread. While this practice prevented the division of a family's property, thus improving the aristocracy's ability to withstand the growing power of the kings, it restricted the economic scope of women, which was largely based on control of land.

Courtly Love and Christian Dogma

As women's real power to act in the world diminished, a new art form developed in which women played a major role, i.e., the poetry of courtly love. Women of the courts, particularly in southern France, patronized the troubadours who sustained this movement. In this romantic cult, the noblewoman, as object of the poet's love, is worshipped almost as devoutly as the Virgin Mary in Christianity. "In chivalry, the romantic worship of a woman is as necessary a quality of the perfect knight as the worship of God."[3] Courtly love, by definition, was extramarital, and it was defined in physical terms. This glorification of the aristocratic lady, the object of the poet's romantic fantasies, is an artistic and intellectual construction that tells us little about the actual roles and contributions of these women to their society.

The romantic adoration of the noblewoman in the poetry of courtly love is one intellectual position diametrically opposed by the misogyny of Catholic religious teachings. From the time of the earliest church fathers, particularly St. Paul, Christian dogma viewed women as embodiments of evil. The ideal Christian life was spent in monastic isolation, avoiding pernicious contact with women. Women were tools of the devil, a bitter necessity for the continuation of the species. And because the clergy who avoided contact with women were the main portion of the population who were educated, their ideas received wide dissemination. St. Thomas Aquinas did not include women in his moral system. He wrote of "making use of a necessary object, woman, who is needed to preserve the species or to provide food and drink . . . woman was created to be man's helpmate, but her unique role is in conception . . . since for other purposes men would be better assisted by other men."[4]

It is an interesting contradiction that this fear and degradation of women coexisted with the Christian cult adoration of the Virgin Mary. The worship of Mary was a very widespread religious phenomenon in the later Middle Ages.

Nunneries

In addition to the role of lady of the manor, women of the upper classes could also become nuns. This was only possible for women of wealth because a dowry was required before a woman was permitted to join a convent.

Furthermore, unmarried women of the lower classes were economically pro-
ductive, and their labor was useful for the family unit. The nunneries provided
a socially acceptable refuge for women whose only other alternative was mar-
riage. The convent schools trained boys and girls of the upper classes. Con-
vents also served as boarding houses for wealthy wives and widows who, for
whatever reason, could no longer reside in their castles. Even though the
contemplative life of a nun was an available option for only a small percentage
of the female population, nunneries fulfilled an important purpose for upper-
class women. Freed from male domination, some women could exercise lead-
ership skills, powers of organization, and management of a complex estate.
Especially in the early Middle Ages, between 500 and 700 A.D., nunneries not
only preserved learning and maintained culture but often exercised power
through their land holdings. The power of abbesses, rivaled only by queens,
was equal to that of abbotts and even bishops.

Nunneries permitted women to pursue lives dedicated to spiritual con-
templation, which was highly respected in the society of the Middle Ages, so
dominated by religious concerns. Furthermore, convents provided a good
education for the nuns and daughters of the nobility, although standards of
education and literacy varied. The most learned women of the Middle Ages,
those who made significant contributions to their culture, were nuns. As we
will see, the convent scriptoria provided women with the opportunity to
become artists.

St. Hildegarde of Bingen was the abbess of a convent in Germany. She is
generally regarded as one of the greatest mystics of the Middle Ages. From her
position as head of a convent she became quite famous in her epoch and
corresponded with the most noted contemporary religious and political fig-
ures. Although not a painter herself, St. Hildegarde was believed to be respon-
sible for the innovative design of the imagery that illustrated her visions, the
Scivias. Although no surviving manuscript may be attributed to her hand, it is
likely that her imagination, which extended to the invention of 950 words,
also contributed to the form of the illustrations.

Herrad of Landsberg, Abbess of Hohenburg, is the author of a very
important medieval pictorial encyclopedia, the *Hortus Delicarum*. The manu-
script is known only through traced drawings made in the nineteenth century.
These 636 miniatures document her strong visual imagination and earn her an
imposing place in medieval art.

At the peak of their population, in 1250 A.D., there were 500 convents in
Germany. By this time, however, the convent was no longer exercising a
leadership role in the society, as in the early Middle Ages. Beginning in the
mid-eleventh century, Church leadership was moving from the monastic sys-
tem to the hierarchical political structure of the bishoprics and the papacy.
Along with this development, the intellectual centers of the society shifted
from the monasteries to the universities, where women were excluded.

Furthermore, the nunneries, suffering from insufficient endowment and

bad management, were by the late Middle Ages in a noted state of decline. Latin was no longer widely understood, standards of education had fallen, and an increasing worldliness had penetrated the cloistered walls. Artists practicing within the convent were no longer exposed to changing stylistic developments, and the art produced was stylistically out of date by the beginning of the Renaissance. This decline may be attributed, at least in part, to the misogyny of the Catholic Church, which fostered a highly mixed attitude toward pious women who wished to pursue a contemplative life.

After the Gregorian reform movement of the late eleventh century, the formerly widespread practice of the double monastery, one for men and one for women, was abolished. Convents were thus excluded from the institutional hierarchy of the Church. There was no female monastic order, despite the efforts of a few men, most notably Pope Innocent III, who wished to keep the women's religious movement within the Church organization. The existing orders, such as the Franciscans, Dominicans, and Cistercians, were not receptive to the integration of nuns into their administrative domain. It is not surprising, given this unwillingness on the part of the established Church hierarchy to accept the administration of pious women, that women formed independent, semi-religious, unofficial communities. Beginning in the twelfth century, pious women known as Beguines gathered together to live in chastity and poverty. Most of these women were from the upper class, both married and single, who renounced all worldly goods to pursue a penitential life and perform charitable acts.[5]

Significant numbers of women were also attracted to heretical sects that provided a wider role for women in their orders. The Waldensians and Carthars, for example, permitted women to preach and act as priests. The Albigensians also concerned themselves more directly with the position of women in society.

Medieval Manuscript Illuminators

Prior to the end of the thirteenth century, the production and illumination of sacred books was solely confined to monasteries and convents. For the history of art, this is the most important role of these institutions. The nunnery was the only place in that society where women could be trained as painters. Consequently, women painters of the Middle Ages came from the upper classes. A limited number of women manuscript illuminators who were nuns are known from the tenth to the sixteenth centuries. The attribution of a manuscript illumination to a woman can be authenticated only by a signature or self-portrait, and many medieval artists did not sign their works. It is possible that many even more important women artists are simply unnamed and therefore unknown.

The first major convent scriptoria, or book-making workshops, coincided with the revived interest in manuscript creation and preservation under

the reign of Charlemagne. Charlemagne's sister Gisela directed the first Car-
olingian convent scriptorium at Chelles, northeast of Paris. Although one
cannot firmly attribute a set of illuminations to women painters at the Chelles
convent (which was part of a double institution of monastery and convent),
other related manuscripts are signed by women. Also, there are literary refer-
ences to illuminators who were nuns in England and Flanders in the eighth and
ninth centuries.

The earliest manuscript firmly attributed to a woman is the Gerona
Apocalypse, signed "En depintrix" and produced in Spain around 975. These
paintings are very fine illustrations of the apocalypse compiled by Beatus. In
the double-page painting reproduced here (Figure 6), one can see a strong
sense of abstract design and linear energy. The horizontal registers provide
both a base line for some figures and a background for other forms. The active
curvilinear shape of the dragon and the drawing of the figures demonstrates a
highly competent draftsmanship. Dorothy Miner has noted "the sensitive play
of sharp colors against disarmingly delicate ones . . ." as another interesting
and original element of En's style.[6] Furthermore, within the tradition of
Mozarabic manuscript illuminations, the "longer and more active bodies, pale
complexions and . . . lively silhouettes"[7] of the figures are personal stylistic
elements of this talented and innovative artist.

The numerous German nunneries mentioned earlier account for the fact
that most known female manuscript illuminators of the Middle Ages were

FIGURE 6. EN. *Battle of the Dragon with Child of the Woman.* Beatus Apoc-
alypse. Gerona Cathedral, Gerona, Spain.

German nuns. A self-portrait identifies Claricia as the illuminator of a manu-
script made in Augsburg, Germany in the twelfth century. In a clever way,
Claricia painted herself swinging from the body of the initial "Q." Another
illuminator named Guda inserted her own image in a manuscript from Frank-
furt also dating from the twelfth century. While Guda is in a nun's habit,
Claricia appears in ordinary clothes. Claricia might have been an upper-class
woman who was sent to a convent for schooling—a common practice. "It
becomes clearer and clearer as the Middle Ages move on that miniature paint-
ing was regarded as an appropriate occupation and a becoming accomplish-
ment for a lady."[8] The future recommendation of Castiglione in the sixteenth
century, advising women of the courts to acquire painting skills, is merely a
continuation of a widespread practice in the Middle Ages and not the initiation
of a new set of expectations for women of the upper classes.

In Dominican convents in southern Germany in the late fourteenth and
early fifteenth centuries, a large number of women were trained as manuscript
illuminators. By this time, however, with the developments of the Renais-
sance, convents were too isolated to keep pace with the changes of style in the
art produced in the secular world.

URBAN WORKING WOMEN

With the emergence of towns and cities toward the end of the Middle Ages,
women took on some new roles and continued some old ones in the urban
economy. Girls in the later Middle Ages had a slightly better chance of receiv-
ing a rudimentary education in the towns than in the countryside. In 1272,
there was one public elementary school for girls in Paris, but eleven such
schools for boys. All women of the lower classes contributed in some way to
the economic stability of their family unit. Girls, like boys, were often appren-
ticed to learn a trade. The female apprentice was under the direct supervision
of the master's wife. Wives and daughters most often worked in the family's
commercial enterprise. Many wives, not directly active in their husband's
trade, would handle the retail end of the business. Because there was a surplus
of women, unmarried women were forced to support themselves and often
worked for wages or ran their own businesses. "Under English common law,
the unmarried woman or widow, the *femme sole*—was, as far as all private, as
distinct from public rights and duties are concerned, on a par with men."[9] In
certain cases when women were conducting businesses of their own, even a
married woman could be treated as a *femme sole* in England.

A number of women workers were employed in the manufacture and
sale of food and beverages. The bread-making and brewing industries were
dominated by women. Women often sold food in markets and were inn-
keepers. These types of employment continued the traditional identification of
women with food preparation for the family.

Of greatest interest for the history of art is the wide range of craft and artisan activities practiced by women in medieval towns. In Paris by the late thirteenth century, women were working at 108 occupations of the most diverse kinds. Women were shoemakers, tailors, barbers, jewelers, goldsmiths, bookbinders, painters, and many other skilled artisans. Of the 110 craft guilds that existed in Paris, five restricted membership to women only.

Another important female occupation during the Middle Ages and continuing into the seventeenth century was midwifery. However, while midwives could practice family medicine and obstetrics, they were not permitted to become professional physicians.[10]

A large number of women were occupied in the rapidly expanding textile industry. In fact, the making of wool, linen, and silk cloths was one of the major occupations of women until the eighteenth century and the Industrial Revolution. Women performed nearly all the work in the preliminary processes of cloth making—combing and carding the fibers, spinning the yarn, etc. Women holding distaff and spindle, the tools of the trade, appear frequently in the marginalia of medieval manuscripts. In England, the Netherlands, northern France, and Italy many women worked at these tasks. The term "spinster," i.e., one who spins, originally identified a person's occupation. By the seventeenth century, the term had acquired the additional meaning of "an unmarried woman," indicating the virtually total identification of spinning with women. Weaving was also a female occupation in the thirteenth century, but by the sixteenth century this craft was taken over by the all male weavers' guilds.

In addition to the wool trades, women dominated the silk-making industry in France. The women who spun the thread and made the silk cloth were paid notoriously low wages. The manufacture of silk belts and alms purses was the responsibility of women's guilds. Until the fourteenth century, dressmaking and embroidery were also female-dominated activities. In fact, English women embroiderers perfected this art in the thirteenth century. Their creations are collectively known as *opus Anglicanum*. These embroidered church vestments and garments were highly desired by the nobility and clergy all over Europe.

While women were very active in a wide range of crafts throughout the Middle Ages, their relationship to the guilds varied widely. Guilds were powerful trade organizations that limited membership in the professions and established regulations controlling the products.

In Paris, women could become independent members of a guild as early as the thirteenth century and were subject to the same regulations as men. Crafts monopolized by women were organized in the same way as crafts with greater male participation.

In the fourteenth century women were often members of German guilds. However, by the fifteenth century, during the Renaissance, women began to be excluded more and more from membership in Italian and German guilds. It

would seem that fear of competition from women who worked at lower wages was the main rationale for their exclusion. The male guild members did not want to be undercut by cheaper female labor.

In England women were almost never admitted as full members to a guild, and there were no guilds for the female-dominated industries. Exceptions were made for widows, who were regularly admitted as full members of their husbands' guilds. Many widows carried on their husbands' businesses, documenting their active partnership in the trade. The progressive exclusion of women from full membership in professional organizations continued into the sixteenth century. "By 1600 women had disappeared almost completely from professional life."[11]

Secular Manuscript Illuminators

In northern Europe, unlike Italy, the art of illuminating manuscripts did not occupy a secondary place to large-scale fresco painting. This form of painting was highly valued and actively supported by the leading art patrons of the era.

As early as the thirteenth century, commercial book illustrators, as opposed to monks and nuns, ran businesses in the cities of Europe. While never very numerous, women painters and sculptors did exist by the late thirteenth and early fourteenth centuries, as documented by tax records. Etienne Boileau's *Livre des Métiers* (1270) refers to a guild of female book illuminators and binders.[12] Women artists were usually members of a family of male artists. As noted earlier, in the artisan classes women regularly worked in the family business.

In 1405 an important feminist writer, Christine de Pisan, wrote a defense of her sex entitled *The City of Women.* Inspired by Boccaccio's *Concerning Famous Women,* which had been translated into French in 1402, Christine de Pisan enumerates the merits of women. She thus initiated a literary debate, which was continued by other early feminist writers, and became known as the *Querelle des Femmes.* From the fifteenth century to the French Revolution, a few educated women writers conducted a polemical defense of women countering the prevailing misogyny of their cultures.[13]

Of special importance to the subject of women artists, de Pisan praises the illuminations of a contemporary artist, Anastaise:

> . . . with regard to painting at the present time I know a woman called Anastaise, who is so skillful and experienced in painting the borders of manuscripts and the backgrounds of miniatures that no one can cite a craftsman in the city of Paris, the center of the best illuminators on earth, who in these endeavors surpasses her in any way. . . . And this I know by my own experience, for she has produced some things for me which are held to be outstanding among the ornamental borders of the great masters.[14]

It would seem that Anastaise specialized in the less prestigious aspects of manuscript painting, i.e., backgrounds and borders. Yet her skills were clearly impressive enough for Christine de Pisan to extol, thereby leaving a record of her existence for posterity.

Although not mentioned in *The City of Women,* at about the same point in history another woman artist, Bourgot, was actively employed by the most important patrons of her era in the decoration of manuscripts. Bourgot was the daughter of the painter Jean Le Noir.[15] Le Noir and Bourgot executed a Book of Hours for Yolande de Flandres, an important and active patron of the era around 1353. This "delicious and delicate" manuscript continued the inventive traditions of Jean Pucelle, but "infused it with a more sturdy expressionism."[16] They moved to Paris where they worked for the King of France, Charles V. Le Noir received payments from Jean, Duc de Berry in 1372 and 1375. The list of their sophisticated patrons testifies to the skills and reputations of Le Noir and Bourgot. Although it is difficult to distinguish the creative contribution of Bourgot from that of her father, one may assume that she was at least a highly competent craftsperson, if not the creative force of the team.

By the fifteenth century, women would appear to be even more active in the art of book painting. The records of the painters' guild in Bruges, which admitted women as members, reveal that 12 percent of the guild members were female in 1454, and that the proportion had increased to 25 percent by the 1480s. As Harris suggests, such extensive participation in this field is an essential background for the emergence of Flemish miniature painters in the sixteenth century.

From this account it is clear that both in convents and commercial enterprises, women formed a small but not insignificant percentage of the artists active as manuscript illuminators. While it is impossible to identify the precise contributions of these craftswomen, their existence can be either inferred from general custom in the society or documented when guild records included women and have been studied by modern historians.

Medieval Embroidery

The association between women and the decoration of textiles with embroidery can be traced back to the ancient world. This time-consuming activity is usually associated with women of the upper classes who had the leisure to devote to the art. During the Middle Ages, many women were taught to embroider, and they used this skill to fashion some of the most significant but fragile works of their epoch. In many of the homes of noblewomen, embroidery was not a casual pastime but a serious occupation, an organized domestic activity.

Embroidery is not widely considered a "fine art" today. In fact, it ranks

fairly low on the hierarchical scale of the crafts. In the Middle Ages, however, embroidery was widely appreciated as an art form. The most noted historian of medieval English embroidery has characterized the status of this medium in the following way: "A vast quantity of work never since equalled in design, technique, or quality of materials employed was produced throughout Europe. In England the art of needlework attained such notable perfection that its masterpieces challenged comparison with the finest paintings."[17] When the status of the art of embroidery is this high, the largely anonymous creators of these works rank with the leading artists of their era.

In the early Middle Ages, prior to the development of the town economies of the twelfth and thirteenth centuries, embroidery was made in convents and in the homes of noblewomen. In Carolingian convents, teams of women produced fine fabrics used for vestments or as export commodities to be sent to Byzantium in exchange for gold. Women's work thus produced one of the few marketable export items of the economy.

Many convents were occupied with the creation of elaborate embroideries used for priests' vestments or as an offering to a saint. These objects were frequently encrusted with pearls and other jewels and often sewn with gold and silver thread. The earliest reference to a woman embroiderer is St. Etheldreda, Abbess of Ely, who lived in the seventh century. She "offered to St. Cuthbert a stole and maniple, a fine and magnificent embroidery of gold and precious stones, worked, it is said, with her own hands, for she was a skillful craftswoman in gold embroidery."[18]

Convent schools taught the arts of needlework to the daughters of the landed nobility as part of their premarital education. This factor, combined with the transmission of techniques informally from generation to generation, did not merely preserve the art but helped to stimulate its practice. Noblewomen prided themselves on the skill of their needlework, lavished on clothing as well as on the decoration of church vestments. The stole and maniple worked by order of Queen Aelfflaed, wife of Edward the Elder (c. 910) have been preserved in Durham Cathedral. The work demonstrates the extreme finesse and technical excellence of the art of embroidery at this time.

In addition to the use of embroidery to decorate religious garments, we know of at least one tapestry that illustrated a narrative of the deeds of a nobleman. Around 991, a woman named Aedelfleda presented the church at Ely with a hanging embroidery illustrating the achievements of her husband. This work, although now lost, may have inspired Odo, Bishop of Bayeux, to commission the most famous embroidered work of the Middle Ages, the *Bayeux Tapestry*.

The *Bayeux Tapestry* is a unique surviving masterpiece of the medieval art of needlework.[19] Made around 1070, it depicts events surrounding the invasion of England by William the Conqueror in the year 1066. The narrative is a moral tale of the downfall of Harold who broke his oath, sworn at Bayeux. Whether the historical account of the Norman Conquest documented in the

Bayeux Tapestry should be considered reliable history is less important than the fact that the tapestry was almost certainly executed by teams of women, following the cartoons of a single designer of undetermined sex. Worked in brightly dyed wool on linen, the *Bayeux Tapestry* is 230 feet long. The elaborate detail, lively movement of men and animals, and sophisticated composition prove that it is a work of highest quality.

The energy and activity of the narrative in the *Bayeux Tapestry* is shown in this banquet scene (Figure 7). Roasted poultry on skewers is taken off the fires and placed on a sideboard. The horn informs the company that dinner is served. Bishop Odo, seated in the center of the semicircular table, says grace; William the Conqueror is seated at his right. The scene uses green, red, and yellow thread that retains some of its original brilliance. The precision of the needlework demonstrates the exceptional technical capabilities of the workers. The decorative borders, enlivened with composite animals, provide additional scope for inventive designs.

Opus Anglicanum

As early as the eleventh century, some lower-class women earned their living practicing the art of embroidery. By 1250, professional women embroiderers in England had an international reputation, and their creations were in great demand. The popes frequently ordered embroidered vestments from English workshops. Royalty, clerics, and wealthy persons all over Europe wanted to own examples of the now renowned *opus Anglicanum,* the term used to refer to works of embroidery created at this time in England. Around 1240, Mabel of Bury St. Edmonds "was possibly the foremost worker," according to Christie. In the early fourteenth century, Rose of Burford, wife of a London

FIGURE 7. Bayeux Tapestry. Detail. c. 1073–1083. Wool embroidery on linen. H.: 20''. Town Hall, Bayeux, France.

merchant, received a commission from Queen Isabella of Spain to decorate a vestment intended as a gift to the Pope.

After 1250 the demand for examples of *opus Anglicanum* was so great that there was a shift from production by individuals in scattered homes to an organized commercial activity in the towns. With this shift the names of more men appear in connection with this art, although they may have been acting more as intermediaries. We do know that by the thirteenth century, a master craftsman such as a goldsmith was considered perfectly competent to supply a design for an embroidered vestment, although the actual fabrication of the garment may well have remained in the hands of women. At first, men may have restricted their role to supervision and management of female workers. "Modern scholars note a general decline in the quality of embroidery being produced by the fourteenth century but without commenting on the growing role of men in this hitherto female craft. By the fifteenth century, we hear of traveling teams of embroiderers, a situation incompatible with extensive female participation."[20] Whether one should attribute this diminished excellence to the greater participation of men or the changing methods of production remains undetermined.

One of the most famous examples of *opus Anglicanum* is the *Syon Cope* (Figure 8), once the property of the Bridgettine Nuns of the Syon Convent, located outside London. Originally a chausable, which was reshaped into its present semicircular form, the cope is a complex composition of interlacing barbed quatrefoils. The heraldic shields of the border are a later addition, and not part of its original design. The work illustrates scenes from the life of Christ and the Virgin, St. Michael slaying the dragon, and the twelve apostles. Seraphim, angels, and two priests fill the interstices of the quatrefoils. Most of

FIGURE 8. *The Syon Cope.* Gold, silver, and silk thread on linen. © Trustees of the Victoria and Albert Museum, London.

the robes of the holy figures inside the quatrefoils are sewn in gold thread. A wide range of colored silk threads enlivens the work. The background colors alternate between salmon inside the panels and green as background in between.[21] The *Syon Cope* is one example of the delicacy, precision, and magnificence characteristic of the best examples of *opus Anglicanum*.

Women artists in the Middle Ages were not among the major painters of fresco cycles, the architects of cathedrals, nor the foremost sculptors of their era. However, their talents did emerge, under the proper sociological conditions, in the media of needlework and manuscript illumination. Anonymous, like most of their male colleagues, these women artists, particularly the secular artists, form a backdrop of activity in the visual arts that was necessary for the emergence of specific women creators in the ensuing Renaissance period.

3

INTRODUCTION
TO THE RENAISSANCE ERA:
1400–1780

The political and economic reorganization of society that marks the shift from the Middle Ages to the Renaissance was a slow and complex process that occurred at different times in different parts of Europe. Beginning in Italy in the thirteenth century, an urban economy based on commerce and the accumulation of money began to replace the medieval system of feudalism in which power and wealth were measured by the ownership of land. This process was well underway by the fourteenth century in Italy and continued through the fifteenth and sixteenth centuries in the rest of Europe and England.

During the fifteenth century, women usually married at age fifteen or sixteen. Beginning in the sixteenth century, women in southern Europe were married by age twenty, but women in northern Europe did not marry until their mid-twenties. By the eighteenth century, women in England and France did not marry until age twenty-four or twenty-five. The postponement of marriage to a later age tended to reduce the overall number of pregnancies and to limit the size of families as compared with earlier epochs. By having fewer pregnancies and bearing children at a more physically mature age, the life expectancy for women was improved. But because both infant and maternal mortality rates remained quite high throughout the eighteenth century, population growth was slow.

The shift to delayed marriage left a sizable minority of unmarried women. Some of these women became the targets of the widespread witch trials of the sixteenth and seventeenth centuries. No part of Europe was immune from witchcraft trials. The largest number of trials and executions occurred under

the Holy Roman Empire. "From 1480 to 1700 more women were killed for witchcraft than for other crimes put together."[1]

As in the Middle Ages, the class status of women was more critical than sex in determining a woman's options. It is necessary, therefore, to consider the diverse situations of women in various socioeconomic classes to understand the ways in which their options affected their potential to become professional artists.

PEASANTS AND LOWER-CLASS WOMEN

Among the lower classes and peasants in the rural areas of Europe, women were active contributors to the family economy throughout this period. Peasant women continued to work at the wide variety of tasks they had performed on the feudal manors. These included agricultural chores, care of farm animals, and dairy production.

In eighteenth-century preindustrial England and France, the majority of women worked in a household setting. Single women worked either for their families or outside for wages, depending on the specific needs of their parental family unit. A single woman also tried to accumulate a small amount of capital to help her set up her own household. Marriage was simply the establishment of a new family economy, the basic unit of reproduction and of work.

Since productivity was low and production was most often located in the home, the bearing of children did not seriously interrupt a woman's working potential. "Views of children and standards of child care were such that children were either sent away at a young age or were incorporated into adult routines and adult work."[2] Hence, a married woman could balance her responsibilities for running the household and bearing children with a home industry in which she could earn wages or create a product to be sold on the market. (Lace making was one such industry that employed large numbers of women in their homes.) Women were employed in "cottage industries" often as "spinsters" for low wages.

As we shall see, with the advent of the Industrial Revolution and the greater concentration of wage-earning potential outside the home, women encountered greater difficulties in balancing work for wages, maintenance of the household, and childbearing.

WOMEN OF THE UPPER CLASSES

The lives of women in the artisan and peasant classes were less dramatically transformed by the sociopolitical changes in society prior to the Industrial Revolution than were the lives of upper-class women. The scope of activities

demanded and expected of the upper-class woman of the Renaissance was more narrowly restricted to the roles of wife and mother than it had been for the noblewoman under feudalism. "All the advances of Renaissance Italy, its proto-capitalist economy, its states, and its humanistic culture, worked to mold the noblewoman into an aesthetic object; decorous, chaste, and doubly dependent—on her husband as well as the prince."[3] The Florentine Renaissance design of the upper-class home, the *palazzo,* reflects this withdrawal of women from the public sphere and their confinement within the nuclear family. These spacious and private town houses substituted an enclosed courtyard for the earlier loggia that opened onto the street.

For most women of all classes, marriage and motherhood were expected roles. For upper-class women, the only other available option was the seclusion of the convent. Marriages were always arranged by parents and continued to be primarily an economic contract or an alliance between two families of the same class status. A daughter's chastity was an absolute necessity and a very high priority of the culture. Daughters were strictly supervised to ensure their virginity. Divorce was virtually unknown.

Women's legal rights throughout this era remained very limited. In general, husbands administered matters and made decisions. Women were not only excluded from holding public office, but also from participation in legal matters and law courts. For example, a law in Florence passed in 1415 forbade a married woman from drawing up her own will or disposing of her dowry to the detriment of her husband and children.[4] In Florence, women "could not adopt children, go bail for any body, act as guardian or representative of any person of minor age, except of their own children, and even for these they were not allowed to appoint a guardian."[5]

Almost all Renaissance treatises on women viewed them strictly as wives, regardless of class status. The most important virtue of the wife was obedience to the will of her husband. After obedience, chastity was an essential virtue. In a wife chastity signified sexual fidelity to her husband, and this was sometimes enforced by the "chastity belt." In addition, silence, discretion, love of her husband, and modesty are frequently cited as ideal qualities for the Renaissance woman. The gentle, passive aspects of her nature were extolled and cultivated; the more aggressive aspects of her character were repressed.

The list of virtues makes it clear that the upper-class woman in the Renaissance was subjugated emotionally to a greater extent than the noblewoman of the Middle Ages, who retained control over property and often ran the estate in the absence of her husband. One of the most important activities of the female members of the upper classes continued to be the spinning of wool and flax, although professional weavers organized in guilds actually made the cloth. Needlework was also deemed one of the most appropriate activities for women.

The education and training of the upper-class girl in the Renaissance was

focused exclusively on her destined role of wife and the skills needed to maintain a household. Therefore, her education aimed primarily at

> . . . suppressing all individuality, fostering both fear of offense and complete dependence upon the will of her husband for all her comforts, and contentedness to live within the orbit of the house. . . . nothing must be allowed in the training of her mind that would encourage or enable her to compete on even ground with men. This general assumption is implicit in everything that was said on the training and education of women, in the limited aim set for their education even by their most ardent supporters, in the restriction on subjects and books, and most of all in the almost total absence of reference to the professions.[6]

While the Renaissance man received an education in a wide variety of subjects, Renaissance women were taught only those skills that would make them competent housewives, except for instruction in religious principles, which would encourage docility and obedience.

An exception to the limited level of education began to develop during the fifteenth century. The Humanists influenced the education of a small group of noblewomen, at first in the courts of Italy, then spreading through Europe. These ideals were incorporated into a "Christian Humanism" in England, France, and the Netherlands, spread by intellectuals like Erasmus and Thomas More. According to the Humanists, women should receive the same education as their male counterparts. Like the Renaissance man, women should study Latin, classical literature, philosophy, and history, as well as geometry, arithmetic, and astrology. This model was eventually adopted for the upper-class women of the towns as well as for the ladies at court. By the sixteenth century, under the influence of Humanism, schools for girls that taught minimal literacy were widespread in northern Europe. Some women, educated in the humanist tradition, wrote lively defenses of their sex, which, as noted in chapter two, became known as the *Querelle des Femmes*.

These Humanist ideals also affected the training of artists. Artists were expected to possess a knowledge of science, mathematics, and perspective, as well as the practical skills acquired in an apprenticeship.

The noblewoman's education was affected by the publication of Castiglione's *The Courtier* in 1528. This book became an enormously influential treatise not only for the education of women but also for the definition of ideal modes of conduct for upper-class men and women. Castiglione grants to the noblewoman all the virtues and potential for perfection of the male courtier. Her education is equivalent to that of men. Most significantly for the history of art, all the arts practiced at court, i.e., music, writing, drawing, and painting, are seen as positive attributes for women.

These arts are not viewed as professional skills to be executed for money, but rather as appropriate accomplishments for a refined and properly educated noblewoman. Castiglione's ideas affected many women in the upper classes,

the stratum of society from which some of the most important women artists of the sixteenth century, like Sofonisba Anguissola, emerge.

Another consequence of Castiglione's book was the perpetuation of the ideals of medieval courtly love, cast in a Neoplatonic context. This version of *courtoisie* survived into the Victorian era. One scholar sees this treatise as the source for the modern concept of the lady as a romantic object set on a pedestal.[7]

WOMEN AND THE REFORMATION

With the establishment of a married clergy in the Protestant religions, prevailing attitudes toward women became more positive. Marriage was viewed as a relationship based on "mutual aid, comfort and sustaining companionship."[8] Under Calvinism, women could take part in religious services as equals of men. Girls living in the towns of northern Europe learned to read and write, although their education rarely passed beyond minimal literacy. The Protestant girl also received instruction in religion and needlework. The Reformation continued to define women's realm in the strictly limited area of wife and mother.

URBAN WORKING-CLASS WOMEN

Compared with the Middle Ages, the independent professional activities of working-class women were more and more restricted during the Renaissance. From the late fifteenth century, stricter guild regulations gradually excluded women's participation in trades organized by guilds. This included most major commercial activities in towns. Because men in all trades objected to competition from lower-paid women, they tried to confine them to the least lucrative work. Furthermore, men were invading trades that had been traditionally exercised by women, for example, wholesale brewing. At this time occupational designations, with a few exceptions, such as the food and clothing trades, were male. By the sixteenth century, women were forbidden to become apprentices or to take the examinations that might have enabled them to become journeymen or masters. In the seventeenth and eighteenth centuries, new commercial organizations that were replacing the guilds were almost exclusively male dominated. Throughout most of Europe, women could not function on a professional basis independently of male relatives during the Renaissance era.

Given this discriminatory situation, it is not surprising to learn that the absolute numbers of women who were professional artists is very small in comparison with the number of male artists. In the sixteenth century, only thirty-five women are known to have been artists. The only women who

became artists in Italy during the fifteenth century were nuns. In the sixteenth century, however, a few women of the upper class benefited from the dissemination of the educational principles of Castiglione, which insisted on training in the arts. Sofonisba Anguissola, for example, was born into an upper-class family that provided her with piano and drawing lessons, since these accomplishments were valued in women of her class. In addition to nuns in convents and noblewomen, daughters of artists also had access to artistic training. Artemisia Gentileschi and Angelica Kauffman were both daughters of artists and received their initial instruction from their fathers.

The obstacles placed before aspiring young female artists were many: cultural mores that discouraged emotional independence, severely restricted legal and economic rights, and, perhaps most importantly, limited access to artistic training. Despite these difficulties, the number of active women artists continued to increase. By the seventeenth century, over two hundred women artists are known, and from the eighteenth century, almost three hundred names of women artists have survived.

From this growing group of professional artists, the painters and sculptors to be discussed in chapters four, five, and six emerged to build their reputations and to create works that altered the course of the history of art.

4

Painters in Italy:
1550–1650

No major women artists were active during the early Renaissance in Italy. The first Italian woman to build an international reputation as a professional painter was **Sofonisba Anguissola,** who did not begin her career until the 1550s. The other artist to be discussed here is **Artemisia Gentileschi,** who painted in a style adapted from Caravaggio, one of the initiators of the Baroque period, in the early 1600s.

The scarcity of women artists in the fifteenth century can be explained by the changing conditions under which artists were trained and the ways in which they practiced their profession in the Renaissance. During the Middle Ages, men and women artists had been either monks or nuns who received their training in the monastery or convent. Unlike the medieval era, the most important male artists of the Renaissance were no longer monks but craftsmen exposed to the new, sophisticated knowledge circulating in the secular art world. However, women artists in Italy in the fifteenth century continued to be mostly nuns, as was the case in the Middle Ages. The seclusion of the convent at a time when stylistic changes were rapidly taking place was an insuperable handicap for women's artistic achievement. It was simply not possible for women to become first-rate artists in the early period of the Italian Renaissance.

Most artists in the early Renaissance came from an artisan or working-class background and were members of guilds. Predictably, one can infer from the artists' guild regulations in Italy that women were hardly ever active. Furthermore, by the fifteenth century, the study of the human body, especially the male nude (from corpses and live models) was an essential component of the artist's training. It was absolutely impossible for women to acquire such

training. Artists were also expected to travel to art centers to study contemporary production. Such freedom of movement was also totally beyond the capabilities of most women.

As in the early and high Renaissance periods, the innovators of Mannerism were all male. This is not surprising because these styles were formulated in multifigured religious compositions. In this most prestigious category of art, women remained seriously handicapped by their inability to study the nude or to acquire systematic and thorough artistic training as apprentices. Deprived of the necessary training, women painters almost never won commissions for large-scale public works of art.

Mannerism coexisted in northern Italy, Flanders, and other parts of Europe along with a counter-Manneristic style that was characterized by a fidelity to natural appearances. In the provincial centers of northern Italy, local aristocrats often commissioned portraits. Portraiture, being less dependent on the study of the nude, was a more accessible type of painting for women. Sofonisba Anguissola is known primarily for her portraits, which are painted in the more realistic, counter-Manneristic style practiced in her native northern Italy.

By 1600 two artists, Annibale Carracci and Caravaggio, had developed personal styles that are seen as jointly initiating a new era in painting known as the Baroque. Caravaggio adapted his native northern Italian naturalistic tradition for his religious compositions in Rome. Avoiding fresco in favor of oil on canvas, Caravaggio developed a radically new style that employed a dramatic chiaroscuro and realistic genre detail.

One of the first and foremost artists to paint in the style of Caravaggio was Orazio Gentileschi. He trained his talented daughter Artemisia Gentileschi, and while her style fits within the Caravaggist mode, it also shows power and originality.

Annibale Carracci and his followers excelled in fresco painting, employing a style dependent on life drawing. Because women could not study the nude or learn the technique of fresco painting as apprentices, it is not surprising that no women are to be found among the disciples of Carracci, such as Guido Reni and Guercino. By 1625 the Bolognese followers of Annibale Carracci had captured all the major fresco commissions in Rome while the Caravaggists, such as Artemisia Gentileschi, were forced either to travel to other cities or content themselves with less lucrative private commissions. In this way Artemisia Gentileschi played an important role in the dissemination of the Caravaggist style.

SOFONISBA ANGUISSOLA (c. 1532–1625)

In the history of art, Sofonisba Anguissola is an important figure not only for her personal achievements but also because she provided a role model for other

Italian women aspiring to be artists. It is hardly coincidental that several other artists, for example, Lavinia Fontana, Fede Galizia, and Barbara Longhi, all from different cities in northern Italy, followed the example of Anguissola and became practicing artists in the latter half of the sixteenth century.

Fortunately, about fifty signed paintings, mostly portraits, have survived. This represents a substantial number of works for a woman artist of this period and permits us to assess Anguissola's artistic achievements.

Anguissola was raised in an exceptional environment that allowed her to develop her creative talents. The oldest of six daughters, she was born into a noble family in the provincial northern Italian city of Cremona. Following the advice popularized by Baldesare Castiglione in *The Courtier,* her family made sure to provide their daughter with instruction in painting and music, as befitted a woman of her class. In addition to lessons in painting, Anguissola was taught to play the spinet, and in several self-portraits she shows herself playing this keyboard instrument. One can imagine that her father, Amilcare, faced with the financial burden of providing dowries for six daughters, was highly motivated to cultivate their talents. In fact, the three oldest sisters all received instruction in painting. Endowed with the fortunate circumstances of her class background and birth, Sofonisba Anguissola was in an unusually favorable position to develop her talents beyond the level of accomplished amateur to that of professional painter.

Because it was not acceptable for a single woman of her class to travel unchaperoned to Rome or any of the major Italian art centers, Sofonisba and her sister Elena, the second daughter, studied with a local painter in Cremona, Bernardino Campi. Elena gave up her career to become a nun. The third daughter, Lucia, also became an accomplished painter, although very few works can be securely attributed to her.

Amilcare Anguissola actively promoted Sofonisba's career as an artist. Recognizing the limitations of her local training, he corresponded with Michelangelo, who was living in Rome. In 1557 he asked the famous master to send Sofonisba several drawings to copy in oil paint and return for his criticism. Clearly, Amilcare was concerned that his daughter be exposed to the instruction of the finest living artist in Italy.[1] On one occasion, Sofonisba sent Michelangelo a drawing she had made of a smiling girl, and asked for the master's criticism and advice. Michelangelo admired the work but challenged her to depict the more difficult subject of a crying boy. In response to this challenge, Anguissola created a drawing that cleverly juxtaposes the two subjects. This work, *Boy Pinched by a Crayfish* (Figure 9), demonstrates Anguissola's ability to represent a range of emotions. The features of the boy were based on those of her young brother (the seventh sibling in the family). This drawing was presented to the duke of Florence, Cosimo de Medici, and had widespread influence. It was seen by other artists, including Vasari, and copies were made of it. It has been suggested that Anguissola's drawing inspired Caravaggio's *Boy Bitten by a Lizard.*[2]

FIGURE 9. SOFONISBA ANGUISSOLA. *Boy Pinched by a Crayfish.* Drawing. Galleria Nazionale de Capodimonte, Naples.

Despite this long-distance contact with the renowned Michelangelo, the main influence on Anguissola's painting style derives from the local environment of Cremona. Surrounded by Milan, Brescia, and Parma, Cremona's painters were exposed to several strands of "verist" or naturalist styles prevalent in these art centers. Artists from this region of northern Italy retained an almost Flemish taste for the precise description of nonidealized forms, in religious painting as well as in portraiture. The stylizations of Mannerism, so dominant in central Italy, never completely overwhelmed this local tradition. Thus, Sofonisba's talents for realistic description and anecdote seen in her drawing of the crying boy reflect the style of her native city.

Paintings from the first period of Anguissola's career, prior to 1559, are mostly portraits of her family. One of the most interesting of these works, *Three of the Artist's Sisters Playing Chess* (1555), is an inventive composition for a group portrait (Figure 10). While the older sister on the left looks directly at the viewer, the younger player with hand raised appears to be speaking to her. The third sister and a servant are spectators to the interchange. This painting may be the first "conversation piece," a type of group portrait that would gain wide popularity in subsequent centuries.[3]

During the 1550s Anguissola painted an unusually large number of self-portraits. These paintings were a form of self-advertisement that was rewarded when, in 1559, she was invited to join the court of King Philip II of

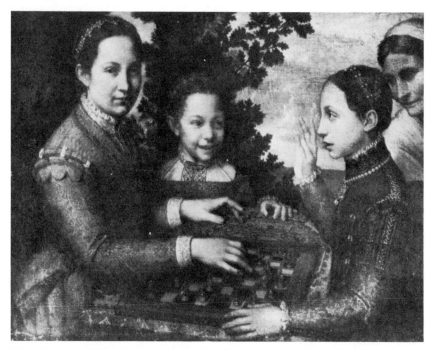

FIGURE 10. SOFONISBA ANGUISSOLA. *Three of the Artist's Sisters Playing Chess.* 1554. Oil on canvas. 27 3/16 × 35 7/8''. Muzeum Narodowe W. Poznaniu.

Spain. The governor of Milan had mentioned Anguissola to the duke of Alba, an emissary of the Spanish court. Anguissola's position as one of Spain's court portraitists fits into a pattern of artistic links between Spain and Italy in the mid-sixteenth century. There was a tradition of importing foreign artists to Spain as well as of sending native Spanish artists to Italy for training. Titian had been appointed as official court portraitist to King Charles V in 1533. In 1567 Philip II hired six Italian artists to work as fresco decorators on the huge palace-mausoleum-monastery complex, the Escorial. The most famous artist working in Spain at this time, El Greco, was trained in Italy. From the 1560's through the eighteenth century many Italian artists worked on a number of royal projects for the Spanish monarchy.

Anguissola remained at the Spanish court through the 1560s. Although no paintings from this period have survived, we can document that she painted several portraits of Queen Isabella, one of which was sent to Pope Pius IV. In 1569 she married a Sicilian nobleman, Fabrizio de Moncada, with a dowry that had been provided in the queen's will. King Philip of Spain gave her in marriage and presented her with numerous gifts. Through her talents as a painter, Anguissola achieved both fame and fortune, and her example was emulated by other aspiring women artists.

Anguissola's renown rests primarily on her pioneering position as the first professional Italian woman painter. Aside from her artistic talents, which were exceptional, she altered the conventions of portrait painting. She injected an innovative liveliness and range of emotion into her intimate portraits of members of her family. Her art anticipates the more overt emotional content of much Baroque imagery.

ARTEMISIA GENTILESCHI (1593–c. 1652)

Artemisia Gentileschi developed a forceful personal style that placed her among the leading artists of her generation who worked in the style of Caravaggio. She traveled a great deal and helped spread the Caravaggesque mode through Italy. The dispersal of her own paintings further extended her influence.

As the child of the successful painter Orazio Gentileschi, Artemisia had the advantage of being raised in an environment where she could acquire the basic technical skills necessary for a professional artist. And because Orazio was one of the four most important artists to adapt Caravaggio's style in the first decade of the seventeenth century, it is not surprising that Artemisia would also develop a Caravaggesque style. One of her earliest paintings, *Judith with Her Maidservant* (Pitti Palace), was copied from her father's version of this theme as a learning exercise.

Orazio must have recognized his limitations as a teacher for his talented daughter because he arranged for her to study perspective with Agostino Tassi, a successful artist and collaborator who was receiving major commissions for fresco decorations of Roman palaces. Tassi seduced and raped Artemisia and then promised to marry her. When it became clear that Tassi, a disreputable character with a prior criminal record, had no intentions of marrying her, Orazio sued Tassi. The trial took place in 1612 and lasted several months.[4] One can only wonder at Orazio's motivation in bringing Tassi to court and publicizing the mortification of his daughter. Artemisia was tortured on the witness stand with thumbscrews, a seventeenth-century lie detector. Tassi was imprisoned for eight months, but the case was ultimately dismissed, leaving Artemisia publicly humiliated. For this she has borne a reputation for licentiousness through the centuries.

Shortly after the trial, Artemisia married a Florentine and went to live in Florence. There was little Caravaggist painting in that city, and Gentileschi's presence stimulated Florentine artists to investigate the new expressive possibilities of Caravaggism.

One of her most impressive paintings from the Florentine period of her career is the dramatically baroque composition *Judith Decapitating Holofernes* (Figure 11). Judith, the Old Testament heroine, stole into the enemy camp of the Israelites, murdered the tyrant Holofernes, and then escaped with his head.

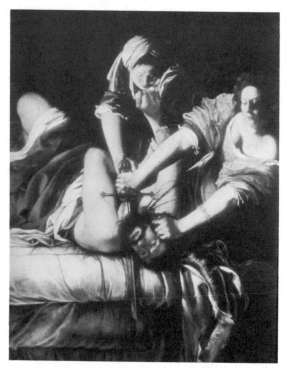

FIGURE 11. ARTEMISIA GENTILESCHI. *Judith Decapitating Holofernes.* 1615–20. Oil on canvas. 46 3/4 × 37 1/4''. Pitti Palace, Florence.

This story was a popular subject among the Caravaggists because it provided a biblical anecdote that could serve as a genre theme of violence or suspense.

Artemisia was especially fascinated with the Judith story and painted at least six different versions of it. It is easy to understand, as has been frequently suggested, why this theme appealed to her. Through the daring deed of Judith, Artemisia was avenging her own betrayal and all the wrongs she had suffered. Judith was an ideal subject for Artemisia—a female hero with whom she could identify as a woman.[5]

When one compares Gentileschi's *Judith Decapitating Holofernes* with Caravaggio's version of the theme (Figure 12), one can see both the extent of Gentileschi's assimilation of Caravaggio's style and the differences that reveal her own vigorous sense of drama and originality. Like Caravaggio, Gentileschi positions large-scale figures in the foreground and uses highlighted forms that emerge from a dark background. The women in both works are not idealized and details are realistic. Both artists have selected the gory moment of decapitation.

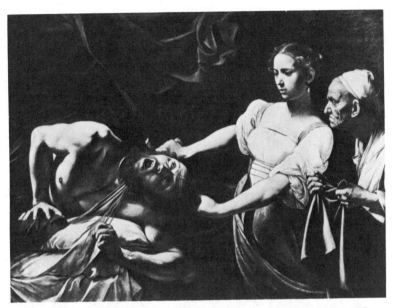

FIGURE 12. CARAVAGGIO. *Judith and Holofernes.* c. 1598. 144 × 195 cm. Galleria Nazionale D'Arte Antica, Palazzo Barberini, Rome.

However, Gentileschi designed a composition that is much more dynamic and energetic. In Caravaggio's painting, the figures are positioned across the picture surface. Gentileschi's composition places the figures in depth and is much more compact, therefore being more dramatic. Caravaggio's old maidservant is peripheral to the action while Gentileschi's maid actively participates in the murder, holding Holofernes down. In Gentileschi's painting, the arms of all three figures intersect in the center of the canvas, fixing the viewer's attention inescapably on the grisly act. The position of Caravaggio's rather pretty, elegant Judith seems frozen; she is not exerting physical force to cut off the tryant's head. By contrast, one can acutely sense the intensity of the physical effort that Judith and her maid bring to this act. The powerful, monumental, and robust anatomy of Gentileschi's women make this decapitation seem much more convincing than Caravaggio's version.

One notable characteristic of Gentileschi's talent is her excellent knowledge of female anatomy. Perhaps being raised in the home of an avant-garde painter, she had the opportunity to study the female nude in private, using a servant or even her own body as a model. Her knowledge of male anatomy was understandably less sophisticated. The drapery covering Holofernes's torso masks this weakness.

In 1621 Gentileschi returned to Rome where she found the situation of the Caravaggists considerably different than when she had left the city almost a

decade earlier. The Bolognese followers of Carracci were winning most major commissions, and Artemisia Gentileschi was now one of the few major Caravaggist painters living in Rome.

One of her finest paintings, perhaps her masterpiece, *Judith and Maidservant with the Head of Holofernes* (Figure 13), was painted in Rome during the 1620s. In this work Gentileschi eschews the overt violence of her earlier painting, replacing it with a hushed suspense and quiet tension. Rather than freezing the moment of the decapitation, she paints the aftermath of the act. The deed is done, but danger is still present. The women must now escape from the enemy camp bearing the head.

Both women look toward the left, frozen for a second, perhaps anticipating imminent discovery. The position of Judith is particularly complex. While her left hand crosses her body, shielding the candlelight, her right hand holds

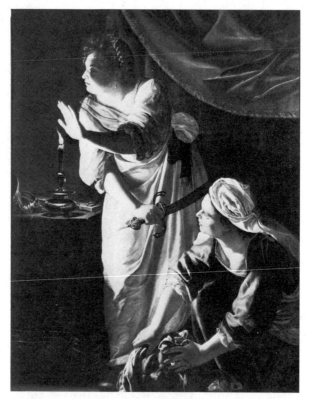

FIGURE 13. ARTEMISIA GENTILESCHI. *Judith and Maidservant with the Head of Holofernes.* c. 1625. Oil on canvas. H.: 6'1/2'' W.: 55 3/4''. 52.253. H.: 1.842m W.: 1.416m. Gift of Mr. Leslie H. Green © 1987 The Detroit Institute of Arts.

the sword in tense readiness. The sword is placed in the exact center of the canvas. Composition and gestures, rather than facial expressions, convey the meaning. The work is painted with great sophistication. The complementary colors of the gown, yellow and purple, contrast beautifully with the ruby-red of the hanging drapery. The Caravaggesque chiaroscuro conveys an element of secrecy and mystery to the scene. The light reveals the forms of the women, but the rest of the canvas is cast in darkness so that the viewer must inevitably focus on Judith and her maid.

The story of Judith was not the only subject in which Gentileschi invented new compositions or discovered new layers of meaning based on her identity as a woman. In an extremely unusual painting, Gentileschi painted herself as the living embodiment of "Painting." In *Self-Portrait as the Allegory of Painting* (Figure 14), Gentileschi depicts herself bearing the widely recognized attributes that identify the allegorical figure "Painting" in this era: on the gold chains hangs a mask standing for imitation; her unkempt hair symbolizes the divine frenzy of the creator; and her multicolored dress demonstrates the painter's talents. The artist is not actually painting but is poised facing the light

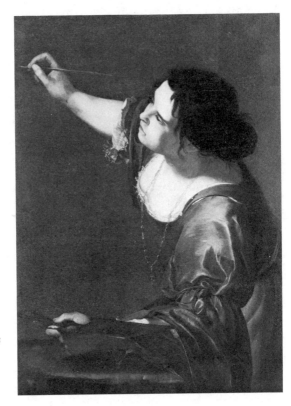

FIGURE 14. ARTEMISIA GENTILESCHI. *Self-Portrait as the Allegory of Painting.* Oil on canvas. 38 1/2 × 29 1/2". St. James's Palace, London. Copyright reserved.

flooding her from an unknown source. She is waiting for inspiration or summoning her mental energies:

> Without recourse to complex personification, Artemisia evokes the contrast between Theory and Practice in her *Self-Portrait*. She has posed herself with one arm raised upward, the hand stretched toward its invisible target, suggesting the higher, ideal aspirations of painting, with the other arm resting firmly on a table, the hand holding the brushes and palette which are the physical materials of painting.[6]

Unlike male artists, who were forced to depict themselves accompanied by a symbolic female figure symbolizing Painting, Artemisia, as a woman artist, could combine her image with the iconography of the allegorical personification of painting and create a deceptively simple composition of great iconographic originality.

Unwilling to abandon her personal style of Caravaggism to accommodate the changing tastes of Roman patrons, Gentileschi traveled to Naples in 1630. Except for a brief visit to London to assist her ailing father on a commission, she lived in Naples for the rest of her life. The selection of Naples as her next residence was logical because more artists worked in a Caravaggist style there for a longer period of time than in any other Italian city. In fact, between 1600 and 1630, Caravaggism was the only advanced painting style practiced in Naples. However, this situation was to change during the 1630s when the influence of the Bolognese school, especially the art of Guido Reni, became increasingly important, even in Naples. Accepting the inevitable, Gentileschi now adapted her style to the more brightly illuminated, idealized mode of the Caracci followers. In the process she lost some of the intensity of her personal style. Scholars generally agree that the works created in her original Caravaggist mode are her finest paintings.

The sheer formal beauty and power of many of Artemisia Gentileschi's paintings serves to rank her with the best artists of her generation. Never a mere imitator of Caravaggio, she adapted some of that artist's devices to forge an original style of strength and beauty. Her inventive adaptations of existing subjects is another aspect of her originality. She harnessed her formal energies to the expression of a personal iconography, expressing her identity as a woman and as an artist.

5

Seventeenth-Century
Dutch and Flemish Artists

The careers of the four artists discussed in this chapter demonstrate the level of excellence that may be achieved by women artists when the expectations for women in their culture do not conflict with a measure of equality of opportunity and access to training. **Clara Peeters,** an important figure in the first generation of independent still life artists, was born in Antwerp, but her later works reflect contemporary developments in Holland. **Judith Leyster,** a contemporary of Frans Hals, one of the major portrait painters of the century, lived and worked in Haarlem. Leyster is an atypical Dutch artist because she painted a variety of types of works, including still lifes, genre scenes, and portraits, all with equal quality and inventiveness. **Maria Sibylla Merian** is generally considered the finest botanical illustrator of her time. Although she was born in Frankfurt, Germany, both her stepfather and her husband were Flemish flower painters. After 1690 she lived in Amsterdam, and her connections with the traditions of Dutch and Flemish illustration are sufficiently strong to warrant her placement in this context. Independent flower paintings gained wide popularity in both Flanders and Holland. By the early eighteenth century, the Dutch painter **Rachel Ruysch** was one of the most famous flower painters of her era.

Holland secured its independence from Spain in 1581 and by the seventeenth century was the major maritime power of Europe, with a far-flung colonial empire. Because Holland was a Protestant country, the Church was not an active arts patron as it remained to some extent in neighboring Catholic Flanders. However, the Dutch middle class was wealthy and purchased paintings on a regular basis. This provided a strong incentive for Dutch artists to

paint the kinds of works that would appeal to the merchants of the middle class—their only source of patronage.

Because these works of art were intended to adorn the burghers' homes, the vast majority of Dutch paintings are small-scaled, suitable for hanging in private houses. With the exception of portraits, paintings were sold on the open market, creating a competitive situation that kept prices low. In this context, painters developed precise areas of specialization, such as still life painting, flower arrangements, landscapes, seascapes, and genre paintings, in an effort to secure a steady market. The unifying factor in all these categories was a dependence on precisely observed natural phenomena. Dutch art is characterized stylistically by its realism. The Dutch created a body of works that humanized art. "Works by a large number of painters reflected the common experiences of life in all their diversity. In concrete terms, they embraced the typical, the ordinary, in human concerns."[1] Rembrandt is, of course, the most famous and most individual genius in seventeenth-century Dutch painting. He is not an isolated genius because he lived in a period of great productivity stimulated by the open market economy. At that time, painting schools were flourishing in Utrecht, Haarlem, Amsterdam, Leiden, Delft, and other cities in Holland.

This competitive art market created an advantageous situation for women artists. Artists could paint what they liked and when they liked, rather than painting only when commissioned. Any artist could accept as many pupils as he wished. Although the guilds were the primary artists' organizations, there were considerably fewer restrictions on who could become an artist in Holland than in other parts of Europe. Furthermore, with the development of the new painting specialties mentioned earlier, there was no need to study the nude; in fact, there are very few nudes in Dutch art.

Still life and flower painting did not require knowledge of anatomy or extensive travel to Italy to study the High Renaissance masters. Throughout Europe, women were in the forefront of still life painting in the early 1600s. Only a still life attributed to Caravaggio is known to predate the works of Fede Galizia in Italy. In France, Louise Moillon painted a series of impressive still lifes, and four women painters of still lifes were elected to the French Academy during the seventeenth century. However, the most noteworthy women still life painters were Flemish and Dutch, since these schools were the most active and suffered least from the French Academy's low esteem for this genre.

The origins of still life painting date back to early fifteenth-century Netherlandish religious paintings. In the *Merode Altarpiece,* the Master of Flemalle included a number of objects—a silver candlestick, a procelain vase with lilies, a polished brass pot, and towel—all painted with great precision. While each object has a symbolic significance related to Mary, the prominence of these inanimate things in a religious work demonstrates a Netherlandish fascination with the illusionistic description of everyday objects. This tradition

continues in the work of Hugo van der Goes, who positions two vases of flowers and a sheaf of wheat prominently in the foreground of his masterpiece, the *Portinari Altarpiece*. Here again, each item has a symbolic meaning: the scarlet lily symbolizes the blood of the Passion; the columbine, a symbol of sorrow, refers to a prophecy of Mary's future grief; and the wheat is both a literal translation of "Bethlehem," which means "House of Bread" in Hebrew, and a symbol of the Eucharist.

The earliest independent still life and flower paintings date from the mid-sixteenth century. Jan Brueghel, in Antwerp, is credited with the invention of independent flower paintings. He created a series of works that depict a single vase of flowers symmetrically arranged, isolated, and set against a dark background.

Flower painters regularly juxtaposed blossoms that could never bloom simultaneously in nature. Each flower was studied individually. Assembling these studies in the studio, the painter created imaginary bouquets. By 1600 the cultivation of flowers as a commodity had become an important component of the Dutch economy. A highly speculative market developed and huge sums were paid for rare tulip bulbs. Prices became so inflated that the market crashed in the 1630s. (The term "tulipomania" is still used today to designate a highly speculative commodity market.)

Painters incorporated into their works the new floral species that were brought back to Europe from the voyages of discovery around the globe. The East and West India Companies were expanding the Dutch colonial empire at this time. The introduction and cultivation of exotic species, not native to Europe, further stimulated contemporary interest in flower painting. As the prosperity of the merchant class increased, there was widespread interest in gardening and the cultivation of flowers, including new and familiar types. All these factors combined to create an especially strong interest in the Netherlands for paintings of flowers.

Another way to account for the widespread interest in flowers is that these fragile objects, which bloom and die so quickly, are universal symbols of life's transience. Whether combined with other objects, associated with the vanity of earthly existence, or standing alone, flowers express in a gentle, beautiful manner the connotations of imminent mortality.

One of the most important artists to continue the tradition of the independent flower painting was Jacques de Gheyn. Born in Antwerp, he lived and worked in various cities in Holland. In 1606 the Dutch government commissioned a flower piece from him for the large sum of 600 guilders, to be presented to Marie de Medici, queen of France. This placed de Gheyn among the best paid artists of his time and indicates the high level of esteem for this type of painting. It is easy to see, then, that when Clara Peeters included bouquets of flowers in her still life pictures, she was both demonstrating her versatility and increasing the marketability of her canvases.

CLARA PEETERS (1594–c. 1657)

Clara Peeters was one of the originators of a type of still life painting known as the "breakfast" or "banquet" piece. She often included vases of flowers in these compositions, demonstrating the versatility of her talent. The origins of the "banquet" still life can be traced back to the paintings of Pieter Aertsen and his nephew, Joachim Beuckelaer, in Amsterdam. In the mid-sixteenth century, these artists created paintings displaying lavish quantities of meats, fish, fruits, and other edibles, and generally including a small religious scene in the background.

During the course of the sixteenth century, these small scenes disappear entirely, and a table filled with food stands alone. Only a handful of such independent "banquet" or "breakfast" pieces can be securely dated before 1608. This is the year of the earliest known banquet piece by Clara Peeters. From this evidence, she can be identified as one of the inventors of this type of still life. By 1611 Peeters was painting works that demonstrate a superb talent for rendering details of texture and form in a wide range of objects.

We don't know very much about the life of Clara Peeters. She was born in 1594 in Antwerp, the art capital of the Netherlands, and displayed a talent for painting at a very early age. Her first works were painted when she was only fourteen. In all likelihood her family decided to encourage her artistic talents rather than marry her off at the usual age of twenty. Actually, Peeters did not marry until she was forty-five, and then probably because it had become too difficult for her to continue to support herself solely from painting. In fact, in this highly competitive art market even the most talented and successful artists had to supplement their incomes regularly from other sources. Aside from her date of birth and date of marriage, there is scant information available about Peeters's career. Had she been a man, there would undoubtedly be more documentation preserved in the Antwerp guild records.

As to her training, we do not know how Peeters acquired her skills. It is possible that she studied with Osias Beert, fourteen years her senior, who was a noted still life painter in Antwerp. Her works relate to those of Beert in the combination of different types of objects: flowers, fruits, tall decorative metal goblets, and flat dishes of fruits. Peeters, however, uses a lower viewpoint than Beert or other Flemish colleagues. With this lowered viewpoint, she employs more accurate perspective to situate the objects firmly in space. The illusion of the arrangement is thus enhanced. This composition also differs from those of her immediate contemporaries in that she groups her objects closer together, permitting a certain amount of overlapping. These elements anticipated the subsequent development of the banquet pieces of artists such as Pieter Claesz and Willem Claesz Heda.

Peeters's innovations are evident in *Still Life with Flowers, A Goblet, Dried Fruit and Pretzels* (Figure 15). This painting is part of a series of four complex works, each focused around a different theme: a fish piece, a game piece, a

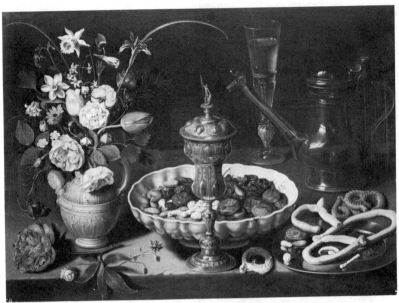

FIGURE 15. CLARA PEETERS. *Still Life with Flowers, a Goblet, Dried Fruit and Pretzels.* 1611. Oil on panel. 19 11/16 × 25 5/16". Prado Museum, Madrid.

dinner arrangement, and the work illustrated here. These paintings are recognized as among the masterpieces of early seventeenth-century still life, yet they were painted by an artist only seventeen years old. The work reproduced here is typical of every known painting by Peeters in its use of a simple stone ledge set against a dark background. An elaborate goblet defines the center of the composition. The central focus is underscored by the low dish filled with dried fruits and nuts. The vase of flowers on the left is counterbalanced by a plate of pretzels, a pewter pitcher, and a glass. The placement of these objects results in a balanced composition that is not symmetrical or monotonous. Each object is rendered in a precise style that conveys clearly the diverse textures of the objects.

In a still life painted the following year, 1612, Peeters uses similar objects but arranges them in a more restrained composition. Instead of the complex, *horror vacui* of the Prado painting (Figure 15), the *Still Life with a Vase of Flowers, Goblets, and Shells* (Figure 16) is rather austere. This painting, often considered Peeters's masterpiece, depicts three tall objects—on the right, the same goblet as in the Prado painting, another goblet in the center, and a vase of flowers on the left. A single tulip, gold coins, a low dish, and some seashells rest on the ledge anchoring the vertical forms. By positioning the vase of flowers to one side rather than framing it with the goblets, Peeters established a dynamic composition. The height of the flowers competes with the height of the metal forms. All three vertical objects are placed at different points in

FIGURE 16. CLARA PEETERS. *Still Life with a Vase of Flowers, Goblets, and Shells.* 1612. Oil on panel. 23 7/16 × 19 5/16". Staatliche Kunsthalle, Karlsruhe.

depth, further energizing the composition. The work is technically brilliant. The artist has even included her own image reflected seven times in the surface of the goblet on the right. (The use of the self-portrait as a form of advertisement was noted in connection with Sofonisba Anguissola.) Shells, often transported from exotic places, were collector's items of the era. In this work the wonders of nature, i.e., flowers and shells, are juxtaposed against beautifully wrought metal chalices, testimony to the creative skills of man.

After 1620 Peeters painted much simpler arrangements of cheeses and humble objects. Her color scheme becomes monochromatic, reflecting contemporary Dutch tastes.

The surviving signed and dated works by Peeters are sufficiently numerous to permit the assessment of her talent. Born in the active art center of Antwerp during its golden age, she created a series of paintings that reveal great technical proficiency and originality in composition.

JUDITH LEYSTER (1609–1660)

Unlike most of her colleagues, Judith Leyster did not specialize in one specific type of painting. She was a versatile artist who painted still lifes, portraits, and genre paintings. The body of works that can be securely attributed to her

demonstrates that Leyster was a talented painter who could invent interesting compositions as well as reinterpret conventional subjects from a woman's perspective.

Leyster's father owned a brewery in Haarlem. Despite the fact that she was not born into an artistic family, she managed to receive an adequate training, although it is not known with whom she studied. In 1628 Leyster's family moved to a town near Utrecht. Utrecht had an active school of painters who were familiar with Caravaggio's innovations. Utrecht artists, such as Terbruggen or Honthorst, often used artificial light to illuminate their religious or genre scenes. In many of Leyster's subsequent paintings she employs this indirect light source.

In 1629 Leyster and her family returned to Haarlem, where she lived until 1636. She became a member of the Haarlem painters' guild in 1633, and most of her surviving paintings date from this period of her life. In 1636 she married a fellow painter, Jan Meinse Molenaer (1610–1668), and the couple moved to Amsterdam where she bore three children. It is not certain why her artistic production declined so dramatically after her marriage. Despite the decline in her production, an adequate number of paintings survive to permit an evaluation of Leyster's position in the active art world of seventeenth-century Holland.

Leyster's *Self-Portrait* (Figure 17) is a characteristic example of her style. In this work, she proclaims her identity as a painter. Holding a palette and brushes, she sits in front of a picture of a laughing musician, one of her specialities in genre painting. Her technique is quite precise and linear. While she does use visible brushstrokes in her lace cuffs and skirt, she generally does not allow the texture of the paint to intrude upon the description of the variety of textures included in her image. Twentieth-century tastes, trained by exposure to Impressionism and subsequent avant-garde art movements, tend to place a higher value on the spontaneous, sketchlike style of her contemporary, Franz Hals. However, Leyster's technique would have been at least equally valued in her own time. In fact, the popularity and skill of an artist was measured in large part by the technical ability to depict a wide range of objects and textures. Therefore, it is not warranted to condemn Leyster's style as inferior when it reveals traits that would have been valued by her own culture. Clearly, despite superficial similarities, Leyster's technique is quite distinct from Hals's. She is not a mere imitator, but an independent artist with a personal style.

While Hals painted only portraits, Leyster painted genre scenes as well. In one of her most famous genre pictures, *The Proposition* (Figure 18), she invents a new content for a familiar subject.[3] The painting depicts a man in a fur hat, leaning over a woman who is sewing. He is offering her gold coins as payment for her sexual favors. The bare interior focuses the viewer's attention on this scene, which is illuminated by a single candle.

The use of a sharply focused artificial light source relates to the influence

FIGURE 17. JUDITH LEYSTER. *Self-Portrait.* c. 1635. Oil on canvas. 29 3/8 × 25 5/8''. National Gallery of Art, Washington. Gift of Mr. and Mrs. Robert Woods Bliss.

of the Utrecht Caravaggists on Leyster's style. However, the light source is the only similarity between *The Proposition* and the scenes of prostitution and procurement common among the artists of the Utrecht school. When one compares *The Proposition* with Dirck van Baburen's *The Procuress* (Figure 19), a wholly different content is immediately apparent. The woman in Baburen's image is a willing prostitute exchanging her favors for the gold coin offered by the male customer. Her low-cut dress reveals her physical attributes. The musical instrument, especially the lute, is a familiar prop in themes of prostitution since music is always associated with Venus and love-making. The old procuress on the right holds out her hand, waiting for payment for the prostitute's services. The mood is clearly jovial and animated.

By contrast, the woman in *The Proposition* is the embarrassed victim of an undesired solicitation. There are no wine glasses or musical instruments, common attributes of brothel scenes. Instead, the modestly dressed woman fixedly concentrates on her sewing. Her feet rest on a footwarmer, further

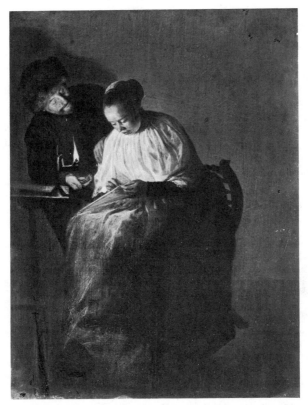

FIGURE 18. JUDITH LEYSTER. *The Proposition.* 1631.
Oil on panel. 11 11/16 × 9 1/2". Mauritshuis, The Hague.

emphasizing the immobility of her pose. In this work, Leyster invented a new interpretation of a genre subject that is more empathetic to women than the paintings of her male colleagues. She conceives of an interaction in which an ordinary woman chooses honor over money. Leyster, as a woman, could realize more clearly than her male contemporaries that not every transaction occurs between willing participants.

The restrained, quiet mood of *The Proposition* may have influenced the next generation of genre painters, including Vermeer and Metsu. In several works, Metsu explores the theme of a sensitive woman victimized by a coarser man, while Vermeer became a master in the intimate domestic scene in which men interrupt women at their work. Both themes are anticipated in Leyster's painting.

Judith Leyster's works demonstrate her ability to combine influences from the Utrecht Caravaggists with her local Haarlem traditions, epitomized by the art of Hals into a personal style of variety, beauty, and iconographic originality.

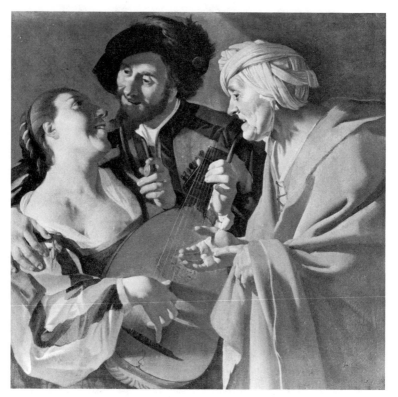

FIGURE 19. DIRCK VAN BABUREN. *The Procuress.* Oil on canvas. 39 3/4 × 42 1/4" (101 × 107.5 cm.). 50.2721, Purchased, Maria T. B. Hopkins Fund. Courtesy, Museum of Fine Arts, Boston.

MARIA SIBYLLA MERIAN (1647–1717)

The history of the science of botany is closely related to the development of flower painting. The documentation and categorization of the many new species of flowers was necessarily dependent on the accurate illustration of each specimen. The original drawings, in watercolor, were reproduced through woodcuts or engravings, and sometimes bound into books.

By the late fifteenth and early sixteenth century, two important artists, Leonardo da Vinci and Albrecht Dürer, had recorded the characteristics of different plants with scientific precision. In the mid-sixteenth century, the Flemish artist Georg Hoefnagle (1542–1600) painted book illuminations in watercolor, describing rare species of flowers and insects with a naturalist's accuracy of detail. By the seventeenth century many artists worked on a number of volumes that documented the hundreds of new flowers imported from other countries in Europe as well as the New World. In fact, travel to

foreign lands was an integral component of the interest in flower paintings as well as the rationale for their documentation in botanical drawings.

The close historical connection between the science of botany and the illustration of flowers is especially relevant for an understanding of the achievements of Maria Sibylla Merian. One of the finest botanical artists of the period, she eventually extended her interests to include the scientific study and illustration of insects and animals as well. Her contributions to the history of entomology and botany have long been recognized. More recently, her position in the history of art is also being reevaluated because her scientific contribution was conveyed through impressive visual images.

Matthaus Merian, Maria's father, was an engraver who published one of the first collections of flower illustrations in 1641. Although Matthaus died in 1650, when Maria was only three, his work provided the inspiration for her first major publication, the three-volume *New Flower Book,* completed in 1680. Maria's mother soon remarried Jacob Marell, a fine Flemish flower painter. One of Marell's students, Johann Andreas Graff, married Maria in 1665. With the advantages of this background, Maria Merian easily received a sophisticated training in the art of flower painting.

Her first completely original publication was *The Wonderful Transformation of Caterpillars and Their Singular Plant Nourishment,* published in 1679. (Two additional volumes were later published.) In this work, the development from larvae to caterpillar to moth of 186 varieties of European insects is illustrated. Each species is depicted with its preferred plant. Maria collected the insect eggs and studied the life cycle of each moth. This was the first time that scientific precision was brought to the investigation of the insect world. Prior to the publication of these volumes, there was no understanding of the life cycles of insects. "Merian thus revolutionized the sciences of zoology and botany and laid the foundations for the classification of plant and animal species made by Charles Linnaeus in the eighteenth century."[4]

Merian lived in Nuremberg from 1670 to 1685. She then resided with a religious sect, the Labadists, for several years, eventually settling in Amsterdam in 1690. There she studied the available insect collections, including that of Professor Frederik Ruysch, Rachel's father. While Rachel Ruysch was very precise in her depictions of plants, animals, and insects, her images, as we shall see, are artificial constructions, without the spirit of scientific inquiry that Merian brought to her study of nature.

In 1699 Merian left Amsterdam accompanied by her daughter and traveled to the Dutch colony of Surinam in South America on a scientific research mission sponsored by the city of Amsterdam. One can imagine the courage and professional dedication that motivated Merian, unaccompanied by any male protector, to undertake such a long and dangerous voyage to a far-off tropical colony. Over the next two years, Merian collected a wide range of specimens of the insects, plants, and animals of Surinam. With anthropological interest, she recorded the customs of the natives as well. After becoming

seriously ill, she returned to Amsterdam with her daughter. Four years later, in 1705, the first volume of her masterpiece, *Metamorphosis Insectorum Surinamsium,* was published. The author of a history of botanical illustration calls it "magnificent."[5] The work consists of sixty large plates, engraved from Merian's watercolors. Some copies were hand-colored by Merian herself. Each plate is accompanied by a detailed description, written by the artist/author.

Plate V (Figure 20) is a characteristic example of the images in this work. The composition is designed to include the maximum amount of information without sacrificing clarity and legibility. Plate V presents a caterpillar striped black and yellow, with red head and tail. Merian's commentary informs us that this caterpillar shed its skin in December 1700 and was transformed into the brown and white moth positioned at the upper right. The moth is rendered with precision and delicacy. This species of caterpillar feeds on the Cassaba plant (breadfruit), which dominates the composition. Merian shows the root system, stem, and leaves, and provides a description of the preparation of breadfruit, a dietary staple of the native population, prepared from the roots of this plant. The artist's more purely aesthetic instincts are shown by the depiction of a writhing, coiled snake. The snake eggs are located in the lower left. These eggs do not have a shell, but rather a skin, like crocodile and tortoise eggs.

Within a unified and beautiful composition, Merian has compressed an

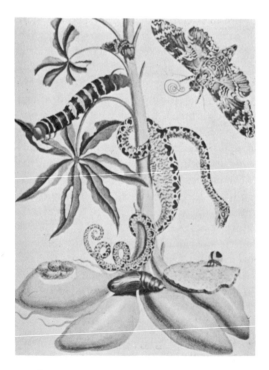

FIGURE 20. MARIA SIBYLLA MERIAN. *Metamorphosis Insectorum Surinamsium,* Plate V. 1705. Hand-colored engraving. Library, The Academy of Natural Sciences of Philadelphia.

extraordinary wealth of scientific information. While her main purpose was the expansion of scientific knowledge, she raised the level of botanical illustration to that of fine art. Coming from a family of flower painters, Merian possessed a highly refined formal sensibility. Her remarkable achievement in the history of botany and entomology also deserves recognition in the history of art.

RACHEL RUYSCH (1666–1750)

While other types of still life painting became less popular in Holland by the late seventeenth century, flower pictures retained their desirability and popularity. The Dutch continued to cultivate a wide variety of species of flowers for business and pleasure during the 1600s. The prosperity of the merchant class encouraged the proliferation of private gardens where new varieties of flowers were eagerly sought and cultivated. Patrons often wanted flower painters to record their best or rarest blossoms.

Rachel Ruysch and Jan van Huysum were the two most prominent and successful painters specializing in flower pictures in the late seventeenth and early eighteenth centuries. Ruysch's complex paintings of flowers, fruits, and fauna were widely admired during her lifetime, and her reputation has not diminished since her death. One indication of the esteem in which her talent was held were the high prices her contemporaries regularly paid for her paintings. Ruysch sold her works for 750 to 1,250 guilders as compared with Rembrandt, who rarely received more than 500 guilders for his canvases.

Ruysch was born into a highly distinguished family, which encouraged her talents. Her father, an eminent professor of anatomy and botany in Amsterdam, had an extensive collection that Rachel could study up close and draw upon for her compositions. In fact, the lizards and insects she included in some of her paintings might very well have been observed among the specimens in her father's collection. Her mother was the daughter of the noted architect Pieter Post, who designed the royal residence near The Hague. Given this stimulating intellectual and artistic milieu, Rachel's talents were bound to thrive.

Ruysch studied painting with the finest contemporary still life painter in Amsterdam, Willem van Aelst. An innovator in flower compositions, Aelst's arrangements were very open and asymmetrical. Like Aelst, Ruysch favored a baroque, diagonal composition, quite different from the compact and symmetrical arrangements of Peeters and other early seventeenth-century flower painters. Such compositional form, which generates a sense of energy, is apparent in *Flower Still Life* (Figure 21). This flower arrangement is contained in a simple vase, placed on a stone ledge, and set against an undetailed background. All visual interest is focused on the tangled and overlapping plants and flowers, with their energetically curving stems.

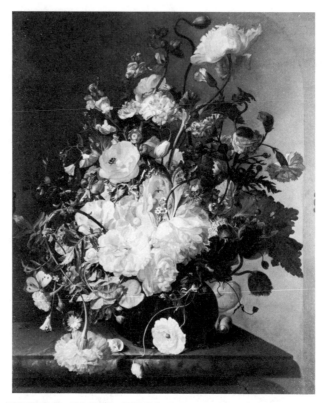

FIGURE 21. RACHEL RUYSCH. *Flower Still Life.* Oil on canvas. 29 3/4 × 23 7/8" (75.6 × 60.6 cm.). The Toledo Museum of Art. Gift of Edward Drummond Libbey.

Ruysch married an undistinguished portrait painter named Jurien Pool in 1693. They were married over fifty years, and Rachel bore ten children. Despite this large family and the burdens of domestic responsibilities, about a hundred authenticated works are attributed to her. The family moved to The Hague in 1701, and over the next years Ruysch developed an international reputation. From 1708 to 1716 she was court painter to the Elector Palatine, Johan Wilhelm von Pfalz, whose court was located in Düsseldorf. During these years most of her paintings were kept in the Elector's collection. One of her most brilliant and complex works, *Fruit, Flowers, and Insects,* was presented to the grand duke of Tuscany, another mark of the extremely high esteem in which her art was held.

Fruit, Flowers, and Insects (Figure 22) demonstrates the power and precision characteristic of her paintings. A cornucopia of fruits and plants cascades in a diagonal from upper right to lower left. The curving stems of the wheat create a dynamic countermovement, filling the upper-left corner. This work is

FIGURE 22. RACHEL RUYSCH. *Fruit, Flowers, and Insects.* 1716. Oil on canvas. Palazzo Pitti, Firenze.

an innovative type of still life picture. Although other artists had pioneered the use of a wooded setting and had created equally complex arrangements, only Ruysch combined the wooded setting with a still life so large that it fills the foreground almost completely. The landscape location is indicated but its description is minimal. Thus, the depicted space remains quite shallow and the viewer's attention rests firmly on the objects in the foreground; there is no escape back into deep space. Each type of fruit, flower, insect, or animal is botanically accurate, demonstrating Ruysch's close study of natural phenomena. Nevertheless, the painting is a wholly artificial construction. Despite the wooded setting, these objects could never be found juxtaposed in this manner in nature. Ruysch's choice of colors, delicate brushwork, and precise description of object textures are aspects of her highly appreciated technique. Ruysch also bathed her compositions in an enveloping atmosphere that heightened the illusionism of her works.

On a symbolic level, Ruysch's paintings, like those of many of her contemporaries, are *vanitas* images. The ripening fruit, grain, and blooming flowers all retain their symbolic associations with the transience of earthly existence, the passing vanities of the temporal world. Lizards were seen as creatures of decomposition, awaiting the end of the body's brief existence. This lizard is devouring an egg—a clear reference to the life cycle, birth and

death. Butterflies were common symbols of the resurrected soul in the after-life. However, these somber symbolic associations do not interfere with the purely sensual pleasure one can take in the accuracy and variety of the depicted objects.

Ruysch's position in the history of art is clear and secure. She was the last of the great Flemish and Dutch flower painters. Towering over her contempo-raries, she enjoyed a highly productive and successful career. Her works are never monotonous. She maintained a consistently high level of excellence in paintings that reveal a range of dynamic compositional formulas. Using a wide variety of plants, insects, fruits, etc., she created monumental paintings of widely recognized and enduring quality.

6

EiGHTEENTH-CENTURY
EUROPEAN PAiNTERS

Women artists continued to function under highly discriminatory conditions throughout the eighteenth century. They were denied access to the major art academies, where their male colleagues studied the anatomy of the male nude and acquired training in the composition of multifigured history paintings. Therefore, it is not surprising that only one of the five artists included in this chapter **Angelica Kauffman,** was able to build a career around the exhibition of history paintings as well as portraiture. Three of the five **Rosalba Carriera, Elisabeth Vigée-Lebrun,** and **Adélaïde Labille-Guiard,** were outstanding specialists in portraiture, **Anne Vallayer-Coster** was a noted still life and flower painter. Also, not surprisingly, three of our five artists were daughters of artists and first learned to paint at home. Rosalba Carriera, a Venetian, did not suffer severely from a lack of proper training, since she worked in two media, pastel portraiture and miniature painting on ivory, in which she invented the techniques. The fifth artist, Labille-Guiard, learned to paint by apprenticing herself to a series of masters who specialized in miniature painting, pastel portraiture, and finally, the technique of oil paint.

Despite the difficulties and obstacles, these women artists managed to achieve tremendous success and recognition for their achievements. As we shall see, all five painters received the highest levels of rewards for their talents in their respective cultures.

It was impossible for women artists to acquire training or develop a market for their works in seventeenth-century France. As opposed to the situation in Holland, where the Dutch middle classes were avid consumers of paintings, virtually all commissions in France during this period came from the monarchy. There was little diversity or scope for personal styles. Louis

XIV believed that the arts, like the sciences, industries, and other activities, should serve the glory of France and her king. Through a reorganization of the Paris Academy in 1663, the fine arts were brought under the direct control of the state bureaucracy. Early in Louis's reign, he decided to create a magnificent setting for himself and his court at Versailles. Most of the efforts of French artists of this era were directed toward the embellishment of this enormous palace. Only male painters were permitted to receive the training necessary to create the large-scale history paintings that decorated the walls and ceilings at Versailles. Control over artists was easily maintained because all artists working for the king had to be members of the Academy.

Given the inflexibility of this system of education and patronage, it is not surprising to find no women artists of major significance in France during the seventeenth century. Denied access to the training essential for a professional artist, the highly structured, state-controlled art world of Louis XIV effectively prevented any women from achieving excellence. Because there was no real market for other types of paintings, few artists specialized in those genres popular in Holland, such as flower painting, still life, and small-scale portraiture, types of art in which women often excelled.

The decentralization and loosening of state control over the arts that occurred in France following the death of Louis XIV in the period known as the "Rococo" created a much more favorable environment for women artists.

The aristocratic clientele, which eagerly purchased the intimate and sensuous paintings of the Rococo masters to decorate their newly built Parisian townhouses, also supported the art of portraiture. By the 1720s Carriera had built an international reputation for her pastel portraits. In 1720 she became the only foreign woman to be elected to the French Academy.

During the eighteenth century, a new appreciation for still life and flower paintings developed among the same French aristocrats who supported portraiture. Chardin, the most famous still life painter in France in the 1700s, had a long, honorable, and successful career. Despite the fact that he painted only still lifes and genre scenes, he was accepted into the French Academy in 1728. Vallayer-Coster, a contemporary of Chardin's, also had an active and respected career as a still life painter. She was accepted into the Academy in 1770 at the early age of 26.

Neoclassicism was an international movement in the history of art that affected many artists between 1750 and 1850. During this epoch, both European and American painters and sculptors employed a formal vocabulary adapted from the art and artifacts of antiquity. Neoclassicism manifested itself in works of art in all media: painting, sculpture, and architecture, as well as designs for the decorative arts. Angelica Kauffman was one of the major painters in the first generation of neoclassical artists. The daughter of a Swiss artist, she worked in Italy and England as both a portrait painter for the aristocracy, like her contemporaries Vigée-Lebrun and Labille-Guiard, and as a creator of history paintings with didactic themes, drawn from ancient liter-

ature. Kauffman played a significant role in the initial formulation of Neo-classicism and the dissemination of the style. Exposed to the circles in Rome that developed the theoretical principles of this movement, Kauffman traveled to England, where she was received as a major artist who practiced both portraiture and history painting.

In the decade prior to the French Revolution, two women emerged as the most eminent portrait specialists of the *ancien regime*. Both better known and more prolific, Elisabeth Vigée-Lebrun and Adélaïde Labille-Guiard received major portrait commissions from the French royal family. Barred from the academic training systems and competitions leading to the Prix de Rome, these artists developed their impressive talents outside of the official state-supported structures. It is no coincidence that both these artists specialized in portraiture. The art establishment did not permit women to acquire those skills needed for the Academy's most prestigious type of painting, i.e., history painting. As noted above, such works required knowledge of the male nude and extensive training in composition for the effective arrangement of many figures into narrative tableaux. However, within the confines of the conventions of commissioned portraiture, both women displayed technical expertise and compositional originality. Viewed as rivals by the contemporary press, they outshone their male colleagues, winning the most prestigious commissions awarded in their society.

ROSALBA CARRIERA (1675–1752)

Rosalba Carriera's special contribution to the history of art was her invention of a new type of art form, the pastel portrait. Her influence in this medium was very widespread, and she won international renown. Carriera's life-size portraits in colored chalks did not merely reflect the Rococo qualities of her epoch, but they contributed to the formation of the tastes of her society. Carriera made an equally important innovation in miniature painting. She was the first artist to use ivory as a support for miniature portraits. Ivory had marked advantages over parchment, both for durability and luminosity, and it was therefore widely adopted by miniature painters during the eighteenth century.

Carriera rose from very humble origins to become one of the most successful artists of her epoch. She was born in Venice; her father was a clerk and her mother, a lacemaker. Harris and Nochlin suggest that she began her career by learning the art of lace making and when this industry declined, shifted to the decoration of ivory snuffboxes.[1] These inexpensive items were produced in mass quantities for the tourist trade. From this initiation, Carriera became familiar with painting on ivory in a small scale, and she began to create miniature portraits.

As a miniature painter, Carriera possessed great skill in rendering detail

and in applying the paint in a range of thicknesses. Her active brushwork revolutionized the style of miniature painting and certainly contributed to her success. *Venus and Cupid* (Figure 23) is characteristic of her miniature style. The modeling of the figures is rendered in a combined technique of painted shadows and tiny dots. The drapery partially covering Venus is painted in a thicker, more active impasto.

Miniature painting has suffered from low esteem in the history of art, despite the fact that miniaturization requires an especially precise technical control. Because they are small, miniatures are often seen as inherently less "significant" than larger-scale paintings. Clearly, painting in miniature is a difficult task to perform because the small size of the image forces the artist to exercise extraordinary manual control. The eyestrain that this work inevitably involved may well have contributed to Carriera's loss of sight in 1746. She spent the last years of her life blind and in seclusion, suffering from periods of depression.

Carriera's first professional successes were in the medium of miniature painting, but she achieved international recognition for her pastel portraits. Although colored chalks, known as pastels, had been invented in the late fifteenth century, no artist before Carriera had explored their formal possibilities. Employing pastels in an unprecedented way, she skillfully created a naturalistic range of textures. At the invitation of a Parisian banker, whom she

FIGURE 23. ROSALBA CARRIERA. *Venus and Cupid.* Miniature on ivory. 4$\frac{1}{16}$ × 3$\frac{3}{8}$″. Statens Museum For Kunst, Copenhagen.

had met in Venice, she arrived in Paris in 1720. One of her first portraits was of the young French king Louis XV (Figure 24). The portrait was greeted with widespread admiration. This image reveals a detailed, highly finished, and almost oil-paint–like treatment of the face combined with a more spontaneous technique in the jacket, cravat, and hair. In these sections, one can actually see the individual marks of the chalk. This precision, combined with a freedom of touch not achievable in oils, amazed her audience in Paris. In recognition of her achievements, she was invited to become a member of the French Academy—a great honor for any artist, and an unprecedented one for a foreign woman. Despite her warm reception in France, Carriera decided to return to her native Venice in 1721.

As a portrait artist, Carriera's talents were widely appreciated by an international clientele. Europe's aristocracy demanded portraits by her hand.

FIGURE 24. ROSALBA CARRIERA. *Louis XV as a Boy.* 1720. Pastel on paper. 19 × 14″. 65.2655, Forsyth Wickes Collection. Courtesy, Museum of Fine Arts, Boston.

The king of Denmark and many members of England's upper classes were among her patrons, while Augustus III, Elector of Saxony and King of Poland, collected more than 150 of her works.

Carriera possessed a refined color sense. She often used bright, fresh colors for a brilliant, luminous effect. This specific aspect of her style relates her art to that of her Venetian contemporary, Tiepolo. Tiepolo also worked for foreign patrons, but unlike Carriera, Tiepolo regularly executed large-scale mural decorations.

A special flair of Carriera's was her ability to make a flattering image of her sitter without losing his or her individual likeness. This ability was essential for an eighteenth-century portraitist, when a portrait often served the purpose that a photograph does today. The duke of Modena, aware of Carriera's success in Paris, commissioned the artist to paint portraits of his three marriageable daughters. These portraits were circulated to attract eligible suitors who could form advantageous political alliances with the duke.[2] Clearly, a flattering image was not merely a matter of vanity but, as in this case, a political strategy as well.

When Carriera did not have the restrictions of a commissioned portrait, she was capable of a forthright realism. This quality is most clearly apparent in her self-portraits. The strong image of herself shown here (Figure 25) was made shortly before she went blind. This work reveals honesty, sharp powers of observation, and unflinching precision.

Carriera's name resounded through the eighteenth century, and she paved the way, as a role model if not as a direct influence, for other portrait painters. Masters of pastel portraiture, such as Maurice Quentin de la Tour and Jean-Baptiste Perroneau, are among the inheritors of her invention. Contemporaries of Vigée-Lebrun and Labille-Guiard regularly compared these artists, active later in the eighteenth century, with Carriera. Theresa Concordia Mengs, Suzanne Giroust-Roslin, and Labille-Guiard's pupil, Gabrielle Capet, are among the many women who followed Carriera's example to become successful pastel portraitists in the eighteenth century.

ANNE VALLAYER-COSTER (1744–1818)

Anne Vallayer-Coster was one of the most talented, versatile, and productive still life painters of the late eighteenth century. Within this genre she painted a wide variety of works, ranging from simple groups of humble kitchen objects to elaborate compositions of exotic things, as well as hunting trophies and arrangements of fruits. She was especially renowned for her paintings of bouquets of flowers.

Vallayer-Coster's technical skills were widely recognized and appreciated by her contemporaries. In 1771 the highly influential critic Diderot wrote that no other artist possessed an equal force of color and assurance. Among her

FIGURE 25. ROSALBA CARRIERA. *Self-Portrait.* Pastel on paper. Gallerie Dell'Accademia, Venezia.

patrons were the Marquis de Marigny, Minister of Arts under Louis XV, the Comte d'Angiviller, who held the same position under Louis XVI, and Marie Antoinette. Through royal decree, she was permitted to live in one of the apartments reserved for artists, a mark of special esteem that had also been accorded to Chardin, her more famous colleague who also specialized in still life painting. The official rewards and successes enjoyed by Vallayer-Coster during her lifetime attest to both the quality of her art and the esteem in which naturalistic still life painting was held.

Anne Vallayer was born into a family of artisan-craftsmen. Her father was a goldsmith who worked for the Gobelins tapestry factory. Eventually, he established an independent shop, which his wife ran after his death. Thus, Vallayer was raised in an environment that cultivated and encouraged her talents. We do not know how she acquired her painting skills, but she was an accomplished artist by her early twenties.

Vallayer's successful professional career enabled her to raise her social

status. In 1781, at the relatively late age of 37, she married a wealthy lawyer and member of parliament, Jean Pierre Silvestre Coster, a match that represented a definite advance in class status for the daughter of a goldsmith.

Although Diderot was appreciative of Vallayer-Coster's talents, he was the first writer to compare her works with those of Chardin, and to some extent her reputation has suffered from this comparison ever since. One cannot deny that there are similarities in subjects and compositions between some of the still lifes of the two. However, one would find such constants in the works of almost any other eighteenth-century French still life painter. They are only the most general characteristics of national and period style in this category of painting. This does not indicate that Vallayer-Coster was less talented or less innovative than Chardin.

Vallayer-Coster's elaborate *Allegory of Music* (Figure 26) was the painting she submitted as her reception piece to the Royal Academy. The carefully composed pyramidal grouping creates a compositional unity, quite distinct from Chardin's more characteristically casual and seemingly random arrangements. The lute, violin, and flute are linear elements that lead the viewer's eye diagonally back into space. This spatial recession is reinforced by the diagonal position of the table. Executed in a linear and precisely controlled technique, the surface description of each object's texture is rendered with extreme clar-

FIGURE 26. ANNE VALLAYER-COSTER. *Allegory of Music.* 1770. Musée du Louvre, Paris.

ity. No brushstrokes or paint textures intrude upon the realism of her depictions of these objects.

Many of Vallayer-Coster's still lifes are not as elaborate as the *Allegory of Music*. She painted a number of works depicting simple objects set on a stone ledge. One of her most sensitive and beautiful still lifes of this type is *The White Soup Bowl* (Figure 27). This painting is a study in shades of white. The artist precisely and sensitively describes the different tones and textures of the porcelain bowl, the linen cloth, and the translucent steam rising from the soup. The composition is deceptively simple. There is a subtle play of horizontal, vertical, and diagonal linear accents that achieve a satisfying balance. The economy of the arrangement is consistent with the restrained color scheme of *The White Soup Bowl*. This painting displays a technical ability of extreme control and finesse. Furthermore, the image conveys tangibility and immediacy. The soup is steaming and soon someone will come to lift the ladle and serve the broth and bread to hungry people.

Vallayer-Coster's talents were not limited solely to the realm of still life painting. She also painted miniatures, portraits, and arrangements of fruits and flowers. Her paintings of flowers received widespread recognition and suc-

FIGURE 27. ANNE VALLAYER-COSTER. *The White Soup Bowl.* 1771. Oil on canvas. 19¹¹⁄₁₆ × 24½″. Private Collection.

cess, continuing the tradition of Peeters and Ruysch. Her flower compositions vibrate with color and freedom of touch, more characteristic of the nineteenth century than of the eighteenth. Both in flower paintings and still lifes, her precision and taste for reproducing exact detail served her purposes quite well. These talents were less appreciated in the realm of portraiture where, as noted in connection with Carriera's success in this field, the artist was expected to beautify the sitter's appearance as necessary.

Anne Vallayer-Coster was one of the leading French still life painters of her generation. She was a versatile artist with a sophisticated sense of composition and sensitivity to color combinations. Her paintings, like those of Chardin, are a realistic alternative to the erotic fantasies of the late Rococo painters, such as Boucher and Fragonard.

ANGELICA KAUFFMAN (1741–1807)

Like other artists discussed in this and preceding chapters, Angelica Kauffman was the daughter of a painter. Born in Switzerland, she received her early training from her Tyrolean father. During her childhood, the Kauffmans traveled about in Switzerland, Austria, and northern Italy, executing commissions for religious murals and portraits. Angelica's precocious talents were recognized and encouraged from an early age. In 1762 Angelica and her father arrived in Florence, and the following year they settled in Rome. Kauffman had the fortuitous opportunity to make contact with all the leading figures of the neoclassical movement at a very early phase in its development. Under the influence of Winckelmann, Mengs, and Hamilton, Kauffman developed a sophisticated neoclassical style that placed her in the forefront of this movement.

In 1766 Kauffman arrived in London where she quickly established herself as one of the leading artists of the English school. She became friendly with Sir Joshua Reynolds, and when the Royal Academy was founded in 1769, she and a flower painter, Mary Moser, were the only two women members. At this time, the vast majority of paintings produced in England were portraits commissioned by the aristocracy. Although she was forced to paint portraits to earn a steady income, Kauffman was one of the few artists working in England and one of the few women artists of any period who produced a steady stream of paintings with themes derived from classical and medieval history. Between 1766 and 1781, she contributed significantly to the widespread vogue for Neoclassicism in England.

In addition to the recognition she received for her history paintings, Kauffman's portraits were widely admired and she attracted many patrons among the English aristocracy. Her talents were held in such high esteem by her peers that she was asked to contribute to the decoration of the new residence of the Royal Academy in 1778.

Unfortunately, her professional successes were not matched by domestic happiness. In 1767 she married a man she believed to be a Swedish count but who turned out to be an imposter. After the scoundrel's death, she married a painter, Antonio Zucchi, who remained forever loyal and supportive of his more famous wife's career. In 1781, following their marriage, the couple returned to Italy. Refusing an offer to become resident court painter to the King of Naples, Kauffman settled in Rome in 1782. Some of her best paintings were created during these years.

Cornelia Pointing to Her Children as Her Treasures (Figure 28) is one of the history paintings from her mature Roman period. Cornelia was a real matron in ancient Rome whose reputation as a paragon of virtue had come down through history. This painting illustrates a didactic anecdote in which a materialistic Roman woman, seated at the right, shows off a necklace, while Cornelia displays her three children as her "jewels." The stylized faces of the women, the severely simplified costumes, and the austere architecture are all characteristic of Kauffman's neoclassical style. The rich, glowing colors of the

FIGURE 28. ANGELICA KAUFFMAN. *Cornelia Pointing to Her Children as Her Treasures.* 1785. Oil on canvas. 40 × 50″. Purchase: Williams Fund, 1975. Photo: #24155. Virginia Museum.

robes and the warm tonality of the light show her assimilation of the stylistic achievements of the Venetian school.

Cornelia is contemporary with Jacques Louis David's *Oath of the Horatii*. A comparison between these two works reveals certain stylistic and compositional similarities as well as thematic differences. Both Kauffman and David arrange their figures in a simple, shallow space like a stage in a theater. Both use idealized classical figure types with legible gestures so the viewer can read the narrative. While both paintings depict an example of moral virtue, the virtues expressed are totally different in content. Cornelia is the admirable Roman matron who prizes her children above all worldly goods and devotes her life to raising them to serve the state. David focuses on the sacrifices of war, with emphasis clearly placed on the virile sons energetically dedicating their lives to defend the Roman Republic. While Kauffman has selected her didactic message to illustrate the behavior of a female role model, David's painting illustrates a male world of military heroism and patriotism. The women in the *Oath of the Horatii* are wilted, weak, limp, and tearful. They are clearly excluded from the male sphere and their role is confined to passive mourning.

Kauffman also combined a contemporary theme with art historical precedents to create her autobiographical image in *The Artist Hesitating Between the Arts of Music and Painting* (Figure 29). Here, Kauffman adapted the iconography of the story "Hercules at the Crossroads between Fame and Luxury" to illustrate an episode in her own youth when she had contemplated embarking on a career as an opera singer. This composition demonstrates the artist's ability to combine a specific portrait likeness (in this instance, a self-portrait) with the idealized neoclassical features of the two allegorical personifications. As Angelica gently presses the hand of Music on the left, her body inclines toward Painting, who points to the temple of fame, symbolically positioned on the summit of a distant mountain. As in *Cornelia Pointing to Her Children as Her Treasures,* the drapery is painted in warm, glowing colors and the whole composition is bathed in a painterly atmosphere.

Kauffman's achievement places her in the forefront of Neoclassicism, as one of its original exponents and disseminators. By the 1760s she was creating convincing history paintings in a neoclassical idiom, anticipating David's paintings of the 1780s. She was one of the most highly respected artists of her era. Some measure of the admiration and esteem she earned during her lifetime may be appreciated when one learns that all the members of the Roman Academy of St. Luke marched in her funeral procession. The funeral ceremonies were modeled after the services conducted for Raphael.

ELISABETH VIGÉE-LEBRUN (1755–1842)

Elisabeth Vigée-Lebrun was among the most talented and successful aristocratic portrait painters of the late eighteenth and early nineteenth centuries. As

FIGURE 29. ANGELICA KAUFFMAN. *The Artist Hesitating Between the Arts of Music and Painting.* c. 1794. Lord St. Oswald, Nostell Priory, England.

official portraitist for the Queen of France, Marie Antoinette, she achieved one of the highest positions in her society. After the French Revolution, as she traveled around Europe, she continued to experience a series of international triumphs. Her output was prodigious: She produced about 800 paintings during her lifetime. Like Carriera, to whom she was frequently compared by her contemporaries, Vigée-Lebrun had the capacity both to reflect and to formulate the esthetic tastes of her aristocratic clientele.

The daughter of a pastel portrait painter, Vigée-Lebrun recalled in her memoirs that her father and his colleagues gave her instruction and encouraged her talents. She also studied the paintings in the Louvre, especially Rubens's Marie de Medici cycle. In this active, supportive environment, her talents developed precociously. When she was twenty, she commanded higher prices for her portraits than any of her contemporaries.

In 1778 Vigée-Lebrun was summoned to court to paint her first portrait of Marie Antoinette. Thus began a relationship that would dominate the career and reputation of the artist. An ardent royalist until her death at the age of 87, Vigée-Lebrun was called upon to create the official image of the queen. The painting that best exemplifies Vigée-Lebrun's role as political propagandist is the monumental and complex *Marie Antoinette and Her Children* (Figure 30).[3] This work was commissioned directly from the funds of the state to defuse the violent attacks on the queen's moral character then circulating in France. It was painted only two years before the cataclysm of the French Revolution, the

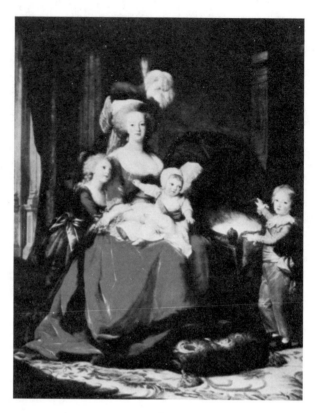

FIGURE 30. ELISABETH VIGÉE-LEBRUN. *Marie Antoinette and Her Children.* 1787. Musée National de Versailles.

imprisonment of the royal family, and their subsequent execution. This official image was designed as an aggressive, if ultimately ineffective, counterattack to the political opponents of the monarchy. Vigée-Lebrun placed the queen in the imposing and easily recognizable setting of the Salon de la Paix at Versailles. The famous Hall of Mirrors is visible on the left side of the painting. The royal crown sits on top of the cabinet on the right, the ultimate symbol of the power and authority of the kings. The figure of the queen herself dominates the composition. Her features have been ennobled and beautified, while the enormous hat and full, voluminous skirts create an impression of superhuman monumentality. Her luxuriant costume, the immense blue velvet robe and hat convey, like Rigaud's *Louis XIV* (Figure 31), the grandeur of the French monarchy. Rigaud, however, relied on iconographical precedents. For his image of the Sun King, Rigaud adopted Louis XIV's stance from Van Dyck's *Portrait of Charles I*. Vigée-Lebrun wanted her painting to express not only the sanctity of divine right monarchy but also the bourgeois, En-

FIGURE 31. HYACINTHE RIGAUD. *Louis XIV.* 1701. Oil on canvas. 9'2" × 6'3". Musée du Louvre, Paris.

lightenment concept of "Maternal Love." The triangular composition is derived from High Renaissance images of the Madonna and Child by Leonardo and Raphael. Like Kauffman's *Cornelia Pointing to Her Children as Her Treasures* (see Figure 28), Marie Antoinette displays her children as her jewels. The Dauphin stands on the right, slightly apart from the group, as is only appropriate for the future king of France (although events were to alter the dynastic succession). The eldest daughter gazes up at the queen with filial adoration. The empty cradle to which the young Dauphin points originally contained the queen's fourth child, an infant girl, who died two months before the painting was to be exhibited at the Salon opening. On that day, August 25, 1787, antimonarchist feelings were running so high that Vigée-Lebrun refused to display the painting for fear that it might be damaged.

There is a strong contrast between the opulent formality of *Marie Antoinette and Her Children* and Vigée-Lebrun's *Portrait of Hubert Robert* (Figure 32). Robert, a close friend of the artist, was a painter who specialized in the creation of picturesque classical ruins glowing in the rosy-tinted atmosphere invented by Claude Lorraine. As opposed to the formal reserve of Marie Antoinette, Robert leans casually on one arm. The relaxed pose contrasts with

FIGURE 32. ELISABETH VIĠEE-LEBRUN. *Portrait of Hubert Robert.* 1788. Musée du Louvre, Paris.

a tense, alert gaze. Robert seems to be receiving inspiration from some undetermined source. The sharp turn of the head, strong lighting, and a sense of barely controlled energy convey a vivid sense of tangible presence. The face is painted realistically, which underscores the immediacy of the image. The barely restrained, proto-Romantic energy of Hubert Robert anticipates subsequent developments in romantic portraiture in the early nineteenth century.

Vigée-Lebrun positioned Robert against an undetailed, neutral background in which brushstrokes are visible. This plain ground is similar to those used by her colleague, Jacques Louis David, for portraits and other types of painting (see *Death of Marat*). However, the neutral background is in marked contrast to the bright, ruddy complexion of Robert and the three primary colors employed in his costume: a yellow vest, blue jacket, and red collar. The primary colors are echoed in the paint brushes, also tipped with red, yellow, and blue. The white cravat, which flows luxuriantly, is painted in impasto brushstrokes.

Her close association with the queen made it dangerous for Vigée-

Lebrun to remain in France after the imprisonment of the royal family. In 1789 she traveled first to Italy, then Vienna, eventually arriving in St. Petersburg, Russia. There, no political revolution had dispersed the aristocratic clientele upon whom she depended for commissions.

Vigée-Lebrun was permitted to return to Paris in 1802, in response to a petition signed by 255 fellow artists, but the era in which she had risen to fame had passed into history. She lived another forty years, sadly out of place in Napoleonic France and neglected during the subsequent Bourbon restoration.

Her career is of great historical interest because she was one of the foremost painters of her era. High prices, prestigious commissions, and critical attention document her position in the society of the *ancien régime*. Unlike David and Labille-Guiard, who adapted their talents to the successive governments of France, Vigée-Lebrun was both emotionally and professionally attached to the monarchy. While the portrait of *Marie Antoinette and Her Children* found a sympathetic audience during the restoration of the Bourbons at the Salon of 1817, its creator never regained the preeminent position she had held before Marie Antoinette was guillotined.

ADÉLAÏDE LABILLE-GUIARD (1747–1803)

Although she was six years older than Vigée-Lebrun, Labille-Guiard's public career is contemporaneous with her colleague. Unlike Vigée-Lebrun, who, as a daughter of a painter, easily acquired the skills needed for portraiture in oil at home, Labille-Guiard was born into a *petit-bourgeois* family with no obvious connections to the arts.[4] Her skills were developed over a period of many years, and it was only in 1780, when the artist was over thirty, that she exhibited her first oil paintings. Following the example set by Carriera, she learned the art of miniature painting during her adolescence from François-Elie Vincent. She then studied pastel technique with the preeminent pastel portraitist of the age, Maurice Quentin de La Tour. She only developed her skills in oil painting later, from Francois-André Vincent, her miniature teacher's oldest son and her future husband. She married Louis-Nicolas Guiard in 1769, lived with him for about ten years, and divorced him in 1792.

Although she had mastered the full range of techniques for portraiture by 1780, she struggled to develop a clientele. Between 1780 and 1783 she executed an uncommissioned series of portraits of preeminent Academicians, such as Vien, the teacher of David. This tactic proved to be an effective political lobbying technique to establish her abilities. She was admitted to the Academy in 1783, simultaneously with Vigée-Lebrun.

Labille-Guiard is remarkable not only for her successful career, but also for her concern and active interest in the education of women artists. After 1780, she accepted into her studio a small group of young women whom she trained. Several of her pupils continued to pursue active professional careers as

portraitists. Her *Portrait of the Artist with Two Pupils, Mlle. Marie-Gabrielle Capet and Mlle. Carreaux de Rosamond* (Figure 33), exhibited at the Salon of 1785, is remarkable for its inclusion of two of her most capable students. Contemporary critics noted the appearance of these, as yet unknown, women artists. So this painting constitutes a public introduction of the aspiring painters.

In this work Labille-Guiard has presented herself in the costume and coiffure of the aristocracy. Documents survive indicating that, despite her Salon success of that year, she was experiencing financial difficulties. Therefore, one must interpret this proud image as a form of self-advertisement, an appeal to potential aristocratic patrons on their own terms, rather than as documentation of the artist's actual social status. This painting is characteristic of Labille-Guiard's taste for muted color harmonies, as opposed to the more highly

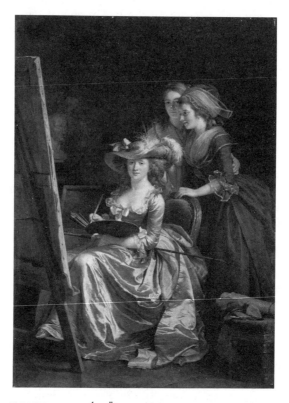

FIGURE 33. ADÉLAÏDE LABILLE-GUIARD. *Self-Portrait with Two Pupils, Mademoiselle Marie Gabrielle Capet and Mademoiselle Carreaux de Rosemond.* 1785. 83 × 59½". The Metropolitan Museum of Art, New York, Gift of Julia A. Berwind, 1953 (53.225.5). All rights reserved, The Metropolitan Museum of Art.

saturated colors often used by Vigée-Lebrun. Also, unlike Vigée, who favored very simplified costumes and hair arrangements, Labille-Guiard took pleasure in delineating precisely all details of the fashionable styles of her time.

According to the authoritative study of the artist, this painting was widely praised by the critical press of the day and helped to establish her reputation as a master painter in oils. The same year this work was exhibited, she was awarded a substantial stipend from the king, although she was denied a studio in the Louvre due to the presence of her young female pupils. The following year she received major commissions from the royal family and worked on portraits of the "Mesdames," the aunts of the king. Her full-length *Portrait of Mme Adélaïde* was hung as a pendant to Vigée-Lebrun's *Marie Antoinette and Her Children* (see Figure 30) in the Salon of 1787. Such obvious proximity encouraged critics to compare the two artists and helped establish a "rivalry" which continued to exist, at least as a critical premise, for the remaining years of the *ancien régime.*

Unlike Vigée-Lebrun, Labille-Guiard did not leave France during the years of the Revolution. With the obvious disintegration of her clientele, her resourceful ability to develop patronage again surfaced, and in the Salon of 1791, she exhibited fourteen portraits of deputies, representatives of the new political elite of France, including Robespierre and Talleyrand. As in her campaign for admission to the Academy, she was again successful in courting a new clientele. She received the same commission from the Constitutional Assembly as Jacques Louis David, *The King Showing the Constitution to the Prince.* Subsequent political events prevented the funding of these paintings, and neither was executed.

Labille-Guiard shrewdly used the political upheavals of the Revolution to lobby for an improved position for women artists. In September, 1790, she addressed the Academy and argued for lifting the quota of four women academicians. In another motion she pressed for an honorary distinction to recognize women, since they could not assume positions as professors or officeholders. She was unsuccessful in effecting these reforms. The following year, Talleyrand presented her proposal for a school for improverished girls to learn art skills suitable for careers in the art industries. Such a school was eventually established in 1805 (see introduction to chapter 9). Her ability to weather the political storms of her day is documented in her finally receiving a studio in the Louvre in 1795 and the large number of portraits she exhibited in 1798.

Both Vigée-Lebrun and Labille-Guiard were widely admired by their contemporaries and recognized for their talents by their peers in the Academy. These ambitious artists outshone those male colleagues who also specialized in portraiture. One may surmise from both artists' determination to achieve excellence that, had the opportunity existed, they would gladly have competed in the realm of history painting as well. Their confinement to portraiture was determined not by talent or ability but by their gender in the state-controlled art establishment of the French *ancien régime.*

7

Introduction to the Modern Era

The beginnings of the modern world are generally traced to the late eighteenth century when two types of revolutions began to transform European and American society. The Industrial Revolution and the American and French revolutions affected women differently from the ways in which they affected men. The immediate effects of the French Revolution transformed women's political and legal rights less than the economic changes brought about by the Industrial Revolution. Changes in infant mortality rates and family size, as well as the spread of public education, also had a profound impact on the patterns of women's lives during the nineteenth century. The feminist movement, active after the mid-nineteenth century, eventually succeeded in obtaining the expanded political and legal rights enjoyed by women in the twentieth century. The modern world has seen a slow but constant progression toward equality between the sexes, although discrimination toward women has not been eliminated.

By the mid-nineteenth century, most women married over the age of twenty. French women married somewhat earlier than their British counterparts, but they restricted family size so they could reenter the labor force. Infant mortality rates dropped dramatically in the early twentieth century, as did the average number of births. The desire to improve one's socioeconomic position also affected the size of families. With fewer children to support, family resources could be channeled to permit upward mobility. The continued improvements in care for mothers and the decrease in infant mortality rates altered older patterns. Contemporary women are much less physically threatened by their role as childbearers. However, the emotional demands of motherhood grew as the birth rate decreased.

Fewer children with longer lives entailed stronger emotional commitment to each one and heightened concern for the quality of child care. Expert opinion converged to professionalize motherhood. Thus while some forces freed women from the endless cycle of childbearing, traditionalism crept in by another door in another guise.[1]

WORKING WOMEN AND THE INDUSTRIAL REVOLUTION

Recent studies indicate that early industrialization did not dramatically influence the types of work women performed. "The majority of women remained in household settings as family farm workers, shopkeepers and servants in France, as servants in Britain, as garment workers and casual laborers in both countries."[2] Throughout the nineteenth century women continued to perform low-skilled jobs with low productivity and low pay. This trend continued until World War I. In 1911 over 70 percent of English working women were either servants, textile workers, or garment workers. The vast majority of women workers were young and single. This group provided the pool from which employers hired women for work in textile factories and other industries. By 1851, in France, for example, women constituted 39 percent of the industrial labor force. This high percentage of women is explained by the fact that women worked for about one-half the wages of men.

While factory work provided regular, year-round employment, most female industrial workers toiled in miserable conditions for long hours at below-subsistence levels of pay. One reason women's wages remained so low was that women were generally unskilled workers. Unions restricted the numbers of women who could work in the better paying, more highly skilled jobs in the industrial sector. Few women underwent technical training. Only after the beginning of World War I, when so many men were called to fight the war, did women begin to enter the skilled trades.

Social legislation began to set limits on the number of hours and conditions of work for women and children. Beginning in England in 1841, and in 1874 in France, the work day was eventually shortened from 12 to 10 hours. As opposed to starting to work at age six, girls were not permitted to work until age thirteen or fourteen. Increasingly, married women without the skills to earn high wages relied on their husbands to be the primary wage earners. Because work was now located outside the home, it was more difficult for lower-class women to combine child rearing with employment for wages. "By 1900 the separation between home and work which had begun a century before was virtually complete."[3] This pattern of women's work continued into the twentieth century. Married women worked less often and only in response to the family's needs. The primary occupation of a married woman was that of wife and mother.

Around 1900 there was a shift from factory work to white-collar employment. Women began to be hired in sales, clerical positions, and the like, which demanded at least a rudimentary education. A small minority of working-class women became teachers and nurses.

Between the two world wars, more and more women worked in the "service" sectors: behind counters and cash registers, as social workers, nurses, and teachers. Many women who had previously been employed in the agricultural sector moved to cities. The rural exodus was widespread. Urban working opportunities offered better wages and regulation of working conditions. Since World War II, the ability of women to earn wages has contributed to the trend toward increased autonomy and freedom from the authority of the husband. The large proportion of women in the work force today may also be attributed to improved household technology, as well as declining birth rates and longer life spans. As Kessler-Harris notes: "Working women, as a group, are becoming older, better educated, less likely to take time off for babies and more likely to be married and have children."[4] However, discriminatory hiring and pay has limited women's financial independence and full equality in contemporary society.

WOMEN'S RIGHTS AND THE FEMINIST MOVEMENT

The Enlightenment thinkers of the mid-eighteenth century did not present a clear case for the legal and professional equality of women. However, Montesquieu and Voltaire did formulate arguments in favor of increased educational opportunities for women. These thinkers countered the prevailing notions of women's intellectual inferiority. The *philosophes* believed that upper-class women should be able to use their skills and education more constructively in the world. Rousseau, however, the most influential Enlightenment thinker, extolled the new bourgeois concept of the family as a closely knit emotional unit. For women, marriage and motherhood were the expected sources of personal happiness. The woman's world was limited to her home. This glorification of woman as wife and mother was accompanied by the ideal conception of the home as a safe haven from the harsh realities of the world.[5] With the growing numbers of the middle classes during the nineteenth century, more and more women were affected by this life option. Any woman whose husband provided an adequate income was expected to find personal happiness in fulfilling her duties as wife and mother. For the middle-class woman, professional work was forbidden. As noted above, this bourgeois ideal of the role of the married woman as wife and mother affected the lower classes by the early twentieth century.

The French Revolution extended legal rights and privileges to many more men than had previously enjoyed them, but it left women largely unaffected. Women remained perpetual legal minors. Despite this, women did

make some gains toward improved rights during these upheavals. Marriage was deemed a civil contract. Women won legal protection for their property and inheritance rights. A leading champion of equality of education for women was the Marquis de Condorcet. Inspired by the American Declaration of Independence, Condorcet demanded increased educational and social opportunities for women as well as civil equality. In fact, the National Convention passed laws in 1794 and 1795 providing free and compulsory education for girls as well as boys. Unfortunately, the instability of the time prevented the implementation of these plans.[6]

The Napoleonic Code of 1804 reversed any gains women may have achieved. The Code strengthened the patriarchal authority of the husband and father, inspired by the Roman model of the *pater familias*. The right to divorce was abolished in 1815, not to be reinstated until 1884. When a French woman married, she forfeited virtually all of her legal rights:

> The law . . . required the wife to obey the husband, in return for which the husband owed her "protection." She had to reside wherever he chose and he was entitled to use force to compel her to do so. If she committed adultery, she was liable to imprisonment for a period of between three and twenty-four months, but he could engage in it with impunity. . . . She could not go to law without his permission even if she had her own business and she could not sell or buy without his approval. . . . The husband had the sole right to administer the joint estate. . . . He had full powers over his children, but when he died, she must act with the consent of his two nearest relatives.[7]

In colonial America the general shortages of labor in general and women in particular gave women a higher status than in Europe. Most women married, and the scarcity of women may have resulted in greater social mobility. Colonial women worked in a wide variety of occupations both inside and outside of the home. Women published and printed newspapers, managed tanneries, and worked, it seems, in almost every occupation in the Colonies. Unlike their European counterparts, they were allowed to conduct financial transactions and were often named as executors of their husband's estates.

Early nineteenth-century women in America were idealized as the guardians of traditional moral values. Many women were active in the Abolitionist and temperance movements. From this background, the movement for women's rights was born in 1848 at the Seneca Falls Convention, organized by Lucretia Mott, a Quaker, and Elizabeth Cady Stanton. A *Declaration of Principles,* which paraphrased the Declaration of Independence, included a resolution for women's suffrage. Through the second half of the nineteenth century, the suffrage movement, which also fought for equal legal rights, equal pay for equal pay for equal work, and access to education, began to gain momentum. In 1888 the International Council of Women held their founding convention in Washington, D.C.

Despite growing involvement of large numbers of women in the suf-

frage movement, especially in America and Britain, it was only as a result of World War I that women were enfranchised. This occurred in Austria, Canada, Denmark, Germany, Great Britain, the Netherlands, Russia, Sweden, the United States, and in other countries. French women did not win the right to vote until 1944.

In addition to legal and civil discrimination, women were also prevented from developing other options in their lives by the restrictions imposed on their educational and professional training. Lower-class women received virtually no education. In France, only after 1850 were towns required to provide primary education for girls. Middle- and upper-class women received a rudimentary education either in convent schools or with tutors in the home. As in the Renaissance, a woman's education tended to reinforce her predetermined life roles as wife and mother, rather than providing practical skills that might lead to financial self-sufficiency. Instruction in drawing and watercolor painting was part of this bourgeois curriculum because "Art" was considered an appropriate hobby for women, if forbidden as a professional career. Women slowly began to enter universities and professional schools, including the art academies, after 1850.

In America, opportunities for education were similar to those in Europe during the eighteenth century. However, American women had access to education earlier than in Europe. Public education for both boys and girls was a priority for the new democracy. Many teachers willing to work for modest salaries were needed, and teaching became one of the few appropriate professions for women. To train these teachers, a few private colleges for women were opened from 1850. Through the 1890s, teaching was the main occupation of female college graduates.

Slowly, during the second half of the nineteenth century, a few women entered European universities. In France the first woman enrolled in medical school in 1868; the law faculty admitted its first woman in 1884. University education remained a potential option for a tiny percentage of women throughout this period.

The general tendency for women to be excluded from professional careers of all types explains the low absolute numbers of professional women artists at the beginning of the nineteenth century. However, during the course of the century, more and more women (as well as men) became practicing artists. By 1900 thousands of women all over Europe were regularly displaying their works in official exhibitions. In the French Salon of 1801, 28 women participated. By 1878, 762 women were exhibiting. With increasing numbers of competent professionals, it is not surprising to find a larger number of women artists achieving excellence and working in the avant-garde movements of the art world. Since the 1870s, women artists have been active in almost every major avant-garde movement.

During the twentieth century, the numbers of practicing professional women artists have risen dramatically, and the trend continues unabated. In

1972, 75 percent of all the art students in America were women. Today the aspiring young woman artist can receive a thorough artistic training, completely equivalent to that available to men. Of course, the more subtle obstacles of cultural conditioning and societal expectations have proven difficult to eliminate. In 1972 a maximum of 10 percent of all works of art purchased by museums were created by women, and only 18 percent of all commercial galleries exhibited any works by women.

As one might expect from the increased absolute numbers of women artists and the enlarged opportunities to receive professional training, women artists have played a more important role in the history of art of the twentieth century than in earlier periods. This will be immediately apparent from the number of artists discussed in the chapters that follow.

8

AMERICAN ARTISTS:
1830–1870

The lives of American women were somewhat different from those of women of similar class background in Europe during the nineteenth century. As noted in chapter seven, girls were better educated under the American public education system. Private colleges for women were established here earlier than in Europe, mainly to train schoolteachers. Similarly, women aspiring to be artists had greater opportunities to acquire the necessary skills sooner than their European counterparts. At the Pennsylvania Academy of Fine Arts, women could draw from plaster casts as early as 1844. By 1860 women were enrolled in the anatomy class, and a separate life drawing class was established for women in 1868.[1] (It was not until the late 1890s that women were admitted to the prestigious *Ecole des Beaux-Arts* in Paris.) There were also possibilities for women to apprentice themselves to male artists, and both **Sarah Miriam Peale** and **Lilly Martin Spencer** learned their craft in these more informal ways. These two painters became outstanding practitioners of the arts of portraiture and domestic genre scenes, respectively, in the era prior to the Civil War. The careers of these two painters does demonstrate the possibilities for exceptional women artists of great talent to flourish in America in this epoch.

A group of American sculptors, known collectively as the *"White Marmorean Flock,"* used a Neoclassical style to produce a body of innovative works in the second half of the nineteenth century. Neoclassicism had retained its significance as an active style longer in sculpture than in painting. This is not surprising because styles in sculpture are generally slower to change than in painting. Furthermore, the art of antiquity had survived primarily in the medium of sculpture, and these classical models had rarely been seriously contested.

During the first quarter of the nineteenth century, a number of Europeans, such as the Italian Antonio Canova and the Dane Bertel Thorwaldsen, were prominent sculptors in Rome who adapted a neoclassical style for their works, in conscious imitation of antique models.

When Horatio Greenough left America and traveled to Italy in 1825, he initiated the exodus that created the first significant American school of sculpture. Prior to this time, Americans who created three-dimensional objects were largely craftsmen, although Patience Lovell Wright (1725–1786) had been active as a maker of wax images in the eighteenth century. In addition to Greenough, Thomas Crawford and Hiram Powers are the most important Neoclassical sculptors of the second quarter of the nineteenth century. Powers's *The Greek Slave* (see Figure 38) became the most famous sculpture produced by an American in the nineteenth century.

Italy retained its attraction for American sculptors both male and female during the third quarter of the nineteenth century. In addition to Randolph Rogers, William Wetmore Story, and William Henry Rinehart, a number of women sculptors established studios in Rome during the 1850s. **Harriet Hosmer** and **Edmonia Lewis** are among the artists of the *"White Marmorean Flock."* This group set a historical precedent for the ability of women to become successful professional sculptors. Henry James coined the name the "White Marmorean Flock" in 1903, and this disparaging phrase has remained attached to these artists ever since. As Jane Mayo Roos convincingly argues, the implication of the appellation is that these women are "tiny, anonymous, hapless creatures who traveled *en masse* and whose accomplisments were diminutive in scale."[2]

In reality, these women artists created a series of famous and popular works, which, like those of their male colleagues, often combined classical subjects with realistic details. American sculptors of both sexes were attracted to Italy for the same reasons. There they could study first-hand the sculpture of antiquity, which were accepted as models of excellence. The famous marble quarries of Carrara provided a ready source of materials. And, perhaps most important, there were many skilled artisans in Italy who could execute numerous replicas, enabling sculptors to fill commissions on demand. There are, for example, about thirty versions of Harriet Hosmer's *Puck,* one of which was owned by the Prince of Wales.

The largest collection of neoclassical sculpture ever assembled was exhibited at the Philadelphia Centennial Exposition in 1876. By this date, however, Neoclassicism was no longer a viable stylistic mode for American sculptors. Post–Civil War America, disillusioned with earlier ideals of America as the new Eden and absorbed in rapid industrialization, could no longer sustain a movement in sculpture that focused so resolutely on past models.

The women artists selected for discussion in this book overcame a variety of cultural and institutional obstacles to acquire the skills necessary for a career in the "fine arts," i.e., painting and sculpture. The vast majority of

women did not have that opportunity. But like photographers, women have found outlets for their visual creativity in ways which did not require specialized training. Sewing was one skill that all women have learned since antiquity. In the nineteenth and early twentieth centuries, many American women designed and fabricated quilts pieced from scraps of cloth. Many of these quilts are remarkably beautiful and original creations, worthy of consideration as works of art. These mostly anonymous women created visual images in cloth that demonstrate a high level of sophistication, anticipating some of the developments in twentieth-century abstract painting. The outstanding achievements of America's quiltmakers warns against the validity of maintaining any strict, a priori value distinctions between the fine arts, i.e., painting, sculpture, and architecture, and the "crafts," i.e., all other art forms. Craft objects were often made by women without access or ambition to develop the skills needed for the execution of paintings or sculpture. As we will see in chapter twelve, the art versus craft controversy has been reopened since 1970 with a modern, feminist-inspired appreciation of craft objects such as quilts. Contemporary artists have realized the expressive potential of china plate painting and needlework, for example in Judy Chicago's monumental *Dinner Party,* while the "pattern paintings" of Miriam Schapiro have led to a renewed appreciation for the decorative possibilities of fabric.

SARAH MIRIAM PEALE (1800–1885)

Like Artemisia Gentileschi, Angelica Kauffman, and other women artists discussed in preceding chapters, Sarah Miriam Peale, the daughter of an artist, was in a highly favorable position to develop expertise and talent as a professional portrait painter in Victorian America. Born into an family of outstanding artists, she was among the few women of her era to build her career on the execution of full-sized portraits. The daughter of James Peale, a miniature painter, and niece of the noted artist Charles Wilson Peale, Sarah acquired training in painting both at home and in the studios of her cousins. Her two sisters, Anna Claypoole and Margaretta Angelica, were also noted artists.

Born in Philadelphia, Sarah Miriam first learned the techniques of painting miniatures on ivory from her father. By 1825 she had moved to Baltimore where her cousins Rembrandt and Rubens Peale operated a museum modeled after that of their father, Charles Wilson Peale, in Philadelphia. Sarah Miriam had already learned more sophisticated painting techniques for flesh tones and fabric textures from Rembrandt. For more than twenty years she lived and worked in Baltimore, creating over one hundred full-scale portraits of the socially prominent of that city and the elected representatives of the nation living in nearby Washington, D.C. *The Portrait of Congressman Henry A. Wise* (Figure 34) falls into the latter category. Peale painted this work when Wise

FIGURE 34. SARAH MIRIAM PEALE. *Portrait of Congressman Henry A. Wise.* c. 1842. Oil on canvas. 29½ × 24½″. Virginia Museum of Fine Arts, Richmond. Gift of the Duchesse de Richelieu, in memory of James M. Wise and Julia Wise, 1963.

was a Democratic congressman from Virginia. He would later be elected governor of the state in the years prior to the Civil War, and eventually served as a general in the Confederate army.[3]

This portrait is a characteristic example of Peale's commissioned works. The isolated sitter is presented half–length, in three–quarter position, confronting the viewer directly. Her style is linear, precise, and realistic. The detailed and well–modeled face, set off against the brilliant white shirt and cravat, and the unmodeled black suit forces the viewer inescapably to focus on the features of this handsome man. The barely indicated column on the left, swagged with a dark red drapery, enlivens the otherwise bare background, while the drapery establishes an echoing diagonal to the sitter's left shoulder.

In Baltimore, Sarah Miriam had a very large clientele, but also direct competitors in the portrait market, such as Thomas Sully and John Vanderlyn. Perhaps this explains her eventual relocation to St. Louis in 1847. The city

must have appealed to her, because she remained there for thirty years, returning to Philadelphia to live out her remaining years with her two sisters. A few still life paintings as well as portraits have survived from her years in St. Louis.

Sarah Miriam Peale capitalized on her birthright to develop her talents to pursue a long, productive, and one may assume prosperous career as a professional portrait painter in nineteenth-century America. She was the most accomplished and outstanding woman artist in this field during her era.

LILLY MARTIN SPENCER (1822–1902)

Lilly Martin Spencer was one of America's most important genre painters in the years before and after the Civil War. In the extensive catalogue, published in 1973, for a major exhibition of the artist's works organized at the National Collection of Fine Arts, she is characterized as "this country's most noted mid-nineteenth-century female artist".[4]

Lilly Martin's parents were born in France and arrived in the United States with their young daughter in 1830. Her parents were liberal thinkers, probably affected by French Utopian intellectual movements, and were to be active supporters of reform movements ranging from Abolitionism to women's suffrage. After settling in Ohio, Lilly and her siblings were raised on a farm and educated at home. Her talent for art emerged in her teens, and, accompanied by her father, she traveled to Cincinnati in 1841 to acquire some training in painting. Cincinnati was in these years a thriving, wealthy port city, which supported many portrait painters and an active cultural life. Lilly Martin lived in this city for seven years, studied with several portrait painters and married Benjamin Rush Spencer. Her marriage was productive and prolific. Seven children survived, and more pregnancies were endured by Lilly. Benjamin would eventually abandon any independent career activities to assist in the painting and selling of his wife's works as well as the domestic responsibilities of their household.

Lilly was able to develop her talents to the extent that she exhibited still life and genre paintings at the newly established Western Art Union in Cincinnati. However, chronic poverty plagued the couple. After selling a work to a New York collector and exhibiting a work at the prestigious National Academy of Design, the Spencers decided to move to New York in 1848, seeking the wider opportunities and broader patronage base of the large city. The artist arrived in New York when enthusiasm for Düsseldorf-school genre painting was at its height. Characterized by defined outlines, crisp details, and bright colors, Lilly worked to acquire a personal style of similar precision and realism.[5] Her subjects reflect the tastes for genre of the largely middle-class patronage of the era, which supported the successful careers of such male genre painters as William Sidney Mount. After developing her skills further, her

genre paintings met with wide critical approval. *Peeling Onions* (1852) shows her newly acquired expertise in combining a kitchen genre scene with a realistically rendered still life. Another famous painting, *Fi! Fo! Fum!*, used her own family as subject for an intimate domestic moment of storytelling. During the 1850s and 1860s Spencer exhibited her works along the Eastern Seaboard and gained popularity through the distribution of hand-colored lithographs based on her compositions, printed in France. By 1858, the year the couple moved to a home in Newark, New Jersey, Lilly Martin Spencer had established herself as one of the leading domestic genre painters in America.

Despite these successes, the family, still growing in size, continued to experience financial pressures. The lower cost of living in Newark was surely the main motivation for the move, and the Spencers even planted a vegetable garden for a source of food in lean times.

In the immediate aftermath of the Civil War, Spencer created several

FIGURE 35. LILLY MARTIN SPENCER. *The War Spirit at Home.* 1866. Oil on canvas. 30 × 32¾″. Collection of the Newark Museum. Purchase 1944 Wallace M. Scudder Bequest Fund.

major compositions reflecting this traumatic experience. *The War Spirit at Home* (Figure 35) depicts a fatherless household celebrating Grant's 1863 victory at Vicksburg, as recorded in the *New York Times,* displayed by the mother, a self-portrait, on the far right of the composition. The lighthearted energy of the children, ignorant of the realties of the conflict, is contrasted with the sober expressions of the mother and servant. The sharply focused light, painterly rendering of the mother's dress, and dramatic foreshortening of the infant are all noteworthy formal elements of this image. Spencer's ability to invent a convincing domestic genre subject on such a serious issue as the Civil War demonstrates her talent for thematic innovatation.

Following the War, artistic tastes began to change. The artist attempted to accommodate the new patronage demands and worked on an over-life-sized allegory, *Truth Unveiling Falsehood* (1869). It remained unsold throughout her life, and there is no evidence that it improved her financial situation. This change of direction marks the end of the most fruitful period of the artist's career. Lilly Martin Spencer lived until the age of eighty and died after a morning spent painting an image of a family reunion, convened to celebrate the 100th birthday of her aunt.

THE "WHITE MARMOREAN FLOCK"

In the mid-nineteenth century a group of American women established studios in Rome and created a body of white marble sculpture that was often neo-classical in form and content. These artists were given the name "White Marmorean Flock" by the noted American novelist Henry James, and this belittling appellation is widely used today to identify these sculptors. Harriet Hosmer was one of the first women to settle in Rome, arriving in 1852. In the 1850s and 1860s, Louisa Lander, Emma Stebbins, Anne Whitney, and Edmonia Lewis established neighboring sculpture studios in Italy. These women were attracted to Rome for the same reasons as their male colleagues: the access to the famed statues of antiquity and the abundance of fine marble and of skilled artisans to work it. Furthermore, they also found in Rome an international community of artists who respected their unusual choice of profession. In Italy members of the "Flock" were released from the cultural restrictions imposed on women by Victorian American society. This freedom, combined with inexpensive living costs, made Rome especially attractive to these American sculptors.

Harriet Hosmer (1830–1908)

The best known figure of the White Marmorean Flock is Harriet Hosmer, who initiated her training in America. She studied anatomy at the Saint Louis Medical College, following the same course as Hiram Powers.

FIGURE 36. HARRIET HOSMER. *Beatrice Cenci.* 1853–55. Marble. The Mercantile Library of St. Louis, St. Louis, Missouri.

Hosmer created an impressive image of a heroine in her statue, *Beatrice Cenci* (Figure 36), which has been described as "a moving, expressive figure and one of the most successful reclining sculptures of the Neoclassical movement."[6] Cenci was executed in 1599 for her participation in the murder of her cruel, evil father. This story had inspired a series of works of art beginning in the Baroque era. In the nineteenth century the romantic poet Shelley wrote a verse drama based on the episode that glorified the tyrannicide.

Hosmer's elegant and graceful statue is one of the most beautiful creations by an American neoclassical sculptor. The soft folds of drapery and the sensuality of her exposed body are contrasted with the hard stone slab upon which Beatrice Cenci reclines. The drapery folds are fluid and Cenci's face conveys an idealized prettiness that will be contrasted with Zenobia's heavier, more classical features. The gentle arch of the figure's body creates a pleasant and active contour. Hosmer depicts Beatrice Cenci asleep, but her sleep implies her impending doom.

Hosmer's most famous statue is *Zenobia in Chains* (Figure 37), depicting the queen of Palmyra who was marched in chains through the streets of Rome following the defeat of her army in 272 A.D. Hosmer does not present Zenobia as a powerful warrior who, according to the historian Gibbon, conquered Egypt and parts of Asia Minor, but rather as a noble captive who accepts her defeat with dignity and reserve. Like Cornelia, Zenobia was a woman of

FIGURE 37. HARRIET HOSMER. *Zenobia in Chains.* 1859. Marble. H.: 49″. Courtesy Wadsworth Atheneum, Hartford.

outstanding talents and abilities whose reputation survived through history and made her a female role model from the classical past.

Hosmer's conception of Zenobia is dependent on the written account of this legendary figure by Anna Jameson, a noted English authority on art and a vocal advocate of women's rights. Hosmer apparently consulted with Jameson during the genesis of the statue. Thus Hosmer's *Zenobia* was clearly and self-consciously developed as a role model of courage and wisdom for contemporary women, challenging prevailing Victorian ideals of femininity. The original statue was a monumentally scaled seven feet tall. The drapery was derived from the authoritative classical model of the Golden Age *Athena Giustinini* and the crown inspired by the *Baberini Juno.*[7]

A comparison of Hosmer's *Zenobia* with Powers's *The Greek Slave* (Figure 38) reveals important differences in attitude toward the portrayal of the female image that existed between two artists of the same neoclassical movement, one a man, the other a woman. Powers made *The Greek Slave*'s nudity acceptable to prudish Victorian American society by the literary references surrounding the work. On one level, the figure was meant to evoke pity rather

FIGURE 38. HIRAM POWERS. *The Greek Slave.* 1847. Marble. H.: 65½". Gift of Franklin Murphy, Jr., 1926. Photographer: Armen, February 1972. Collection of the Newark Museum.

than lust, since she has been captured by the Turks during the Greek War of Independence. She is naked because she is about to be sold into slavery. But this motif was merely a respectable pretext because the statue is clearly designed to titillate the Victorian male viewer, and the chains emphasize the captive's passivity and vulnerability. By contrast, Zenobia, although chained, is clothed and retains her dignity and integrity as a woman. In this work, Hosmer provided an alternative to the sexual objectification of women so evident in *The Greek Slave* and chose, instead, to depict an individual woman of antiquity, worthy of deep respect and admiration on a number of levels.

Edmonia Lewis (1843–1900)

One of the most interesting artists in the "Flock" was Edmonia Lewis, who was half black and half Indian. The subjects of her sculpture reflect her racial heritage. In 1867, as a monument to the recent emancipation of the American slaves, Lewis created a two-figure group, *Forever Free*. The white marble sculpture presents a black woman kneeling in a gesture of prayer beside a standing black man who displays his broken chains.

Lewis was raised as a Chippewa Indian. *Old Indian Arrowmaker and His Daughter* (Figure 39) is one example of her ability to create sculptural images of Indians of great dignity and symbolic force. This work contains some very realistic details. Object textures of the fur garments are articulated, and the Old Arrowmaker has a sharply defined face with prominent cheekbones. He holds a flint and stone, while his daughter plaits a mat. This work is one of several created by Lewis that were directly inspired by Longfellow's famous poem "The Song of Hiawatha," and thus we can identify the daughter as Minnehaha. The slain deer could be the one killed by Hiawatha, and implying his presence. In this sculpture Lewis has developed an original and expressive symbol of generational transmission and preservation of unique cultural values.[8]

The achievements of the sculptors of the *"Marmorean Flock"* were widely recognized in their era, and many of these women received commissions for monumental works to be placed outdoors. Although in retrospect their works may seem stylistically conservative, this should not affect our appreciation of the historical position and achievement of these artists. Their statues were highly regarded in their day and were extremely popular. The works of the

FIGURE 39. EDMONIA LEWIS. *Old Indian Arrowmaker and His Daughter.* 1872. George Washington Carver Museum, Tuskegee Institute.

"Flock" embodied an idealism and optimism that reflected American aspirations and expectations of the mid-nineteenth century. The critical success and widespread recognition of this group is significant not only historically but also because it set a precedent for the many important women sculptors of the twentieth century.

AMERICAN PIECED QUILTS

Sewing has always been an occupation associated with women. But sewn objects, except for the works of medieval embroidery discussed in chapter two, usually do not have a place in the history of art. However, during the nineteenth century in America, the design and fabrication of quilts, pieced together from leftover bits of cloth, produced many works of extreme complexity and sophistication. One such example is the anonymous quilt created with the pattern known as "Log Cabin, Barn Raising" (Figure 40).

Unlike many Victorian designs for objects of daily use, quilts are made with geometric shapes because straight edges are the easiest to sew together.

FIGURE 40. *"Log Cabin, Barn Raising" Quilt.* Dechert Price & Rhoads, Philadelphia, PA.

From the scraps of fabric left over from clothing, square units of uniform size were stitched together. These individual squares were then arranged to form the overall design of the quilt. Some quilts used identical blocks creating a repeating pattern, while others, such as the example illustrated here, used differing blocks. The cutting of each piece to be fitted into the patchwork quilt had to be extremely accurate so the blocks would fit together precisely.

This "Log Cabin, Barn Raising" quilt employs a broad sampling of late nineteenth-century cotton calico fabrics. Most are printed in small, closely spaced patterns popular at this time. The lighter tones are mostly from fabrics used for men's shirts. After cutting, the bits of fabric were sewn into the basic unit, known as the "Log Cabin." Each individual square or block contains strips of fabric usually cut into right angles or pieced into this shape from smaller scraps. The sections of fabric fit together into a telescoping pattern until there is a small square in the center. Each of the units is divided diagonally into a dark and a light-toned triangle. The individual blocks are then assembled so that the light-dark modulations create an overall pattern of diamonds called the "Barn Raising." The term is derived from the resemblance of the pattern to the sections of a barn wall laid flat on the ground before it is built. Thus, the main design elements of this quilt are abstracted from vernacular architecture. One may even see the corner blocks as the "cornerstones" of the quilt.

Despite these references to architecture, the quilt functions visually as a two-dimensional "painting." The patterns of the fabric emphasize the flat surface of the quilt. The light-dark transitions are carefully modulated to avoid a forceful effect of movement forward and backward in space. The color scheme is dominated by cool blues, greens, and earth tones. The border is a dark midnight blue. The combinations of different fabrics indicate a refined sensitivity to color.

Once the top layer of the quilt was stitched together, it was joined to a solid backing, and a filler of cotton or wool was sandwiched in-between. The three layers were joined by the quilting technique itself. This final quilting was often accomplished at a social gathering known as a "quilting bee." Quilting bees were a valid pretext for a party, breaking the often oppressive isolation of rural life.

Quilts served a very practical function at home. They covered beds and kept the sleeper warm. However, quilts were also a conspicuous demonstration of the skills of their creators. Pride, care, and effort were lavished on them. Long after the invention of the sewing machine, quilts were sewn by hand. Women made quilts as part of their dowry and mothers made a quilt for each child. The creation of quilts was intertwined with the cycle of women's lives.

From the perspective of the twentieth century, we are prepared to appreciate these quilts with their geometric designs as works of art in their own

right. The anonymous creator of this quilt did not possess the specialized training available to the painters discussed in this chapter. She used a readily available and economical technique, i.e., sewing bits of leftover fabric, as the means to create a beautiful, abstract image that expresses an individual visual sensibility.

9

PAINTERS IN FRANCE:
1850–1900

During the second half of the nineteenth century, more and more women in Europe became practicing professional artists. One explanation for this phenomenon was the acknowledged surplus of unmarried women among the bourgeoisie. A career in the arts, like teaching, was one of the few acceptable means for a middle-class spinster to earn her living. These women were active in both the fine arts of painting and sculpture (to a lesser degree), as well as in the crafts traditionally associated with women, such as embroidery, lacemaking, china painting, and book illustration.

Another reason more women turned to art was the increased access to training, in public and private schools and artists' studios, during the nineteenth century, although women's art education still remained discriminatory. The implementation of Labille-Guiard's idea (see page 89) occurred in 1805, when the first free drawing school for women was founded in Paris. In 1849, after the death of her father, **Rosa Bonheur** assumed the directorship of this school. By 1879 there were twenty such schools in Paris solely designed to train women for positions in the art industries, although such jobs were scarce and underpaid. In the first half of the nineteenth century, women could also study privately in the studios of established artists. During the 1870s there was a separate women's class at alternative schools such as the Académie Julian in Paris, where women worked with a model. In 1896 the most prestigious art academy of France, the Ecole des Beaux-Arts, officially admitted women, thus removing the most obvious institutional barrier to equality of artistic training. This feminist victory was achieved only after seven years of sustained political pressure by the Union des Femmes Peintres et Sculpteurs, the first professional organization of women artists in France.[1]

In Germany an equivalent group, the Verein der Kunstlerinnen, had been founded in 1869. This society established separate schools in Berlin and Munich to train women artists. As late as the 1890s, women were still not permitted to study at the state-sponsored art academies in Germany or Austria. The Royal Academy in London admitted its first woman in 1861, but a life drawing class was not provided for women until 1893.

Of the four artists to be discussed in this chapter, only Rosa Bonheur was the daughter of an artist. **Berthe Morisot, Mary Cassatt, and Paula Modersohn-Becker** all benefited directly from the increased access to professional artistic training that became available, at least for middle-class women, in the second half of the nineteenth century. Only two of these four artists were actually born in France. Both the American Cassatt and the German Modersohn-Becker developed their historically significant styles in Paris in direct contact with the French avant-garde.

Rosa Bonheur painted images of animals in naturalistic landscapes with scientific accuracy and a fidelity to direct observation characteristic of the movement known as Realism. The Realists "sought to revitalize the centuries-old artistic tradition of accurate, truthful recording of the world and to give this tradition contemporary relevance."[2] Unlike Courbet or Millet, also associated with this movement, Bonheur virtually eliminated the human figure from her art, preferring to concentrate on subjects from the animal world. Thus, her brand of Realism was more acceptable to the conservative government of the Second Empire and her official rewards greater than her more widely recognized male contemporaries.

Although a few women artists had been stylistically innovative in the past, Impressionism is the first avant-garde movement in the history of art in which women were significant members. Both Berthe Morisot and Mary Cassatt exhibited with the group and maintained strong personal and professional ties with the male Impressionist painters. However, despite the close association of Cassatt with Degas and Morisot with Manet and Renoir, each of these women developed an individual and original painting style that was certainly equal in quality to that of their more famous male colleagues.

Like the Norwegian Edvard Munch, the Spaniard Pablo Picasso, and the American Mary Cassatt, Paula Modersohn-Becker was a non-French artist whose career was decisively influenced by exposure to the Parisian avant-garde at a formative phase in her development. Modersohn-Becker was the first artist from Germany to evolve a personal post-Impressionist style based on a synthesis of German and French influences. She created images that are symbols of the enduring life force of the human race.

ROSA BONHEUR (1822–1899)

Rosa Bonheur was one of the most famous and popular French painters of her epoch. She devoted her entire career to painting animals, both domesticated

and wild, in outdoor settings. Her style was based on a complete dedication to precise observation and the thorough study of animal anatomy characteristic of Realism. Many Romantic artists, such as Eugène Delacroix, Antoine-Louis Barye, and George Stubbs, chose to depict violent attacks of predatory animals when they selected subjects from the animal realm. Bonheur, by contrast, avoided bloody encounters between animals, preferring more peaceful situations that she could observe directly. Her innovative animal subjects, depicted with naturalism of detail, were greatly appreciated by her contemporaries. Numerous engravings, after her compositions, were circulated in Europe and America, ensuring her widespread popularity and fame. One indication of this success is her absence from the Salons. After 1853 she did not exhibit her paintings in those large exhibitions. She was able to maintain her financial independence from the proceeds of private sales and the income produced from engravings of her compositions.

Bonheur has the distinction of being the first woman artist to be honored with the highest award of the French government, the Cross of the Legion of Honor. The empress of France presented the medal to Bonheur in her studio in 1865.

Born in Bordeaux, Bonheur received her initial training, along with the other children of the family, from her father. All four Bonheur siblings became competent *animaliers,* i.e., artists who specialized in animal subjects. She is the first woman artist in the nineteenth century whose upbringing was directly affected by the beliefs of the utopian philosophical movement known as St. Simonianism. Bonheur's father, Raymond, was an active member of the St. Simonians, who believed that both women and artists had special roles to play in the creation of the future perfect society. The St. Simonians prayed to "God, Father and Mother of us all."

While women gained a much higher status in this ideal, utopian community, it was assumed that the leaders of the group would be male. One can understand Raymond Bonheur's attraction to St. Simonianism since male artists were given an important leadership role: "It was taught that the religious side of the sect would be directed by the man of the most artistic nature, who would be the supreme priest."[3] Armed from childhood with a belief in the innate superiority and religious mission of both women and artists to transform society, Bonheur developed her talents to the fullest extent possible. Her dedication to her art was total and unequivocal.

Bonheur regularly proclaimed the superiority of the female sex. Late in her life, she told her biographer:

> Why would I not be proud to be a woman? My father . . . told me many times that the mission of women was to elevate the human race, to be the Messiah of future centuries. I owe to these doctrines the great and proud ambition I maintain for the sex to which I have the honor to belong. . . . I am certain that to us belongs the future. . . . [4]

The deep emotional attachments of her life were only with other women. Bonheur never married, but lived for over forty years with a female companion, Natalie Micas. However, while Bonheur idealized women, she regularly wore male clothing, usually identified with the masculine point of view, and often referred to herself in masculine terms, such as "brother."[5] As Albert Boime has so perceptively noted, Bonheur's beliefs and lifestyle were an expression of revolt against the rigid polarizations of gender roles in her society. In place of the stereotypical male and female roles defined by her culture, she substituted a belief in an ideal androgyne, symbolizing a mystical union of the sexes. This revolt against social mores was paired with political views which were quite conservative. Bonheur's subjects were more acceptable to the Second Empire than the more overtly leftist political images of Courbet or Millet.

On many levels, Bonheur rejected her own society in favor of the animal kingdom, which she valued higher than that developed by mankind. Bonheur did not percieve a clear-cut separation between the animal and the human realms. She believed in metempsychosis, the migration of souls into animal forms. Thus, she could easily identify with animals and even referred to herself, on occasion, as an animal. Like the blurring of sexually defined characteristics, the blurring of distinctions between the animal and human worlds formed a fundamental part of her intellectual makeup. Although Bonheur acquired the rudimentary principles of painting from her father, the true basis upon which she built her images came from her studies of animals.

A Realist urge toward accuracy is clearly apparent in Bonheur's masterpiece *The Horse Fair* (Figure 41). This large painting (over 16 feet wide) won immediate critical and popular acclaim for its creator, firmly establishing her reputation. It attracted large crowds when it was displayed in France, England, and America. Widely reproduced in engravings, this work became one of the most famous paintings of the nineteenth century. Bonheur said that *The Horse Fair* was originally inspired by the frieze of horsemen on the Parthenon. The even distribution of the horses across the picture surface and the processional movement from left to right do recall the Parthenon frieze. One can even see an echo of a Parthenon horseman in the man with an upraised arm, riding the rearing black horse in the center of the composition. However, instead of the classical restraint, simplicity, and slowly measured pace of the Parthenon frieze, Bonheur has presented an image of forceful energy, in which men and horses strain against one another. Another interesting comparison may be made with a painting by Theodore Gericault, whom she admired. Bonheur manages to endow her image with the same romantic spirit and energy that Gericault gave both his horse and rider in *Mounted Officer of the Imperial Guard* (1812).

In actuality, *The Horse Fair* is also the result of a conscientious study of horses at a market that was located on the outskirts of Paris. She obtained official permission in 1852 to wear men's clothing so she could move about with freedom to study animal anatomy in the slaughterhouses of Paris or in the

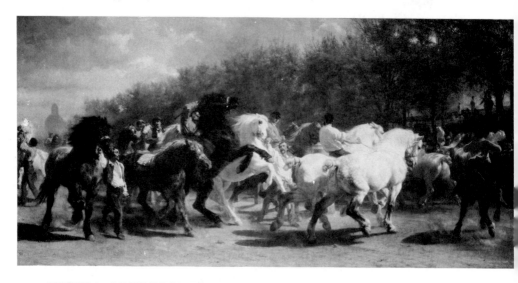

FIGURE 41. MARIE ROSA BONHEUR. *The Horse Fair.* Oil on canvas. H.: 96¼″, W.: 199½″. Signed and dated lower right Rosa Bonheur 1853–5. The Metropolitan Museum of Art, Gift of Cornelius Vanderbilt, 1887. All rights reserved, The Metropolitan Museum of Art.

markets where live animals were sold. Both the realism of details, the large scale, and the unified composition contribute to the powerful impression the work makes on the viewer. Bonheur has designed an unprecedented scene of great excitement, vividly portrayed, which places the viewer in the midst of the action as the horses are displayed in a circle. Her beliefs in the superiority of animals is evident in this composition by the dominant role played by the horses. In comparison, the humans look puny and insignificant.

After 1860 Bonheur lived with Natalie Micas in relative isolation near Fontainebleau, where she continuously studied the natural beauty of the forest and surrounding farms. On the extensive grounds of her chateau, she kept a personal menagerie to permit her to observe a variety of animals.

Bonheur remained faithful to her form of Realism throughout her life, keeping her vision fresh and direct in all her works. Her intense powers of observation and her humility before the wonders of nature impressed her contemporaries, who frequently compared her art to the Dutch painters of the seventeenth century who set the standards for realistic description.

BERTHE MORISOT (1841–1895)

Although increasing numbers of women artists employed conservative paint-ing styles in the nineteenth century, Berthe Morisot has the distinction of

having been one of the founding members of the avant-garde group known as the Impressionists. Like the other members of the group, Morisot devoted her career to the creation of images that depict, with elegance and spontaneity, intimate scenes from daily life. Often using her family as models, Morisot's paintings permit the viewer to enter a closed domestic realm populated mainly by women and children.

Morisot's art is characterized by delicate brushwork and elegant colors, juxtaposed in subtle harmonies. These "feminine" qualities of her paintings were regularly noted by critics evaluating her works but are actually stylistic elements also found in the paintings of her male Impressionist colleagues. Both technically and thematically, Morisot belongs with the Impressionists. Her exhibition strategy was the same as that of Renoir, Monet, Degas, or Pisarro, because she also avoided the official Salon and submitted her works only to the private group shows held between 1874 and 1886.

There was little in her background to predispose her to the life of a dedicated avant-garde artist. Morisot was born in Bourges into an upper-middle-class family. When she was seven, the family moved to Paris. She and her sister, Edma, were given drawing lessons at an early age. Both sisters showed greater dedication to their art than was expected from or appropriate for women of their class. One of their teachers, Joseph Alexandre Guichard, warned Mme. Morisot:

> Considering the characters of your daughters, my teaching will not endow them with minor drawing room accomplishments; they will become painters. Do you realize what this means? In the upper class milieu to which you belong, this will be revolutionary. I might almost say catastrophic. Are you sure that you will not come to curse the day when art, having gained admission to your home, now so respectable and peaceful, will become the sole arbiter of the fate of two of your children?[6]

In 1861 the Morisot sisters met Camille Corot, who became their mentor for the next five years. Berthe Morisot's early paintings reveal Corot's influence in the rendition of effects of early morning light and in the closely toned color harmonies in her landscapes.

In 1868 Morisot met Edouard Manet and, through him, most of the members of the Impressionist group. Morisot encouraged Manet to take up painting outdoors. In 1874 she married his younger brother Eugène Manet. Although Edma stopped painting after her marriage, Berthe pursued her career throughout her lifetime, with only a brief interruption for the birth of her daughter.

The Cradle (Figure 42), a beautiful and characteristic example of Morisot's Impressionist style, depicts her sister, Edma, gazing tenderly at her newborn child. This is an intimate, domestic moment that turns the viewer into either a member of the family circle or an interloper.

Unlike Bonheur, Morisot did not outwardly rebel against the social

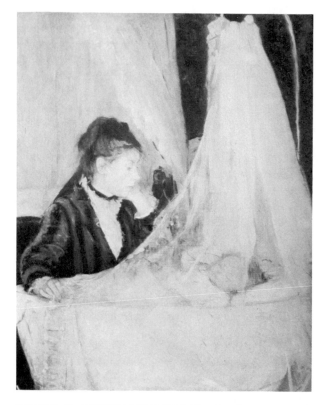

FIGURE 42. BERTHE MORISOT. *The Cradle.* 1872. 22½
× 18½". Musée d'Orsay, Galerie du Jeu de Paume, Paris.

mores of her epoch. She accepted the importance her culture placed on mater-
nity for women. In some paintings, such as *The Cradle,* Morisot brings a
sensitivity to the intensity of maternal love that derives from her gender identi-
fication with her sister. Formally, the image is a beautiful study in tonalities.
The translucent, pearly-gray of the fabric covering the cradle is highlighted
with a few touches of pink. The drapery covering the window is suffused with
a blue hue indicating filtered daylight. The overall touch is quite painterly and
the baby is indicated with the barest economy.

During the 1880s Morisot's brushwork took on even greater fluidity and
rapidity. She often used her daughter Julie as a model, but in *Little Girl Reading*
(Figure 43) she employed a model with a striking resemblance to her
daughter. This simple, contemplative theme is contrasted with the energy of
the paint application and the vivid saturation of the colors. The selection of
colors is designed for the most vibrant effect, with the repeated juxtaposition
of complementary tones. The model's red hair is set off against the comple-
mentary green palm fronds that arch above her, echoing the shape of her bent

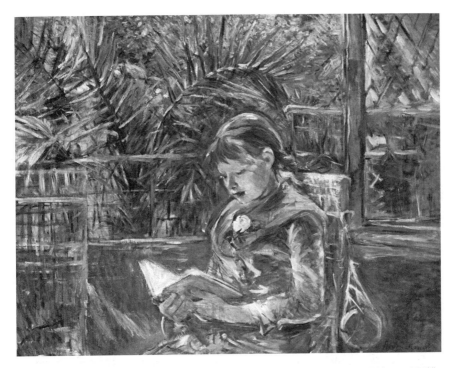

FIGURE 43. BERTHE MORISOT. *Reading.* 1888. Oil on canvas. 29¼ × 36½".
Museum of Fine Arts, St. Petersburg, Florida. Gift of the Friends of Art in memory of
Margaret Acheson Stuart.

head. The marvelous and expressive impasto brushwork reveals an artist in full control of her means.

As Charles Stuckey has noted, the surface is integrated through the latticelike patterns of wicker chair, palm fronds, and trellises, creating a linear mesh that interlocks the sitter and her environment.[7] A further integration of figure and ground may be noted in the faint reflection of the back of the reader in the window. Griselda Pollock has termed such highly compressed pictorial environments, so prevalent in the compositions of both Morisot and Cassatt, as "the spaces of femininity." She argues convincingly for an interpretation of such shallow picture spaces as a comment on the restricted sphere of movement permitted women of this class in nineteenth century France.[8] Several paintings by Toulouse-Lautrecs reveal the impact of Morisot's image. Whistler also was impressed with Morisot's recent works shown in May 1888, at Durand Ruel's.[9]

As a full-fledged member of the Impressionist group, Berthe Morisot occupies a secure position in the history of art. United by common interests with the Impressionists, Morisot developed a personal style of originality, fluidity, and delicacy. Along with her male colleagues and Cassatt, these artists

valued the private women's world of home and family and created pleasantly delightful images of beauty and elegance.

MARY CASSATT (1844–1926)

Like Berthe Morisot, Mary Cassatt was an active and loyal member of the Impressionist group. Born in Pittsburgh into an upper-middle-class family similar in status to Morisot's, Cassatt also possessed the personal strength and force of her convictions to pursue a career as an avant-garde painter, eschewing official recognition and juried competitions. Stimulated by the exciting environment of Paris, Cassatt became, in the view of many scholars, the best American artist, male or female, of her generation.

Cassatt overrode her family's initial resistance to her early decision to become an artist. In 1861 she entered the Pennsylvania Academy of Fine Arts, one of the first art academies in the world to open its doors to women. After four years of study there, she recognized the limitations that America imposed on artists. Like the women of the "White Marmorean Flock" and many male artists of her generation, she traveled to Europe in the late 1860s to study the old masters. After 1872 she settled permanently in Paris and pursued her artistic training. Here her sister Lydia and her parents joined her in 1877. Although she became most famous for her paintings of mothers and children, Cassatt never married. She continued to paint until the age of 70 when her eyesight began to fail. Her achievement was recognized, relatively late in her life, by the award of the medal of the French Legion of Honor in 1904.

Cassatt possessed a brilliant instinct for determining what the history of art has deemed most important in the confusingly active art world of Paris. She told her biographer that, by the late 1870s, when Degas invited her to participate in the Impressionist exhibitions, "I had already recognized who were my true masters. I admired Manet, Courbet and Degas. I hated conventional art. I began to live."[10] Cassatt learned from these artists without losing her individuality and personal style.

In the late 1870s and 1880s, Cassatt's works reflect the influence of Impressionism. *Lydia in the Loge* (Figure 44), a painting of the artist's sister, was exhibited in the fourth Impressionist exhibition of 1879 and is characteristic of Impressionism in a number of ways. Degas and Renoir had previously painted women at the opera, so the subject is typical of the Impressionists' taste for scenes of the amusements of Parisian life. The relaxed asymmetrical pose of the sitter, with one arm cropped by the picture frame, is also a typical Impressionist device. Degas would often "cut" his figures to convey a sense of immediacy, almost like a snapshot photo. In this painting, Cassatt was extremely interested in the effects of artificial light on flesh tones. Like Degas's studies of ballerinas on the stage, also illuminated by artificial gas lights, Lydia's face and shoulders are unnaturally radiant. Despite these glowing ef-

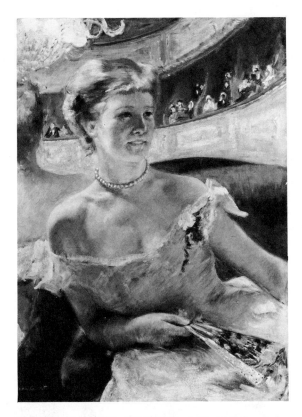

FIGURE 44. MARY CASSATT. *Lydia in the Loge.*
1879. Oil on canvas. 31⅝ × 23″. Philadelphia Museum
of Art: Bequest of Charles Dorrance Wright (1978-1-5).

fects of artificial light, the figure is firmly modeled and her contours are well
defined. Brushstrokes are evident in Lydia's dress, fan, and the reflected back-
ground. The spontaneity of Cassatt's touch is another element that connects
her style with Impressionism. *Lydia in the Loge* is painted with a sophisticated
and original color sensibility. The pink dress is beautifully contrasted with the
ruby-red banquette. The colors shimmer and sparkle in the gas light of the
theater at intermission. An innovative aspect of this work is the use of a
mirrored background. This device conveys a reflection of the space, in which
the viewer must also sit, without creating an actual illusion or description of
deep space. Thus, the picture includes an image of the environment of the
opera without violating the flat two-dimensionality of the picture surface.
Cassatt's use of a mirrored background anticipates Manet's similar use of a
mirror in his famous work *The Bar at the Folies-Bergères* (1881–82).

Beginning in the late 1880s, the works of Cassatt and many other Im-
pressionists demonstrate a renewed concern with the clear articulation of

forms. Obvious brushstrokes are eliminated, colors become more highly saturated and less naturalistic, and compositions develop greater structure. These post-Impressionist qualities are all clearly apparent in one of Cassatt's largest and most ambitious paintings, *The Boating Party* (Figure 45). In this work, Cassatt used one of her favorite subjects, a mother and child united physically in a relaxed and seemingly unposed manner, with a powerful and original composition. This work was probably inspired by Manet's *Boating* (Figure 46). Cassatt admired this painting and was instrumental in its purchase by her friends, Henry O. and Louisine Elder Havemeyer. However, Cassatt has transformed Manet's Impressionist work into a forceful post-Impressionist masterpiece.

While Manet positions his boat at a 45-degree angle to the picture surface, Cassatt aggressively foreshortens her boat so the viewer is thrust into the opposite end of the craft. Furthermore, there is no precedent in Manet's painting for the strong linear contours that subdivide the composition.

The Boating Party is carefully constructed to focus attention on the baby. Strong diagonal lines of the oar, the man's left arm, and the triangular sail all point to the child. The shadow bisecting the baby's face continues the bright white contour of the prow of the boat, as well as connecting the line formed by the upper edge of the sail, the rope, and the right edge of the prow. Cassatt's

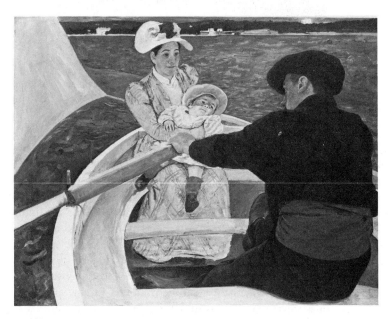

FIGURE 45. MARY CASSATT. *The Boating Party.* Canvas. 35½ × 46⅛″ (0.92 × 1.171). 1893–1894. National Gallery of Art, Washington. Chester Dale Collection.

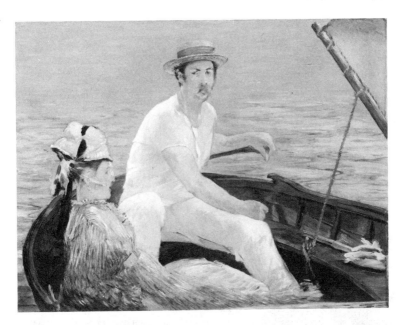

FIGURE 46. EDOUARD MANET. *Boating.* Oil on cavas. 38¼ × 51¼″ (97.2 × 130.2 cm). Signed (lower right): Manet 1874. The Metropolitan Museum of Art, Bequest of Mrs. H. O. Havemeyer, 1929. The H. O. Havemeyer Collection. (29.100.115)

use of color is equally original. The juxtaposition of the bright yellow in the interior of the boat with the man's navy blue costume, all silhouetted against a highly saturated royal blue expanse of water, is both dramatic and effective in focusing the viewer's attention onto the canvas. By contrast, Manet's colors are much less intense, bleached by the sunlight in the more naturalistic manner of typical Impressionism.

Like her friend Degas, Cassatt was an ardent admirer of Japanese woodblock prints. The elevated viewpoint, high horizon line, and bright areas of relatively unmodeled color in *The Boating Party* are all elements derived from Japanese prints. For this painting, Cassatt utilized her recent experience in the creation of one of the murals for the Woman's Building at the Chicago World's Fair of 1893. The large scale, bright colors, and clearly defined, simplified contours of this painting are effective if the work is viewed from a distance. This mural, which has not survived, depicted an allegorical representation of *The Modern Woman.*

Cassatt also made an important contribution to the history of printmaking. In 1891, inspired by an exhibition of Japanese woodblock prints, she created a series of ten prints using an unprecedented technique. *The Fitting* (Figure 47) was created with a combination of etching and engraving tech-

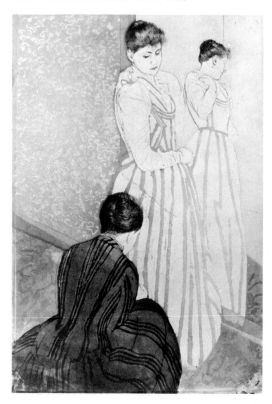

FIGURE 47. MARY CASSATT. *The Fitting.* 1891. Drypoint, soft-ground and aquatint. 14¾ × 10⅛″. The Carnegie Museum of Art, Pittsburgh; Museum Purchase, 1919.

niques for the lines. Cassatt applied the beautiful and subtle earth-toned inks directly to the copper plate for each print. Each image is executed with the strictest economy of lines. This is particularly evident in the crouching figure of the seamstress. In *The Fitting,* the use of a mirror introduces a formal element of spatial complexity similar to the mirrored background in *Lydia in the Loge.* The image in the mirror is even more simplified than the "real" woman standing in the room.

Mary Cassatt possessed both superb technical skills and great talent. Her dedication and devotion to the highest standards for her art helped her overcome the "handicap" of being a woman. As an American in Paris, at a time when Paris was the center of the art world, she absorbed the best innovations in her contemporary world of painting. Cassatt developed an independent style based on precise draftsmanship, refined color sensibility, and a gift for creative compositions.

PAULA MODERSOHN-BECKER (1876–1907)

Before her premature death at the age of thirty-one, Paula Modersohn–Becker developed an innovative personal style based on a synthesis of French Post-

Impressionism and native German art forms. Her mature paintings, which include some recognized masterpieces, reveal a talented and original artist whose works bear comparison with the best paintings of her European contemporaries in the post-Impressionist era.

Paula Becker was born in Dresden, Germany, into a cultured, upper-middle-class family. She first became interested in becoming an artist when, at age sixteen, she was given art lessons as part of her finishing school education. Visiting wealthy relatives in London, she attended St. John's Wood School of Art, which prepared students for admission to the Royal Academy. Overcoming her parents's resistance, in 1896 she enrolled in Berlin in the art school for women run by the Verein der Kunstlerinnen. Käthe Kollwitz had studied at this school nine years earlier.

After two years of this traditional instruction, Becker moved to the artists' colony located in Worpswede, a small village in northern Germany. The Worpswede artists, such as Fritz Mackensen and Otto Modersohn, used the local peasants and the bleak landscape as subjects and painted with a dark earth-toned, naturalistic palette. Becker studied with Mackensen, and, at first, she adopted the realistic style of this painter.

On New Year's Eve, 1900, Becker left Worpswede for Paris. This was her first visit to the world's art capital. Over the next seven years, Becker spent long periods in Paris, where she acquired more art training and absorbed the latest developments in French avant-garde painting. Becker joined many other women artists who were studying art in Paris at the turn of the century. She worked at the Académie Colarossi where, for a small fee, an aspiring artist could paint or draw from the live model and receive some criticism from established masters. Becker also benefited from the recent opening of classes to women at the Ecole des Beaux-Arts.

Returning to Worpswede, Becker married the recently widowed Otto Modersohn in 1901. Even after marriage, Modersohn-Becker continued to make independent journeys to Paris. In 1903, 1905, and during a prolonged stay from February 1906 to April 1907, she abandoned the style of Worpswede naturalism for an avant-garde method that attained a greatly simplified monumentality.

Poorhouse Woman with a Glass Bowl (Figure 48) is both a portrait of a specific Worpswede woman, "Mother" Schroder, and a symbol of the stoical endurance of the peasants. Becker had drawn this old woman many times in the Worpswede poorhouse, an institution that sheltered destitute peasants during the winter.

Like the surrounding flowers that also decorate her skirt, this "Poorhouse Woman" survives each winter to work the soil with her enormous hands every spring. Flowers often symbolize the transience of life and the inevitability of death. In this work, however, the flowers may be seen as symbols of nature's cycle of perennial renewal. The shape of the glass bowl echoes Mother Schroder's ample form and flattened head. Both the woman and the bowl seem to grow directly from the earth.

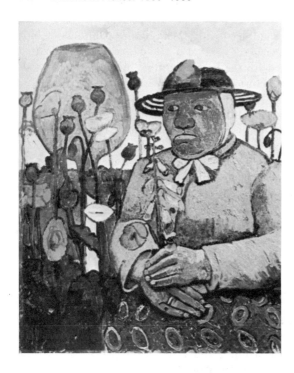

FIGURE 48. PAULA MODERSOHN-BECKER. *Poorhouse Woman with a Glass Bowl.* 1906. Oil on canvas. 96 × 80.2 cm. Ludwig-Roselius Sammlung, Böttcherstrasse, Bremen. Private collection.

Becker's use of simplified shapes, heavily outlined contours, and highly saturated colors all reveal the influence of Gauguin's Synthetism and Van Gogh's mature style. Like them, Becker's ability to create a nondescriptive image was based on careful study of natural phenomena. In 1903 she defined the goal for her art in the following way: "Generally through the most intimate observation to aspire to the greatest simplicity."[11] *Poorhouse Woman with a Glass Bowl* demonstrates Becker's ability to combine naturalistic observation and the stylistic innovations of the French avant-garde for the expression of a personal iconography.

Like Cassatt and Kollwitz, Becker also found the theme of the mother and child a continuously stimulating subject. *Kneeling Mother and Child* (Figure 49) is one of her most powerful and monumental versions of this theme. The figure is painted with thick, visible brushstrokes that assert the two-dimensional surface of the canvas and also firmly model the form. The enormous scale of the woman and her kneeling position on the isolation of the white cloth convey a sense of religious awe at woman's ability to create life and nourish an infant. The circle of fruits and the framing plants relate this modern "madonna" to the productivity of the earth itself. Her generalized features reinforce one's impression that this image is an icon dedicated to an Earth Mother who symbolizes female fertility.

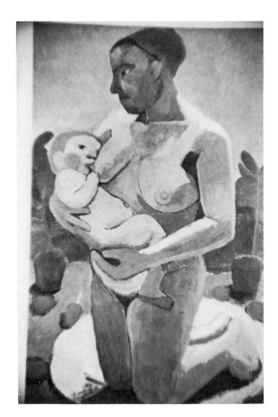

FIGURE 49. PAULA MODERSOHN-BECKER. *Kneeling Mother and Child.* 1907. Oil on canvas. 113 × 74 cm. Ludwig-Roselius Samm-lung, Böttcherstrasse, Bremen. Private collection.

In this painting Becker has created an image that is outside any historical framework, an impersonal archetype of fertility. As opposed to Cassatt's mothers and children, which are always portraits, or Kollwitz's mothers, who are forces for political change, Becker emphasizes the biology of creation. It is important to appreciate the different messages these images communicate. Women artists often approach the specifically female experience of maternity as well as every other subject in distinctive ways. Factors such as nationality, political views, and family background influence the outlook and philosophy of an artist at least as much as, and perhaps more than, the artist's sex. Becker's *Kneeling Mother and Child* is related more closely to Gauguin's paintings of Tahitians than to the works of Cassatt or Kollwitz.

Otto Modersohn followed his wife to Paris in 1906. She became preg-nant and returned with him to Worpswede in 1907. It is possible that Becker was already pregnant when she painted *Kneeling Mother and Child*. She died three weeks after giving birth to a daughter, tragically ending a career that had just reached maturity. Nevertheless, she had lived long enough to create a

group of paintings of great artistic power and originality. As the first German artist to forge an original style that incorporated the innovations of French painting from the 1890s, her importance within the European Post-Impressionist avant-garde is firmly established.

10

EARLY TWENTIETH-CENTURY ARTISTS

Between 1900 and 1940 the pace of change in the art world, as in Western culture as a whole, accelerated dramatically compared with preceding centuries. A multiplicity of avant-garde movements altered the appearances and premises of painting more radically than in any period since the Renaissance. As women gained access to educational facilities, more and more women became professional artists in the twentieth century. Many elements of discrimination that had excluded women from participation in the fine arts in earlier epochs were no longer operative. Therefore, it is not surprising to find that women have participated not individually, but in groups, in almost every major avant-garde movement of the modern era.

Prior to World War I a number of talented German artists focused their energies on the expression of a range of strong passions, using exaggerated, nonnaturalistic formal means. **Käthe Kollwitz** was an expressionist who remained unaffiliated with any group movement. She created impressive works of art in the graphic media and in sculpture. Although nine years older than Modersohn-Becker, Kollwitz's expressionist style, which often reflected socialist political beliefs, is more directly related to early twentieth-century developments in German art than to late nineteenth-century post-Impressionism. For this reason, she is discussed in this chapter.

Between 1910 and 1920 a group of Russian artists, about half of whom were women, developed an abstract vocabulary based on geometric shapes for the creation of works of art that appear extremely modern even today. Under the initial impact of Cubism, the Russian avant-garde movements of Suprematism and Constructivism radically simplified the appearance of paintings. In collaboration with their male colleagues, Kasimir Malevich, Mikhail

Larionov, and Vladimir Tatlin, women such as **Natalia Goncharova** and **Lyubov Popova** created images that rejected virtually all elements of pictorial illusionism utilized by Western artists since the Renaissance. These Russian artists anticipated the extreme purity of Mondrian's Neo-Plasticism, developed in Holland in the 1920s. Many of these women artists moved beyond the so-called fine arts to adapt their abstract styles for mass-produced objects, theater sets, costumes, and textile designs.

 Sonia Terk-Delaunay was also a Russian artist famous for her personal abstract style. Because she spent her creative life in Paris, she is not considered a member of the Russian avant-garde, although her artistic concerns are closely related to those of her Russian compatriots. Prior to World War I, in collaboration with her husband, Robert Delaunay, she developed an abstract avant-garde style, termed "Simultanism," which utilized brightly colored discs, creating effects of rhythmic movement and pulsating color. After World War I she utilized this innovative artistic vocabulary for a wide range of applications outside of easel painting. She designed sets and costumes for the Ballet Russe, ran a successful fashion design business, and even created a "simultaneous" decoration for an automobile. Delaunay's art is a significant contribution to the history of twentieth-century modernism.

 Surrealism was a major international style that affected developments in both the fine arts and literature in the 1920s and 1930s. Many artists in Europe and America were affected by the Surrealist premise that the artist should tap creative sources beneath the level of consciousness. Surrealist images attempt to illustrate a different reality from that which the conscious mind understands and the senses perceive. This "sur-reality" can originate in any number of sources, such as dreams, chance juxtapositions, or the artist's imagination. The Swiss **Meret Oppenheim,** the American **Dorothea Tanning,** and the Spaniard **Remedios Varo** are among the numerous women artists whose works belong within the Surrealist movement. Many of the works of the "Women of Surrealism" relate specifically to female experiences and rank in quality with the best products of their male colleagues, such as Salvador Dali, Max Ernst, or René Magritte.

 In America during the 1920s, **Georgia O'Keeffe** developed an original style of great simplification and monumentality. O'Keeffe's works do not often move into pure abstraction but retain an identification with nature. Unconnected with any specific movement, O'Keeffe is widely acknowledged as an exceptionally gifted artist who is among the very best American painters of the twentieth century.

 By 1930 there were many women artists in America. A census of that year identifies 40 percent of all practicing American art professionals as women. Women were also prominent as administrators of federally funded arts projects during the Depression. These programs were notably free of sex bias; 40 percent of those receiving assistance were women. These statistics indicate that women artists were no longer interesting oddities or exceptions in a male

dominated profession. From that time to the present, the percentage of art students and artists who are women has steadily grown.

Whether to consider photography an art and photographers artists, rather than technicians or craftsmen, has been the subject of debate since the invention of photography in the nineteenth century. Although most nineteenth-century authorities thought of photography more as a science or craft than as an art, the consensus today is that photography is indeed an art form. Photographs are collected, displayed in museums and galleries, and subjected to critical evaluation. Major photographers are the subjects of scholarly monographs. Photography has its own history, with recognized masters, which parallels the history of painting and sculpture. Therefore, while photographers are not generally discussed in standard art history texts, contemporary opinion justifies the inclusion of a select group of outstanding women photographers in this study.

Because photography was not regarded as an art in the late nineteenth and early twentieth centuries, the field was open to everyone without restrictions. Anyone who wanted to could make photographs, and no official schools controlled the dissemination of the technical knowledge necessary to practice photography. This made it possible for a number of women to achieve the first rank of excellence in the new medium. Women photographers, like women active in the fine arts, have created impressive images of a wide variety of subjects in many different photographic styles. As in the fine arts, women photographers were active participants in many avant-garde groups. The Englishwoman **Julia Margaret Cameron** was one of the most famous photographers of the late nineteenth century. **Gertrude Käsebier,** an American, was a "pictorial" photographer, active in the first decades of the twentieth century. Employing a softly focused style with simplified forms, she altered the conventions of portrait photography and narrative images. In contrast to Käsebier's style, **Imogen Cunningham** used a sharply focused, finely detailed technique. Working on the West Coast in the 1930s, Cunningham was a member of the Group f. 64, placing her in the avant-garde of her profession. **Dorothea Lange** and **Margaret Bourke-White** are noted photojournalists of the period. Both women began their careers documenting the poverty of America during the Depression. For almost thirty years Bourke-White's photographs were reproduced in the popular magazines *Fortune* and *Life,* as well as in her own books. The widely disseminated photographs of these talented women shaped and altered the perceptions of contemporary Americans.

KÄTHE KOLLWITZ (1867–1945)

Käthe Kollwitz shares a common nationality and generation with Paula Modersohn-Becker. However, aside from the fact that both women created works of great force and originality often focused on women's primordial role as

Mother, there are few similarities between them. While Becker retained a strong attachment to color and the medium of painting, Kollwitz, from the beginning of her career, concentrated on drawings and prints in black and white. Her self-imposed restriction to the graphic media stems from both personal inclination and political conviction. While still an art student, Kollwitz was fascinated by the demands of the printmaking process. She did not feel the need of color to express her powerful political messages. A print is less expensive than a painting because a number of original copies can be made from one source. Therefore, Kollwitz's graphics could be bought if not by the destitute workers, whom she depicted so sympathetically, then at least by the middle-class people who shared her political beliefs.

Käthe Schmidt was born into an unusual family in the small Baltic seaport of Königsberg (now Kaliningrad). Her father was an ardent believer in socialism and an activist in the Social Democratic Worker's Party. Käthe absorbed these political beliefs, and throughout her lifetime her works express her sympathies for the oppressed poor and her strongly anticapitalist convictions. Her family encouraged her artistic talents and gave her drawing lessons with a local artist. In 1885 she studied art in Berlin at the school for women established by the Verein der Kunstlerinnen. After a few years at home, in 1889 she entered the Verein's school in Munich where the cultural environment was more stimulating.

In 1884 she became engaged to Karl Kollwitz, who shared her family's political convictions. Fearful that marriage might interfere with her ambitions to become an artist, she postponed the wedding until 1891, when Karl had completed his medical studies and was a practicing doctor in a working-class neighborhood in Berlin. During the 1890s she bore two sons and worked on her first major graphic series, *The Revolt of the Weavers,* completed in 1897. The work was inspired by a play that told the true story of the 1844 armed rebellion of a group of destitute linen weavers in the German province of Silesia. This subject contains many recurrent themes that Kollwitz was to illustrate throughout the rest of her life: the misery of the impoverished working classes, the omnipresence of death, and a sympathy with armed revolt to improve inhuman conditions. *The Revolt of the Weavers* was greeted with great critical praise when it was displayed in 1898. The six prints that constitute this work established Kollwitz as one of Germany's leading graphic artists. Although she was nominated for a gold medal, the Kaiser denied her the award because of the radically leftist political content of the series.

Kollwitz's next major print cycle, *The Peasant War* (1902–8), was inspired by an uprising of German peasants in the sixteenth century. Kollwitz believed that women could be a force for political change, and she was attracted to this particular event because the leader of the revolt was a woman, Black Anna. *Outbreak* (Figure 50) depicts Black Anna inciting the men, who are armed with primitive weapons. In this extraordinarily powerful image, a peasant army races across the scene with a seemingly invincible force. Stylisti-

FIGURE 50. KÄTHE KOLLWITZ. *Outbreak.* 1903. Mixed technique. 20 × 23¼".
Courtesy of the Library of Congress.

cally, Kollwitz retained enough descriptive details to characterize the individual features of the peasants, and there is an element of naturalism in the figure of Black Anna. The tension of the scene is intensified by presenting Black Anna with her back to the viewer. Kollwitz used her own body as a model for her great back. In this manner, emotion and energy are expressed through posture and gesture rather than mere facial expression. Technically, Kollwitz employed a mixture of etching techniques, aquatint, and soft ground to achieve the range of textures, shadings, and details of the finished work.

The experience of World War I was a great trauma for Kollwitz. In 1914 her son Peter was killed in Belgium. Kollwitz channeled her grief and fury into many prints in which she made statements against the futility of war and the destruction of young sons. The emotional content of *The Mothers* (Figure 51) must be understood in the context of the artist's intense revulsion toward the senseless killing of war. *The Mothers* is structured like a great sculptured bas-relief. Four women stand facing the viewer. The central figure and the one closest to us grasps her two children to her body in a protective embrace. Two other women hold their babies in their arms, and one figure uses her other arm to protect a small child. The fourth, the childless woman on the left, holds her

FIGURE 51. KÄTHE KOLLWITZ. *The Mothers.* 1919.
Lithograph. 17¾ × 23″. Philadelphia Museum of Art: Given
by an anonymous donor. (46-79-1).

hands to her face in pathetic gesture of grief. The image is rendered in a
drawing style that conveys energy and spontaneity. Compared with *Outbreak,*
the style of *The Mothers* is greatly simplified, demonstrating the freedom of her
mature draftsmanship.

Kollwitz's later works continue to explore the themes that had fascinated
her in her youth. Many images focus on the horrors of sudden death, the pains
and joys of motherhood, and the injustice of the economic exploitation and
political oppression of one class by another. Avoiding the abstraction and
stylistic innovations of many avant-garde artists, Kollwitz maintained a some-
what naturalistic style throughout her career, although her works become
more simplified and forms more generalized in the 1920s and 1930s. Her
talents were widely recognized during her lifetime. In 1919 she became the
first woman to be elected to the Prussian Academy of the Arts. In 1928 she
became director of graphic arts at this school. It was not until the Nazis
assumed power in Germany that, like so many other artists, she experienced
discrimination and was forced to resign from the Academy in 1933.

Kollwitz's compassion extended not only to the oppressed but also to her
fellow women artists who were not as famous as herself. She was elected
president of the Frauenkunstverband (Women's Art Union) in 1914. The main
goal of this group was "securing the right of women to teach and study in all
public art schools."[1] In 1926 she helped found GEDOK (Society for Women
Artists and Friends of Art), a feminist organization "dedicated to showing,
sponsoring, and contributing to the work of women artists."[2]

Kollwitz continued working into her seventies. She witnessed the anni-

hilation of yet another generation of German youth in World War II. Her grandson, Peter, named after the son who had perished in World War I, also died in battle. The works she left to posterity are loaded with the fullest possible range of human emotions. Her images express her convictions as a woman, a mother, and a political being. They are frequently painful and always emotionally stirring.

RUSSIAN WOMEN ARTISTS OF THE AVANT-GARDE

A remarkable group of women artists were active participants in the pre– World War I avant-garde in Russia. Along with their male colleagues, they developed a totally abstract formal language for art, altering the basic vocabulary of painting. These artists, most of whom remained in Russia even after the Revolution of 1917, courageously explored the full range of possibilities of color, line, and shape in their art. Natalia Goncharova, Liubov Popova, and Olga Rosanova are among the most prominent Russian women in the avant-garde of this epoch. In the 1920s many of these artists designed textiles, stage sets, and other objects outside the realm of the "fine arts." The concentration of women in this avant-garde movement is consistent with the international trend in the twentieth century in which women artists are more frequently active participants in radical groups.

In Russia, as in other countries of Europe, aristocratic women were often enthusiastic amateur painters. In 1842 the St. Petersburg Drawing School was opened to women. Later on there was a group of successful, if conservative, women artists active in the 1870s and 1880s, among whom Marie Bashkirtseff was perhaps the most famous. Such precedents established a base that at least partially explains the number of women artists in the pre- and post-Revolutionary Russian avant-garde.

The artists under consideration here unanimously rejected the Western Renaissance pictorial system. However, aside from their dedication to abstraction, their art shows great diversity and individuality. They all emerged from the same cultural matrix and share a solid position in the vanguard of the history of twentieth-century art.

Natalia Goncharova (1881–1962)

Natalia Goncharova is one of the most important and inventive figures of the Russian avant-garde. In 1898 she enrolled in the Moscow School of Painting, Sculpture and Architecture. She was one of the first artists to appreciate native Russian folk art forms and medieval icon paintings. In her works prior to 1912 she often combined the simplifications of these primitive art forms with the formal innovations and saturated colors of French Fauvism. Goncharova depicted scenes from the urban environment, such as machines

and electric lights, but she was also interested in the decorative potential of women's fashion accessories. In *Ostrich Feathers and Ribbons* (Figure 52) she arranges these female ornaments into an elegant, brightly colored composition. In this work three ribbons—navy blue, magenta, and rust—swirl and intertwine around the canvas. These linear forms seem to be moving because the eye must follow their sweeping patterns. Blue-black ostrich feathers provide another sort of curling form. She also uses white shapes that seem to be a fabric pierced with eyelet embroidery. The background of the upper half of the composition is brilliant orange dotted with red, and there is no recognizable three-dimensional space. It is not surprising that Goncharova was also creating patterns for women's dresses and embroidery at this time. Her interest and sensitivity to ornament evolved into a fascinating painting that works on a very abstract level yet retains its connection with fashion accessories.

In 1912 Mikhail Larionov (1881–1964) began to use an aesthetic system known as Rayonism. Related to Cubism and to Italian Futurism, Larionov's paintings frequently depict the light rays that radiate from objects. Although some of Goncharova's works use a Rayonist style, she never pursued this system into the realm of pure abstraction as Larionov did, and she never used it to the exclusion of other styles. Goncharova maintained a separate and highly personal artistic identity despite having lived with Larionov from 1900 on.

Goncharova's talents for the organization of decorative ensembles at-

FIGURE 52. NATALIA GONCHAROVA. *Ostrich Feathers and Ribbons.* 1912. Oil on canvas. 35⅛ × 27½". Courtesy Leonard Hutton Galleries, New York.

tracted the attention of Serge Diaghilev, director of the Ballet Russe. Between 1914 and 1926 Goncharova designed the sets and costumes for several ballets for this company. She and Larionov joined the company in Paris in 1915. World War I prevented their return to Russia, and after 1918 they settled permanently in Paris. She continued to paint and produce book illustrations until the end of her life.

Lyubov Popova (1889–1924)

Another extremely important member of the Russian avant-garde was Lyubov Popova. There is widespread scholarly agreement that Popova was an exceptionally gifted artist. She traveled to Paris in 1912 to study Cubism, and in the next years she painted in an abstract Cubo-Futurist style. Between 1918 and 1922 she developed a more personal style of radical simplification that makes her Cubist works look almost old-fashioned by comparison. "Her canvases illustrate the clearest and most consistent conception of Constructivism in painting to appear in the Soviet Union or anywhere else."[3] A typical example of this Constructivist style is *Architectonic Painting* (Figure 53). This work consists of intersecting multicolored planes without any reference to objects in nature. Despite a certain amount of overlapping, it is impossible to say that these forms exist in a three-dimensional space. The traditional technique of modeling is employed nontraditionally because one cannot perceive these planes as rounded objects. Colors are also selected arbitrarily. This work is constructed with the most basic elements of painting, manipulated in a totally new way, overturning the Western tradition of painting since the Renaissance.

FIGURE 53. LYUBOV SERGEIEVNA POPOVA. *Architectonic Painting.* 1917. Oil on canvas. 31½ × 38⅝". Collection, The Museum of Modern Art, New York. Philip Johnson Fund.

Popova and other women artists who painted in a Constructivist style became active in "production art," which included theater sets and costumes, industrial, graphic, and textile designs. As early as 1918, despite the political upheavals in Russia, the Visual Arts Section of the People's Commissariat for Enlightenment opened a special Subsection for Art-Industry, organized and directed by Olga Rosanova (1886–1918). The purpose of this group was to restructure the industrial design of the country. Rosanova encouraged many existing schools to join this organization.[4] She also devised a plan to reorganize the museums of industrial art in Moscow, which was eventually implemented. Many of her ideas were incorporated into the manifestos of Constructivism in the 1920s.

By 1924 Popova was working in the First State Textile Factory, designing new fabric patterns of great originality. She was very successful in transforming her refined and spare aesthetic sensibility, evident in her paintings, into textile designs. Using simple circles or arrangements of lines, Popova created patterns that seem to move back and forth in space. Such movement was more appropriate for fabrics than for paintings because the pattern had to enclose the three-dimensional body of the wearer.

Both the outstanding achievements of the Russian avant-garde as a whole and the extensive contribution of women artists to that achievement are appreciated today among scholars and critics. This movement changed the course of art history, anticipating many later developments in twentieth-century art. As we have seen, the women artists of this group were among the most radical and innovative artists in Russia, or indeed the world, at this time in history.

SONIA TERK-DELAUNAY (1885–1979)

Just before World War I Sonia Delaunay created a painting system that employed brilliantly colored discs to create an effect of rhythmic movement. Her style, known as "Simultanism," is an important and influential contribution to twentieth-century avant-garde painting. Like her countrywoman, Goncharova, Sonia Delaunay possessed a finely developed sensitivity to colors and their interrelationships.

Born in the Ukraine, at the age of five Sonia was adopted by her maternal uncle, Henry Terk, and raised in the wealthy, cultured environment of his home in St. Petersburg. Sonia Terk's artistic talents were encouraged, and from 1903 to 1905 she studied art in Germany. Her artistic training began in earnest when she arrived in Paris in 1905. Like Modersohn-Becker, who was also in Paris during these years, Terk absorbed the latest developments of French Post-Impressionism and Fauvism.

In 1908 she had her first one-woman exhibition in the gallery of Wilhelm

Uhde, but she did not exhibit her works in public again until 1953. The following year she married Uhde, but she divorced him in 1910 to marry the painter Robert Delaunay (1885–1941). Each of their talents complemented the other's, and their lives became a team effort that enhanced their individual gifts. Both Sonia and Robert Delaunay acknowledged the influence the other exerted on his or her art, especially between 1910 and 1914 when they both were formulating their definitive styles.

A major turning point in Sonia Delaunay's development was triggered by the creation of a quilt for her infant son in 1911. Unlike the American quilt makers discussed in chapter eight, Delaunay was prepared to appreciate the possibilities of this abstract language for painting. The results of this breakthrough were soon visible in her works.

Electric Prisms (Figure 54) is one of her most important pre–World War I paintings. This large canvas (almost 8 feet square) was inspired by the electric lamps that had recently replaced gaslights on the Parisian boulevards. Using concentric circles divided into quadrants, the alternating and repeating colors create an optical effect of pulsating, brilliant light. These colored sections are arranged in a complex pattern of disks and are divided by straight lines and waving arclike sections.

The exploration and depiction of "colored rhythms" or "rhythms of color" (both frequent titles of her works) was to be Delaunay's lifelong obsession. Her paintings, gouaches, and other two-dimensional works show a ceaseless inventiveness in the arrangement of colors to express movement and syncopation. Musical analogies seem unavoidable in the description of her pictorial language because she uses colored units like notes in a musical scale.

FIGURE 54. SONIA DELAUNAY. *Electric Prisms.* 1914. Oil on canvas. 98½ × 98½". Musée National d'Art Moderne, Centre Georges Pompidou, Paris.

employs only the most basic elements of painting to construct her
she defined her aesthetic system in the following way:

The pure colors becoming planes and opposing each other by simultaneous
contrasts create, for the first time, new constructed forms, not through
chiaroscuro but through the depth of color itself.[5]

The term "simultaneous contrasts" refers to Chevreul's law, which states that
when two complementary colors, such as red and green, are juxtaposed, their
contrast is intensified. Delaunay once explained her devotion to abstraction by
stating: "Beauty refuses to submit to the constraint of meaning or descrip-
tion."[6]

Delaunay lost her personal income during the Russian Revolution, so
after World War I she turned increasingly to commercial, income-producing
activities. Like Goncharova, she designed sets and costumes for the Ballet
Russe. She became a successful and highly innovative fashion designer. In
1925, at the famous and influential International Exhibition of Decorative
Arts, she displayed her fashions and fabrics at a "Boutique simultanée" (Figure
55) Vivid colors and geometric patterns characterize the textile designs, which
were shown in loose-fitting full skirts and tunics. Such styles, which liberated
the wearer from the confines of the wasp-waisted corsetted, pre-War sil-
houette, were very popular in the new culture of the 1920s. The Depression of
1929 put her out of business. Sonia Delaunay's activity in the decorative arts
industry demonstrated her unorthodox, independent attitude toward the con-
ventional hierarchies of fine verses applied art and male verses female realms.[7]
She did not perceive her activities outside of easel painting as inherently less
important or intellectually demanding.

The fact that Sonia Delaunay did not exhibit her paintings between 1908
and 1953 has affected the public's knowledge of her artistic achievement.
However, since the 1950s her works are more widely known. Major retro-
spective exhibitions of her works were held in Paris in 1967 and in the United
States in 1980. Sonia Delaunay has escaped the fate of many a woman artist
married to another artist. Both Sonia and Robert Delaunay have received full
recognition, individually and as a team, for their contributions to the history
of art.

WOMEN OF SURREALISM[8]

There is an irony inherent in the Surrealist position on the nature of women,
the "other" sex. André Breton, the leading theorist of the Surrealist move-
ment, valued woman as a primal force that he viewed with respect and awe.
He advanced definitions of woman as catalytic muse, visionary goddess, evil

FIGURE 55. SONIA DELAUNAY. *Boutique Simultanée,* photo of installation. Display of fabrics, coats, and accessories at the Boutique Simultanée at the Exposition des Arts Decoratifs, Paris, 1925. Photo courtesy of Arthur A. Cohen.

seductress, and most significantly, as *femme-enfant,* the woman–child whose naive and spontaneous innocence, uncorrupted by logic or reason, brings her into closer contact with the intuitive realm of the unconscious so crucial to Surrealism. Breton exalted woman as the primary source of artistic creativity, saying, "The time will come when the ideas of woman will be asserted at the expense of those of man."[9] However, Breton expected men to translate this intuitive woman's realm, viewed as closer to natural forces, into the culture as art. As flattering as his adulation of woman might seem, his theories relegated the "other" sex to the status of male-defined object, leaving little place for real women or women artists to develop independent identities. Thus, the women of Surrealism, as Gloria Orenstein has suggested in a landmark article, had to struggle against limitations placed on them by the very concepts of Surrealism itself.[10]

Yet Surrealism, as a movement that sought to explore altered states of consciousness, to penetrate the realm of dreams, and to make the imaginary real, includes a number of women who produced significant works. Meret Oppenheim, Remedios Varo, and Dorothea Tanning are among the leading women artists whose works fit within the Surrealist movement.

Meret Oppenheim (1913–)

Raised in Switzerland and southern Germany, Meret Oppenheim went to Paris at the age of eighteen to become an artist. She became the subject of some of Man Ray's most beautiful photographs, and in 1933 she was invited by Alberto Giacometti and Jean Arp to exhibit with the Surrealists. She continued to participate in their exhibitions until 1937 and again after World War II until 1960.

In the catalogue of Surrealist imagery, one piece stands out as the paradigm of the disturbing object: the fur-lined teacup of Meret Oppenheim. Although this work, alternately titled *Object* and *Fur Breakfast* (Figure 56), is frequently reproduced in standard texts, there is "a truly stunning absence of critical curiosity about Meret Oppenheim herself."[11]

Her fur-lined teacup remains a most potent example of the Surrealist goal to transform the familiar into the strange. Here, a mundane household object is rendered useless, while evoking the viewer's response to the sensation of drinking from wet fur. In another clever Surrealist object, Oppenheim trussed up a pair of women's high-heeled shoes like a holiday bird served on a silver platter, complete with paper frills. She also transformed a mirror by silkscreening onto the surface a face in the process of metamorphosis. She maintained a commitment to the ideas that formed the basis of Surrealism: "Artists,

FIGURE 56. MERET OPPENHEIM. *Object.* 1936. Fur-covered cup, saucer, and spoon; cup, 4⅜″ (10.9 cm.) diameter; saucer, 9⅜″ (23.7 cm.) diameter; spoon, 8″ (20.2 cm.) long; overall height, 2⅞″ (7.3 cm.) Collection, The Museum of Modern Art, New York. Purchase.

poets, keep the passage to the unconscious open. . . . The unconscious is the only place from which help and advice can come to us."[12]

Remedios Varo (1913–1963)

Many of the women artists of Surrealism have examined the specific creative identity of Woman, not as muse to male creativity, but as an independent force. Although each has refined a complex, personal iconography, images recur in which woman is viewed as an alchemist or explorer, pursuing the mysteries of creation and creativity as a source of spiritual rebirth. This is particularly true in the work of Remedios Varo.

Born in Spain, Remedios Varo became part of the Parisian Surrealist circle in the late 1930s. It was not until years later, however, from the distance of Mexico where she settled as a World War II exile, that she was able to develop a mature Surrealist vision and a distinctive painting style that evokes enthusiastic critical acclaim. Combining masterful rendering with a miniaturist's attention to detail, she created jewel-like compositions, small in size but monumental in scale. In a magical world of fantastic yet plausible events, she placed owl/artists, insect/geologists, crazed botanists, magical astronomers, and intrepid travelers who journey in fancifully invented vehicles or experiment in laboratories to find mystical sources and harmonies in the universe.[13]

In *Harmony* (Figure 57) an androgynous inventor is seated in a medieval-

FIGURE 57. REMEDIOS VARO. *Harmony*. Private Collection.

looking study filled with the tools of the alchemist. Taking objects from a treasure chest—geometric solids, jewels, plants, crystals, handwritten formulae—she places them as notes onto a musical staff. From a chaos of possibilities, the order that is music is created. Like Pythagoras, she searches for the secret harmony that exists between nature and mathematics. In this work she is aided by phantom figures that emerge from behind peeling walls. These "collaborators" symbolize objective chance. In Varo's words, the Surrealist concept was "something which is outside of our world, or better said, beyond it. . . ."[14]

Much as Varo's work is an exploration of other realities, it is also a metaphor for the world in which she lived. As Varo's biographer, Janet Kaplan, has suggested, virtually all the protagonists in Varo's paintings, whether male, female, or the ideal androgyne, bear a striking resemblance to the artist and should be understood as schematic self-portraits. Thus, it is Varo herself who is the alchemist or explorer. In creating these characters, she is defining her identity.

Dorothea Tanning (1910–)

For Dorothea Tanning, too, personal identity can be seen as a central source of imagery. In her paintings women often appear placed in isolating and potentially menacing situations. One painting depicts young girls dressed in rags who seem haunted as they rip wallpaper into shreds along lonely corridors. In another work a woman, barefoot and half-clothed in a robe of dead branches, stands transfixed before a maze of doorways. She is accompanied by a fantastic creature with wings, tail, claws, and snout, who is her chimera or incubus.

Tanning's images speak to the condition of woman. This is most powerfully seen in *Maternity* (Figure 58). In this work a barefoot mother and child, dressed in identical sleeping cap and nightgown, stand between two open doorways in an otherwise barren landscape, tenderly hugging each other. Their only companion is a pet Pekinese dog whose face bears a strong resemblance to Tanning's own features as a child. Dark storm clouds fill the sky above a sulfurous yellow desert. In the background a menacing figure, half-organic, half-machine, looms through a distant doorway. The woman's gown is shredded over her abdomen as a distended belly and engorged breasts push through, suggesting the violent wrenching of birth and the strong biological link that inextricably binds mother to child. Maternity, that experience unique to women, is here expressed as tender but bitter, uniting but isolating, a door that opens to some experiences but closes off others.

Although born in the United States in 1910 and not associated with the Surrealists in France until the 1950s, Tanning felt that unknowingly she had already become a Surrealist by the age of seven when, in the small town of

FIGURE 58. DOROTHEA TANNING. *Maternity*. 1946. Oil on canvas. 44 × 57". Private collection.

Galesburg, Illinois, she composed messages to secret loves and sealed them in paper cubes. But it was only after seeing the "Fantastic Art, Dada and Surrealism" exhibition at New York's Museum of Modern Art in 1937 that she realized that her artistic personality could be understood as part of a larger movement. Upon meeting her future husband, the Surrealist artist Max Ernst, who had emigrated to the United States during World War II, the links between her art and Surrealism became more direct. Together they spent the 1940s in Sedona, Arizona, where Tanning produced many of her best known works. In the 1950s and 1960s while living in France, she combined her painting with scenery and costume design; during the 1970s she experimented with soft sculpture. She, too, remains true to Surrealist principles. "Me, I want to seduce by means of imperceptible passages from one reality to another."[15]

Oppenheim, Varo, and Tanning each developed an independent style to explore highly personal subject matter while remaining loyal to the basic tenets of Surrealism. Recent research has begun to recognize and evaluate the contributions of these artists. Surrealism, a movement that exalted Woman as the creative force, may also be understood and valued for the women creators within it.

GEORGIA O'KEEFFE (1887–1986)

Georgia O'Keeffe is widely recognized as one of the best American painters of the twentieth century. A highly individual artist, she cannot be easily classified with any movement or school of painters. Although she is sometimes related to the Precisionists, such as Charles Sheeler, her largely organic abstractions and her painterly style separate her from the machine aesthetic of that group. O'Keeffe is truly an "original"—an independent American who remained uninfluenced by the contemporary European abstract movements.

Born on a farm in Wisconsin, O'Keeffe acquired some academic training at the Art Institute of Chicago and then at the Art Students League in New York. In 1912 she was exposed to the teachings of Arthur Wesley Dow, one of the few art educators in America who rejected academic realism in favor of the simplifications and flat patterning of Oriental art.

Between 1912 and 1916, O'Keeffe spent winters teaching art in Amarillo, Texas. Inspired by the vast expanse of the plains and responsive to Dow's concepts, she began drawing abstract shapes that came from her internal visual imagination. In 1916 she sent a friend some of these drawings. Her friend took them to Alfred Stieglitz, the noted photographer, who ran a gallery in New York that showed avant-garde European and American works. The following year O'Keeffe had the first in a series of annual one-woman shows at Stieglitz's 291 Gallery. In 1924 she and Stieglitz were married, and they lived mostly in New York City until his death in 1946.

O'Keeffe's ability to distill abstract shapes from natural phenomena is never more apparent than in her famous paintings of flowers. In *Black Iris* (Figure 59), the flower is presented in a strictly frontal position, revealing its form to the viewer. From the mysterious mauve darkness of its center, one's eye moves outward to the violet-gray veil-like shapes at the peak. The black-gray lower section forms a kind of base upon which the upper half of the flower is supported. O'Keeffe has explained the rationale for the creation of her flower paintings in the following way:

> Everyone has many associations with a flower. . . . Still—in a way—nobody sees a flower—really—it is so small—we haven't time—and to see takes time, like to have a friend takes time. If I could paint the flower exactly as I see it, no one would see what I see because I would paint it small like the flower is small.

> So I said to myself—I'll paint what I see—what the flower is to me but I'll paint it big and they will be surprised into taking time to look at it—I will make even busy New Yorkers take time to see what I see of flowers.

> Well I made you take time to look at what I saw and when you took time to really notice my flower you hung all your own associations with flowers on my flower and you write about my flower as if I think and see what you think and see of the flower—and I don't.[16]

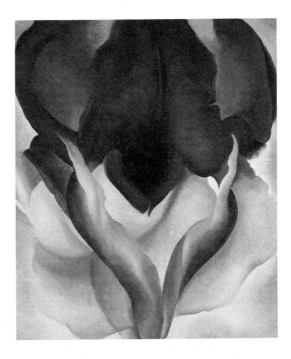

The "associations" from which O'Keeffe separates herself refer to the connections often drawn between images such as *Black Iris* and women's sexual anatomy. It is a tribute to the power of O'Keeffe's works that they can evoke a broad range of associations that vary from viewer to viewer. The relationship of this image to the female body is but one layer of metaphorical meaning that may be taken from it. Another interpretation might view it as fantasy architecture, an elaborate construction, or as a metaphor for a shelter, enclosure, or protection of a special being or sacred object. As Lloyd Goodrich has written, "The flower became a world in itself, a microcosm. Magnification was another kind of abstraction, of separating the object from ordinary reality, and endowing it with a life of its own."[17] The sheer formal power and brilliance of O'Keeffe's flower paintings secure their place among the most important American paintings of the twentieth century.

Beginning in 1929, O'Keeffe spent summers in New Mexico, where she felt a strong attraction to the stark beauties of the desert landscape. In addition to the geography of the desert, O'Keeffe repeatedly painted the bleached animal bones she found in the parched wilderness:

> When I found the beautiful white bones on the desert, I picked them up and took them home too. . . . I have used these things to say what is, to me, the wideness and wonder of the world as I live in it.[18]

Red Hills and Bones (Figure 60) is an image that combines these animal bones with the actual landscape of the desert. In 1939 O'Keeffe explained her attraction for the desert badlands in the following way:

> The red hill is a piece of the badlands where even the grass is gone. Badlands roll away outside my door—hill after hill—red hills of apparently the same sort of earth that you mix with oil to make paint. All the earth colors of the painter's palette are out there in the many miles of badlands. The light Naples yellow through the ochres—orange and red and purple earth—even the soft earth greens. You have no associations with those hills—our waste land—I think our most beautiful country.[19]

Red Hills and Bones juxtaposes two bleached animal bones with rolling hills. Both hills and bones stretch across the full width of the canvas. The general shape of the two bones is echoed in the gently rounded mounds of the hills. Like the desert geography, the bones are both smooth and full of crevices. The openings between the vertebrae are related formally to the erosion creases of the distant hill.

In the statement just quoted, O'Keeffe mentions that the colors of the

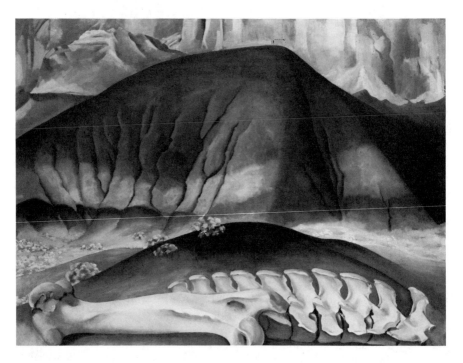

FIGURE 60. GEORGIA O'KEEFE. *Red Hills and Bones.* 1941. Oil on canvas. 30 × 40″. Philadelphia Museum of Art: The Alfred Stieglitz Collection.

desert earth are the raw material for the painter's palette. The "red hills" of this painting are, in fact, painted in a range of saturated colors from violet through brick red to bright yellow. In this highly self-conscious painting, the realms of the natural world, the forms of animal skeletons and geography, are presented so the viewer becomes aware of their correspondence.

In 1949, after settling Stieglitz's estate, she moved permanently to the remote town of Abiquiu, New Mexico. O'Keeffe's art—spare, clear, and powerful—forces us to see that portion of nature she explored in a new and more profound way.

WOMEN PHOTOGRAPHERS BEFORE WORLD WAR II

As noted in the introduction to this chapter, because photography was not considered an art, women experienced no overt institutional discrimination in acquiring the skills necessary to become photographers. That accounts for the number of outstanding women photographers whose achievements are widely recognized in the history of photography. Women photographers, like women painters, worked in a wide variety of styles and with an equally broad range of subjects.

Julia Margaret Cameron (1815–1879)

One important woman photographer from the nineteenth century to achieve success and recognition from her works is Julia Margaret Cameron. Julia Pattle was born in Calcutta, India. Her father was a wealthy merchant in the East India Company. After being educated in France and England, Julia returned to Calcutta at age nineteen. A few years later she met Charles Hay Cameron, an upper-class Englishman, and they were married in 1838. Cameron, twenty years older than Julia, was an eminent jurist who codified the Indian statutes. In 1848 the couple returned to England, and in 1860 they settled on the fairly isolated Isle of Wight. Julia Cameron took up photography at the age of forty-eight as a diversion because her six children were grown and her husband was frequently away on business. Although she had no formal training and her knowledge of photography came from popular manuals and trial and error, she attacked the new medium with characteristic energy and enthusiasm.

In her time, Cameron was best known for her romantic, unfocused photographs. She often recorded sentimental allegories, influenced by the subjects of pre-Raphaelite paintings. Today, however, her portraits are considered her best works. The Camerons were part of Britain's social and intellectual elite, friendly with many of the most notable Englishmen of the era, who often visited the family on the Isle of Wight. Among her illustrious sitters were the painters George Watts and William Holman Hunt, the poets Alfred, Lord

Tennyson and Robert Browning, and the scientist Charles Darwin. She also used family members as sitters. The photograph of her niece, Julia Jackson, taken in April 1867 (Figure 61) is a typical example of her portrait style. Julia Jackson, wife of Herbert Duckworth, was the mother of Virginia Woolf, one of the most important writers of the twentieth century. The eminent art critic Roger Fry has termed this portrait "a splendid success," noting further that "the transitions of tone in the cheek and the delicate suggestions of reflected light, no less than the beautiful 'drawing' of the profile, are perfectly satisfying."[20] In a tribute to Cameron written in 1926, Fry asserts the validity of considering photography an art form and refers to her as the "most distinguished" artist-photographer who ever lived.

Gertrude Käsebier (1852–1934)

Gertrude Käsebier, one of America's most noted photographers around the beginning of the twentieth century, is famous as both a portrait photographer and a pictorialist. Like Cameron, Käsebier used posed situations to express sentimental scenarios, and also like Cameron, Käsebier became a photographer rather late in life and in a similarly unplanned encounter with the

FIGURE 61. JULIA MARGARET CAMERON. *Portrait of Mrs. Herbert Duckworth.* 1867. Silver print. 12½ × 10¼". Collection B. and N. Newhall, The George Eastman House, Rochester, New York.

medium. Gertrude Stanton was born in the frontier settlement of Fort Des Moines, Iowa. The Colorado gold rush drew her father to Eureka Gulch, where the family lived from 1860 to 1864. After her father's death, when Gertrude was 12 years old, the family settled in New York City. Gertrude received a proper middle-class education and, in 1874, married a German shellac importer, Eduard Käsebier. She broke out of the typical pattern of Victorian wife and mother (the couple had three children) when she enrolled in Pratt Institute in 1889 to study portrait painting. Käsebier's interest in photography began in a casual, amateur manner while making photographs of her family. During a summer spent studying painting in France, she made her first indoor portrait and soon thereafter decided that portrait photography, not painting, was her true vocation. From 1897 on, Käsebier operated a successful and fashionable portrait photography studio in New York City. Utilizing her knowledge of painting, she elevated the portrait photograph to the status of an art form. William Homer believes that this is her most important contribution to the history of photography. "In her commercial portraits, she was the first to break away from the stilted, artificial, and overly detailed images that were so common in the professional studios of her day in favor of effects that were simple, dignified, and artistic."[21] Her style was widely praised and imitated by other commercial portrait photographers.

Around 1900 Käsebier began to make photographs that were not simple portraits, for they used sitters as actors in situations that conveyed symbolic themes. In this manner she entered the ranks of the "pictorial photographers." Stylistically, she avoided specific details and sharp focus, striving for a moody, generalized image also favored by contemporary painters active in Europe, such as James A. McNeill Whistler and Eugène Carrière.

Käsebier often used the subject of maternity as her theme—sometimes in an idealized manner, at other times in an ironic one. Her most famous photograph, *Blessed Art Thou Among Women* (Figure 62), is both a portrait of her friend Frances Lee and her daughter and a symbol of the joys of maternity. The title, which alludes to the biblical Annunciation carried to Mary by the Angel, is lettered on the picture frame in the background. The white tones of the door frame are elegantly echoed in the white gown of the mother and contrasted with the dark upright form of the little girl. Simple, yet effective, the image expresses the protective, nurturing aspect of motherhood and its fulfillment as a religious duty. The following year Käsebier photographed Frances Lee again in *The Heritage of Motherhood* (c. 1900). This time the sitter is positioned alone on a cliff, hands clasped together. This photograph expresses the theme of a mother's fortitude and endurance when she is left alone after her children have grown.

Between 1902 and 1913 Käsebier was a member of the Photo-Secession, an avant-garde group founded by Alfred Stieglitz. The Photo-Secession was an influential group that promoted the acceptance of photography as an art form. To disseminate these views, Stieglitz published the journal *Camera*

FIGURE 62. GERTRUDE KÄSEBIER. *Blessed Art Thou Among Women.* c. 1900. Platinum print on Japanese tissue. 9⅜ × 5½". Collection, The Museum of Modern Art, New York. Gift of Mrs. Hermine M. Turner.

Work. The first issue, in 1902, was dedicated to Käsebier's photographs, thus securely establishing her reputation as one of the foremost photographers of her time. Käsebier was also one of the most technically expert and prolific in the field. She experimented with a very wide variety of printing processes and created the extraordinary number of 100,000 negatives during the course of her career.

Imogen Cunningham (1883–1976)

Along with Edward Weston and Ansel Adams, Imogen Cunningham is known for her sharply focused images of natural phenomena. Reacting against the style of "pictorial photography" favored by Stieglitz and Käsebier, these San Francisco photographers formed a rather unstructured organization known as the Group f. 64. An f. 64 setting on a camera is a very small lens opening that gives a sharply focused, finely detailed image along with a greater depth of field. Through the 1930s the Group f. 64 was the most influential photography society in the country. Among Cunningham's most famous photos are very close-up studies of flowers and plants with strong light-dark contrast. This type of subject, as we have seen, was also favored by O'Keeffe.

Cunningham met the dancer Martha Graham (Figure 63) during the summer of 1931, when both women were living in Santa Barbara. Graham was visiting her mother, and Cunningham isolated her against the dark interior of the barn to achieve the dramatic light-dark contrasts of this image.[22] The expressive positioning of the hands is made even more exaggerated by the close-up focus and severe cropping of the image. Cunningham seems to have been inspired by the beauty, power, and intensity of Graham's choreography to create a photographic portrait worthy of this giant of modern dance. Cunningham's original vision has established her reputation as one of the foremost women photographers of the twentieth century.

Dorothea Lange (1895–1965)

Born of German immigrants in Hoboken, New Jersey, Dorothea Lange had decided to become a photographer by the time she was seventeen years old. While attending courses to become an elementary school teacher, she worked in several photographers' studios in New York learning her craft. Leaving home with a girl friend, Lange settled in San Francisco in 1918, where she established herself, like Käsebier, as a professional portrait photographer.

Lange's contribution to the history of photography dates from the 1930s, when she was hired by the Farm Security Administration both to document

FIGURE 63. IMOGEN CUNNINGHAM. *Martha Graham, Dancer.* 1931. The Imogen Cunningham Trust, © 1970.

the plight of the migrant workers and to arouse sympathy for federal relief programs to aid them. *Migrant Mother* (Figure 64) is the most famous photograph from this program. The circumstances surrounding the encounter with the subject of *Migrant Mother* have an almost eerie quality of intuitive recognition. Lange said, "I drove into that wet and soggy camp and parked my car like a homing pigeon."[23] This woman was only thirty-two years old. She and her children had been surviving on frozen vegetables gleaned from the fields and birds caught by the children. There was no more work since the pea crop had frozen. They could not move on because the car tires had just been sold to buy food. We do not really need to know this background saga of desperation. The anguish on this woman's face, her children who hide their faces from the photographer—these are immediately recognizable symbols of extreme poverty and stoical endurance. In fact, the image conveys this information so directly and eloquently that it has become one of the most memorable pictures of the last fifty years.

Margaret Bourke-White (1904–1971)

Like Dorothea Lange, Margaret Bourke-White was a documentary photographer, and she is remembered as one of the most famous and prolific American photojournalists. Born in New York, she was an active amateur

FIGURE 64. DOROTHEA LANGE. *Migrant Mother, Nipomo, California.* 1936. Gelatin-silver print. 12½ × 9⅞″. Collection, The Museum of Modern Art, New York. Purchase.

photographer by her freshman year at the University of Michigan in 1921. Her professional career began in Cleveland in 1927, following the collapse of a two-year marriage. In 1929 she was hired as a staff photographer for a new magazine, *Fortune,* published by Henry Luce. When Luce founded the magazine *Life* in 1936, Bourke-White was hired as one of its four original staff photographers. She continued to work for the immensely popular *Life* until 1956, when the debilitating effects of Parkinson's disease forced her into retirement.

Bourke-White was an aggressive, fearless documentary photographer. She traveled the globe in pursuit of images to inform the American people of the major world events of the epoch. Her courage and determination to get the right photo are legendary. She understood her works as historical documents and, in fact, her images shaped the consciousness of millions.

Bourke-White traveled through the Dustbowl of America's Midwest in the 1930s, recording the daily lives and the effects of poverty on the people of small-town America. Like the works of Lange, Bourke-White's images forced the readers of *Life* magazine to empathize with the plight of the unfortunate and destitute people captured in her photographs. *Louisville Flood Victims, 1937* (Figure 65), one of her most famous photographs, depicts homeless refugees lining up for emergency supplies. The juxtaposition of these impoverished blacks and the billboard behind them proclaiming the prosperity of the "typical" American family is ironic social commentary.

FIGURE 65. MARGARET BOURKE-WHITE. *Louisville Flood Victims, 1937.*
Life Magazine © 1937 Time Inc.

Bourke-White was a courageous war photojournalist. At the end of World War II she arrived with General Patton to record the liberation of Buchenwald, one of the Nazi concentration camps. Her photograph of the emaciated and expressionless survivors, *The Living Dead of Buchenwald, 1945,* became an unforgettable image of the Holocaust and inspired Audrey Flack to incorporate it into her painted memorial to the victims of the Holocaust (see Figure 91). Bourke-White recorded her reactions to this experience in her book, *Dear Fatherland, Rest Quietly:*

> I kept telling myself that I would believe the indescribably horrible sight in the courtyard before me only when I had a chance to look at my own photographs. Using the camera was almost a relief; it interposed a slight barrier between myself and the white horror in front of me . . . it made me ashamed to be a member of the human race.[24]

According to Beaumont Newhall, author of the definitive *History of Photography,* one personality trait that unites these women photographers is "drive"—a combination of determination, persistence, and energy. Despite stylistic differences, each photographer possessed great force of personality that accounts, in part, for her success in this medium.

11

Artists of the Post-World War II Era

Women artists have been increasingly influential and active as equal partici-
pants in the full range of developments in painting and sculpture since World
War II. A cursory overview of works by women artists during more recent
times indicates that sex alone is not a strong enough factor to determine any
particular predisposition toward a specific style of art. The large numbers of
women artists, of whom only a handful of the most outstanding have been
selected for discussion in this chapter, have worked in a wide variety of styles
in the most diverse media imaginable. In the absence of institutional barriers
and with the increased equality of women in all phases of the postwar culture,
women artists have demonstrated in the past few decades that they are capable
of originality and can achieve the highest levels of creativity in the visual arts.

Unlike earlier centuries, when prominent sculptors like Hosmer were
rare indeed, there have been many important and influential women sculptors
in the twentieth century. **Germaine Richier, Barbara Hepworth,** and
Claire Falkenstein are among the major sculptors of recent decades. Richier,
a Frenchwoman and contemporary of Giacometti, used the traditional method
of bronze casting to create a series of figurative works that reveal a personal
style and iconography. Her major pieces date from the 1950s and combine
elements of Surrealism and Expressionism in a synthesis of originality and
force.

Hepworth is generally acknowledged as one of England's most impor-
tant sculptors. A contemporary and colleague of Henry Moore, Hepworth's
art also employs an abstract, biomorphic vocabulary. Beginning in the late
1920s and continuing into the 1970s, her art continuously explores the arche-
typal correspondences between humanity and the natural world. Unlike

Richier, who modeled her works and then cast them into bronze, Hepworth developed her style through the process of direct carving.

Living in Paris in the 1950s, the California-born Falkenstein began creating a group of sculptures based on her understanding of Einstein's theory of relativity and the expanding universe. Often employing linear elements, welded into symbols of infinity, her works are beautiful, mysterious, and fascinating creations.

Louise Nevelson's contribution to the history of modern art derives primarily from the invention of a new method to create large-scale, monumental sculpture. In the late 1950s she gathered together small pieces of wood, arranged them into compositions within boxes, then piled these units together to form large environmental structures. Employing this assemblage technique on a much larger scale and in a manner different from any previous artist, Nevelson opened up a whole new range of possibilities for the creation of sculpture. Her originality is undisputed and she is generally considered one of the most important American sculptors of the post–World War II era.

In painting, Abstract Expressionism was the first major American painting movement to develop independently of European influences after World War II. Along with Jackson Pollock, Willem de Kooning, Franz Kline, and Clyfford Still, **Lee Krasner** must be included among the first generation of Abstract Expressionists. Adopting all-over compositions and relying on gestural application of pigment to convey emotional content, these artists invented abstract vocabularies that broke definitively with the Cubist framework and the specific references to nature still so essential to Surrealism. Until recently, her role as Jackson Pollock's wife overshadowed Krasner's unique contribution to the movement of Abstract Expressionism.

Helen Frankenthaler is recognized as one of the major figures in the second generation of Abstract Expressionists for her invention of the "soak-stain" technique in 1952. Instead of using pigments, which retain the imprint of the brush, or the viscous textures of Pollock's "drip" technique, Frankenthaler thinned the paint so it soaked into the canvas, creating a very luminous and lyrical effect. By the late 1950s, a number of artists in the second generation of Abstract Expressionists, such as Morris Louis, Kenneth Noland, and Paul Jenkins, were exploring the possibilities of this new method of paint application, pioneered by Frankenthaler.

While Frankenthaler's method was one form of response to the dominance of the painterly gesture of Abstract Expressionism, by the late 1950s another group of painters known as Minimalists were exploring other methods to create works of art. Minimalism, as a movement, asserted the importance of holistic systems, hard edges, immaculate surfaces, and geometric forms. Elsworth Kelly, Ad Reinhart, Barnett Newman, and **Agnes Martin** were among the first artists to use simplified systemic and symmetrical formats for their paintings. Martin's most characteristic works employ a grid

format, pencilled onto a pale and uniformly colored surface. Through the grid, Martin retained an intensified, conceptual control over the creation of the work of art. The use of a grid was as different as possible from the random and seemingly spontaneous methods of Abstract Expressionism.

Minimalism developed contemporaneously with both Pop Art and Op Art in the early 1960s. All these painting movements reacted against the "action painting" of Abstract Expressionism. Artists used serial imagery, immaculate surfaces, and geometric shapes to order the picture surface. Op Art, the nickname for "Optical Art," examined the actual processes of visual perception. **Bridget Riley** was in the forefront of this movement, creating images in black and white in the early 1960s that epitomized this concentration on the physiology of vision.

Independently of the prevailing movements of Abstract Expressionism, Pop Art or Minimalism, **Alice Neel** created an extensive oeuvre of portraits. Using a dramatic style of exaggerated forms, flattened spaces, and spontaneous brushwork, Neel's gallery of contemporary characters always maintain their individual identities yet reflect the tensions and anxieties of the urban condition of the late twentieth century. Her highly individual contribution to the history of twentieth-century art was only recognized when Neel was already in her seventies.

The avant-garde sculptures of **Eva Hesse** and **Louise Bourgeois** share common elements. Their works are often small scaled non-geometric in form, and they frequently use unusual materials, such as string, wire, or rubber latex. Their imagery most frequently makes some reference to organic forms or human sexuality. In place of the seriousness and architectural pretensions of minimal sculpture, both artists invented postminimal styles based on highly personal symbol systems with clear references to the human body. The works of Hesse and Bourgeois are crucial for subsequent developments in the art of the 1970s. Hesse's sculptures are now seen as influential models for the entire movement in sculpture known as "Process Art." Bourgeois expanded her works in the 1970s into large-scale environments, often coupled with elements of performance. The expression of feminist sensibilities in her imagery was an important role model for those artists seeking the formal expression of women's experience. Recognized for her achievement by a major retrospective in 1982 at the Museum of Modern Art in New York, Bourgeois's art has sustained relevance and originality over a period of four decades.

GERMAINE RICHIER (1904–1959)

The sculpture of Germaine Richier combines elements of Expressionism with the dream world of Surrealism. Using the traditional technique of bronze casting, Richier evolved a personal sculptural style that deals with themes of

growth and decay, terror and violence. Richier makes archetypal images— symbolic forms through which she explores the mythic dimensions of human experience.

Richier was born on a farm near Arles in the south of France. Raised in close contact with nature, her childhood fascination with the insect life of the region reappears in her art. In works such as *The Preying Mantis* or *The Batman,* she transforms a human figure into something primeval and animal.

Richier's interest in making sculpture can be traced back to her early youth. She told an interviewer: "I had always wanted to do sculpture, without painting as a transitional state. I didn't draw. What excited me was building."[1] Following three years of study at the Montpellier Ecole des Beaux-Arts, Richier arrived in Paris in 1925. There, she entered the studio of the noted sculptor Antoine Bourdelle. Although she remained with Bourdelle for four years, her mature sculptural style is more closely related to the Surrealist distortions of Giacometti, whom she met in Bourdelle's studio, than to the more classical vision of Bourdelle himself.

Richier's sculpture began to receive recognition in the 1930s. During World War II she and her Swiss husband lived in neutral Zurich. Although she made sculpture during the war years, her most famous works date from the early 1950s. In *Water* (Figure 66) one can see the characteristic pitted surfaces of her images. Her figures often appear to be eroded over time, like ancient artifacts. In this work, the spindly arms, legs, and thin base are contrasted to the massive volume of the body of a woman. This is a typical characteristic of Richier's sculpture: "I like thin legs supporting heavy masses . . . [other sculptors] made thick legs when sculpture had a respect for the canon. This, I do not care to maintain."[2]

At the neck, the two handles refer to the form of a Greek amphora, or vase. The concept of the female as a container or vessel is very ancient. One of the attributes of the primordial female deity, the "Great Goddess," was a divine water jug. The Great Goddess "is mistress of the upper waters, the rain; and the lower waters, the brooks and streams that spring from the womb of the earth."[3] The fertility of woman was associated with the waters of life that, like amniotic fluid and rain, were believed to be magically connected with the giving of life. The potential of the female body to contain a child related woman metaphorically to the concept of a vessel. Possibly the ancient activity of women who made containers, especially pottery, served to confirm this association. Richier transforms this mythological concept, also used by her contemporaries Henri Matisse and Pablo Picasso, into an impressive sculptural statement.

While *Water* expresses the life-giving potential of the female body, many of Richier's works evoke a shudder of imminent mortality. Both the expressive elongations and the corroded or pitted surfaces she uses so frequently serve to convey a sense of material decay. This dematerialization of the flesh can be rather frightening. Reflecting the anguish of two world wars, Richier

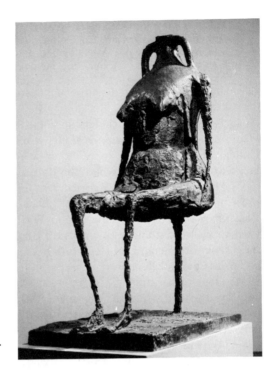

FIGURE 66. GERMAINE
RICHIER. *Water.* 1953–54.
The Tate Gallery, London.

did not avoid the darker emotions of the human condition. Her figures were always set in isolation, not placed into social interaction. Thus, they convey the existential loneliness of the modern era. "We southerners . . . look cheerful, but beneath the surface a drama is buried. Arles is a tragic town."[4] Although Richier's art is not widely known, she created an original group of works that convey powerful emotional content.

BARBARA HEPWORTH (1903–1975)

Barbara Hepworth is one of England's most internationally celebrated sculptors. Like Henry Moore, with whom she is frequently compared, Hepworth employs a personal vocabulary of organically abstracted shapes and forms to create her works. Primarily through the technique of direct carving, Hepworth's art explores the fascinatingly complex relationship between man and nature.

Hepworth's earliest memories are of the Yorkshire landscape in which she was born. Her father was a surveyor, and as a child she accompanied him on his trips. In her autobiography she states:

All my early memories are of forms and shapes and textures. Moving through

and over the West Riding landscape with my father in his car, the hills were sculptures; the roads defined the form. Above all, there was the sensation of moving physically over the contours of fulnesses and concavities, through hollows and over peaks—feeling, touching, seeing, through mind and hand and eye. This sensation has never left me. I, the sculptor, am the landscape. I am the form and I am the hollow, the thrust and the contour.[5]

At age sixteen she won a scholarship to the Leeds School of Art, where she met Henry Moore. The following year Hepworth and Moore enrolled in the Royal College of Art in London. In 1924 they were both awarded travel fellowships. Hepworth went to Italy, where she learned the technique of marble carving.

Although Hepworth married a sculptor, John Skeaping, in 1925, the most important artistic and personal alliance of her life was with the painter Ben Nicolson. They were married in 1931 and shortly thereafter traveled to Paris to visit the studios of Constantin Brancusi and Jean Arp. The works of these sculptors encouraged Hepworth to employ increasingly simplified forms and to use biomorphic, abstract shapes in her art. After the birth of triplets in 1934, Hepworth eliminated all references to natural forms in her work and employed a totally abstract, geometric vocabulary. "I was absorbed in the relationships in space, in size and texture and weight, as well as in the tensions between the forms."[6]

Like Moore, Hepworth was fascinated with the action of piercing the solid mass to reveal the negative shape. As early as 1931 she explored the potential of the concavity and the void in a series of carved wooden forms. Prior to 1956 Hepworth used only the technique of direct carving to make her sculpture. In that year she began modeling works in plaster and then casting the forms into bronze. The most famous and important work Hepworth executed in bronze is the great monolith, *Single Form* (Figure 67), dedicated as a memorial to Dag Hammarskjöld, former director of the United Nations. The *Single Form* is a soaring shape, 21 feet tall, broader at the top than at the base. It is constructed from six large slabs of bronze. The lines that mark the divisions between the pieces subdivide its planar surface. A large hole is the most significant accent of the work, relating this sculpture to Hepworth's other forms, which frequently incorporate voids. The *Single Form* is a proud, noble shape recalling the massive uprights of Stonehenge. Its primitive simplicity increases its impression of monumentality.

Hepworth's career punctures many stereotypical misconceptions about women artists, particularly women sculptors. For much of her career, she created her works through carving. Clearly, male physical strength is no prerequisite for the sculptor's craft. In the *Single Form* she proved that she could sustain her vision on a monumental scale. And although married to two artists, she managed to maintain her professional identity and individuality. Today Hepworth's reputation is secure. She is widely recognized as an important innovator in the realm of organically abstract sculpture.

In 1968 the importance of Hepworth's oeuvre was recognized with a

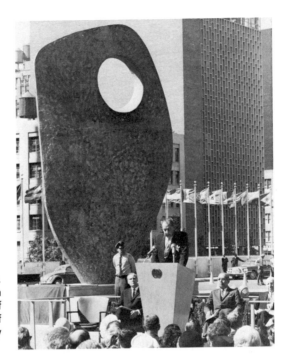

FIGURE 67. BARBARA HEPWORTH. *Single Form.* 1964. Bronze, mounted on granite base. H.: 21'. Gift of Jacob Blaustein in memory of Dag Hammarskjold. Courtesy United Nations, New York.

major retrospective exhibition at the Tate Gallery in London. Her works are in most major museum collections and the bibliography on her art is extensive. She worked continuously at making sculpture until her death in a studio fire in 1975.

CLAIRE FALKENSTEIN (1908–)

Over the course of a lengthy and prolific career, Claire Falkenstein has created an enormous oeuvre of highly innovative abstract sculpture. While her materials range from enormous cedar logs of the *Forum, Memorial to A. Quincy Jones* to delicate welded wire, her works illustrate universal forces and processes as understood by twentieth-century science and philosophy.

Falkenstein was born in a small rural community in Oregon, but her family moved to the San Francisco Bay area early in her life. She graduated from the University of California at Berkeley, where she studied anthropology and philosophy. These early intellectual interests would persist throughout her career and serve as sources for her aesthetic systems.

Alexander Archipenko was the first famous sculptor with whom Falkenstein studied. Archipenko's interest in the expressive possibilities of negative spaces, although still tied to the human form, was influential for Falkenstein who would pursue her exploration of sculptural form, freed from

enclosing volumes throughout her career. In the late 1940s she taught sculpture at the California School of Fine Arts with such noted Abstract Expressionist painters as Clifford Still.

A significant turning point occurred in her career when she moved to Paris in 1950, living and working abroad until 1962. Falkenstein matured as a sculptor during these years, creating a significant body of works of great originality. Like Sam Francis, Joan Mitchell, and Ellsworth Kelly, Falkenstein found Paris inspirational. Like Hepworth, direct contact with European masters such as Brancusi, Arp, and Giacometti, coupled with access to works of the School of Paris and the freedom of movement far from the competitive environment of New York, made Paris a liberating and fruitful environment. In the welded wire sculptures known as the "Sun Series," Falkenstein created works that demonstrate her rejection of the closed, defined, and measurable world of Euclidean geometry in favor of an active curved space illustrative of her understanding of "topology." The flowing and continuously expanding forms of topological space are related directly to Falkenstein's understanding of Einstein's theory of relativity.

> So when I'm talking about expanding space, I'm thinking in terms actually Einsteinian, the Einstein attitude of the expanding universe. I'm thinking about total space, that you do not make something to displace space but whatever you do is part of space. It's a through thing. It's not something that pushes space away from it, but space goes through it.[7]

Thus, one underlying principle of Falkenstein's art is never to create objects or images that imply that one can entrap or separate space from the unity of the natural world.

To illustrate this concept sculpturally, Falkenstein often employs "the sign of the U," a curved, open linear shape flattened at both ends. In the monumental *U as a Set* (Figure 68) a mass of U signs made of copper tubing have been welded into a gigantic shape, which is also a "U" over twenty feet long. It is placed against a "wall" of fountain jets and isolated in its own reflecting pool on the campus of California State University in Long Beach. The interaction of active linear forms in the sculpture and the shooting sprays of water provide two parallel references to the motion of natural forces.

This conception of space which flows and extends uninterruptedly moved logically in Falkenstein's oeuvre into metaphors of infinite expandability, i.e., a symbol of infinity, which is the "never-ending screen." Using a basic three-pronged module, the "never-ending screen" is a code or metaphor for infinity. Inspired by Brancusi's *Endless Column*, the "never-ending screen" has the intellectual potential to express endless expansion. Falkenstein has explained this principle in the following manner:

> I feel that the total sense of the universe can be revealed in a thing like this if one has within them the possibility of entering into it . . . we human beings are part

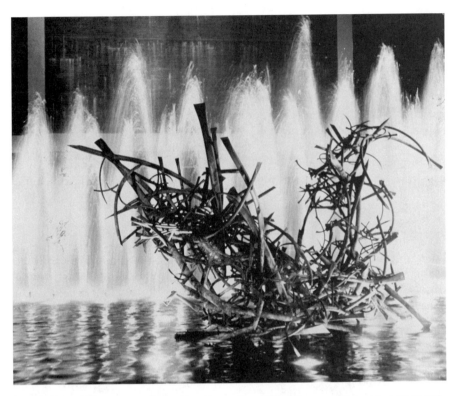

FIGURE 68. CLAIRE FALKENSTEIN. *U as a Set.* 1966. Copper tubing. 14 × 20 × 10′. California State University, Long Beach, California. Photo courtesy of the artist.

of space that we as mobile parts of the universe have multiple points of view, we're in motion, everything is in change and flux, and whatever in our environment has real meaning has to be in sympathy and harmony with all mobility.[8]

The "never-ending screen" first appeared on a major scale in the commission for a monumental set of gates for Peggy Guggenheim's villa in Venice: In that remarkable work, large chunks of Murano glass are entrapped in a web of welded linear elements that articulate the screen. The most complete expression of the "never-ending screen" in an architectural context was the artist's contribution to St. Basil's Church on Wilshire Boulevard in Los Angeles. Eight doors and fifteen enormous stained glass windows (ranging from 80 to 130 feet) were created from her quarter-scale models. This architectural ensemble demonstrates her ability to juxtapose color, light, and the linear "never-ending screen" in a work of great beauty and spirituality.

When the "never-ending screen" is expressed three-dimensionally, it takes the form of the "truss." Falkenstein's most recent work developed from this system is a sculptural complex on the campus of California State Univer-

sity at Dominguez Hills, the *Forum: Memorial to A. Quincy Jones* (Figure 69). Using Port Orford cedar logs, selected for their ability to withstand the test of time, Falkenstein has created a beautiful complex that functions as a metaphor of the cosmos. In this work Falkenstein evokes the principles of nature on the scale of nature.

Falkenstein's works constantly surprise and confound programmed expectations of sculpture, painting, or architecture. Although she came to maturity in the era of second-generation Abstract Expressionism and her works can be seen in that historical context, they do not fit easily or securely within a specific period, movement, or group. Emerging from a firm philosophical basis, their quality resides in a high level of distinctive, individual expression.

LOUISE NEVELSON (1889–1988)

Louise Nevelson is generally recognized as one of the major innovators in the history of twentieth-century sculpture. By the late 1950s she was making large-scale works that were technically and formally without art historical precedents.

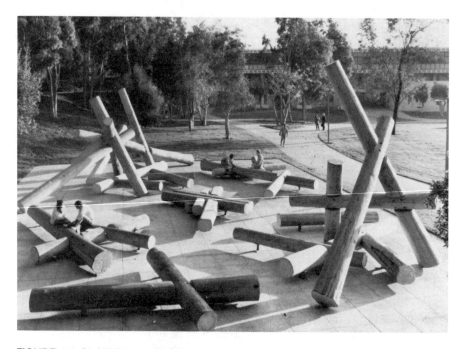

FIGURE 69. CLAIRE FALKENSTEIN. *Forum: Memorial to A. Quincy Jones.* 1987. Port Orford cedar logs. 18 × 50 × 70′. California State University, Dominguez Hills. Photo courtesy of the artist.

Louise Berliawsky was born in Russia to Jewish parents. When she was six years old, the family emigrated to the United States, settling in Rockland, Maine. Louise's affinity for wood dates from her childhood, spent in the proximity of her father's lumber yard. In 1920 she married Charles Nevelson, whose family owned a cargo-shipping business. Two years later her son Myron was born. During the 1920s Nevelson studied voice, drama, and dance, as well as the visual arts. In 1931 she separated from her husband and began to focus her energies on her painting classes at the Art Students League. She continued her painting studies through the 1940s, but it was only when she began to make sculpture from pieces of wood, nailed together and painted a uniform color, that Nevelson found her identity as an artist. Her reputation rests upon a series of environmental structures that she began building in the 1950s.

These large-scale works are constructed from fragments of wood, arranged in compositions within box-like enclosures. They are always painted a uniform color. During the 1950s, the color was black, but later the color changed to white, then gold. However, the black sculptures are the best known and most characteristic of her works.

Sky Cathedral (Figure 70) is one wall of an environmental installation typical of her style. The work is over 8 feet tall and 11 feet wide. By its sheer scale, it dominates the viewer and commands attention. The title evokes a sense of the sculpture as mysterious, awe-inspiring architecture. It is not a

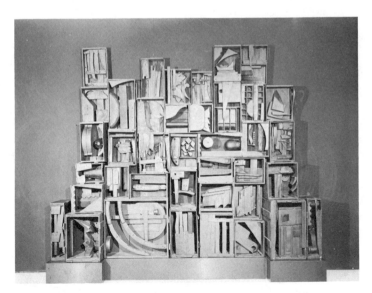

FIGURE 70. LOUISE NEVELSON. *Sky Cathedral.* 1958. Wood, painted black. 102½ × 133½". Albright-Knox Art Gallery, Buffalo, New York. George B. and Jenny R. Mathews Fund, 1970.

unified, coherently designed work. In this sense, Nevelson's aesthetic is diametrically opposed to the sculptures of contemporary Minimalism. *Sky Cathedral* is divided into boxlike enclosures so the work operates on two levels: an overall impression and the compositions of each individual box.

Nevelson began to enclose her sculpture in boxes in 1956 for emotional reasons:

> I wanted to be more secretive about the work and I began working in the enclosures. . . . There's something more private about it for me and gives me a better sense of security.[9]

From the confined limits of the box, Nevelson found the freedom to develop the fullest range of expressive potential in the interior compositions. However, she wanted to maintain a monumental scale for her sculpture, so she began piling these boxes on top of one another to create larger-scaled works:

> I attribute the walls to this: I had loads of energy. I mean, energy and energy and loads of creative energy. . . . So I began to stack my sculptures into an environment. It was natural. It was a flowing energy. I think there is something in the consciousness of the creative person that adds up, and the multiple image that I give, say, in an enormous wall gives me so much satisfaction. There is great satisfaction in seeing a splendid, big, enormous work of art.[10]

Part of the distinction of Nevelson's sculpture is that it operates very effectively on the microcosmic scale of the individual enclosures and the macrocosmic scale of a mural or piece of architecture.

Sky Cathedral contains great variety and diversity within its overall unity. Each of the enclosures has a distinctive composition, balanced and complete within its own confines. For example, the third box from the left, on the floor, is a study in curving versus straight elements. Two sweeping arcs are counterbalanced by four horizontal units. The circular shape is then repeated with a disk set on a third spatial level. It is very carefully arranged so that the abstract elements contain their own tensions. Unity is maintained by the overall black color and the consistency of the use of wood fragments.

Black is traditionally associated with death in our society. Yet Nevelson has said: ". . . it's only an assumption of the western world that it means death; for me it may mean finish, completeness, maybe eternity."[11]

Nevelson's art, as noted above, had variety and unity, complexity and a certain awesome simplicity. It is both very small and intimate in the box compositions and very large in overall impact. Nevelson believes that her work reflects her identity as a woman:

> I feel that my works are definitely feminine. . . . A man simply couldn't use the means of, say, fingerwork to produce my small pieces. They are like needlework. . . . My work is delicate; it may look strong, but it is delicate. . . . My whole life is in it, and my whole life is feminine. . . . Women through all ages

could have had physical strength and mental creativity and still have been femi-
nine. The fact that these things have been suppressed is the fault of society.[12]

It may be surprising at first to hear Nevelson relate her work—which uses
nails, saws, and other tools to needlework. But Nevelson has indeed taken bits
and pieces of material, the debris of society, and transformed them, like a
patchwork quilt, into a series of beautiful and impressive works of art, unlike
the sculpture of any other creator.

LEE KRASNER (1908–1984)

Lee Krasner is the only woman artist of note who was a member of the first
generation of Abstract Expressionism. Until recently, her role in the move-
ment has been overshadowed by her position as the widow of Jackson Pollack.
A reevaluation of her contribution was undertaken only a year before her death
with a major retrospective exhibition at the Museum of Modern Art in New
York.[13]

Born into a Russian Jewish family with absolutely no predispositions to
the arts, Krasner was determined to become a painter by her teens. After
studying on scholarship at Cooper Union in New York, she received very
traditional academic training at the National Academy of Design. However, it
was her years in the classes of Hans Hoffman that opened her art experience to
the European masters Matisse, Picasso, and, of crucial importance, Mondrian.

From this grounding in the formal options of European Modernism, she,
like the other Abstract Expressionists, eventually rejected the cool, intellectual
distance of that art in favor of the immediacy and spontaneity urged by Sur-
realism. Between 1942 and 1945 she shared Pollock's studio. These years mark
a time of doubt and lack of direction for Krasner. Suffering from the sexism of
the art world, the disdain of Peggy Guggenheim, and the mysogynistic at-
titude of the Surrealists, which, Rose records, began to rub off on the Ameri-
can members of the New York School, Krasner was tentative and hesitant.
She was reluctant to abandon Cubist structure and the tenuous ties to the
natural world advocated by Surrealism.

In the spring of 1945, after her marriage to Pollock, the couple moved
out of New York City to East Hampton, Long Island. The following year
both artists began to become preoccupied with allover compositions. Between
1946 and 1949 Krasner created the "Little Image" paintings, which may be
divided into three series. These works, created simultaneously with Pollock's
drip paintings, are executed on a smaller scale and with a greater degree of
precision and control.

Noon (Figure 71) is an example of the "mosaic" or divisionist pattern of
the earliest group of "Little Image" works. Rose maintains that the original
source for the all-over image was Mondrian's ocean and pier (or plus or minus

FIGURE 71. LEE KRASNER. *Noon.* 1946. Oil on linen. 24 × 30″. Private collection. Photo courtesy of the Robert Miller Gallery, New York.

drawings) and that it was Krasner who first drew Pollock's attention to the possibilities of this composition. Pollock, in turn, encouraged Krasner to abandon her tenuous Cubist ties to physical nature.

Noon is composed of an even, all-over surface of thickly impastoed paint in brilliant colors. Yellow, turquoise, orange, pink, and blue tonalities are evenly distributed over the surface. The sparkle of these juxtaposed hues creates an energetic and intense visual experience, related to the dots of Neo-Impressionism. The brushwork maintains a uniform density and rhythmic regularity. This totally abstract work exists in a highly compressed space. It communicates joy, energy, and exuberance. The other works in the "Little Image" series are composed of dripped webs of paint, inspired by Pollock's famous technique, and tight grids of hieroglyphics.

It was only after 1950, when the artist was over forty, that she secured her own self-confidence to the point that she began to create large-scaled, monumental canvasses. However, Krasner's originality and talent never permitted her to settle into a signature style. From the aggressive, Dionysiac frenzy of *Celebration* (1959–60) to the precision and linear majesty of the "Majuscule" series (1971), Krasner's painting has never moved smoothly on a rutted track. Exploring the range of coloristic possibilities or restricting her palate to earth tones, using forms from nature or rejecting any organic illu-

sionism, Krasner's art springs from sincerity, dedication to craft, and the strength of purpose found in the survivors of personal tragedy.

HELEN FRANKENTHALER (1928–)

Helen Frankenthaler is one of the major figures in the second generation of Abstract Expressionism. Her prominent position in the history of modern painting is secure because she invented a highly influential method of paint application known as the "soak-stain" technique. While O'Keeffe paints identifiable objects to reveal their abstract qualities, Frankenthaler uses abstract shapes to evoke the forms of the natural world.

Frankenthaler was born into a distinguished upper-middle-class family. Her father was a Justice of the New York State Supreme Court. Frankenthaler received an elite, private school education in New York City. According to her own recollection, by age fifteen or sixteen she had decided to become an artist. She attended Bennington College where she painted in a Cubist style. Then, upon graduation in 1949, she returned to New York where the influential critic Clement Greenberg introduced her to the leading male artists of Abstract Expressionism.

Frankenthaler's historically most significant painting is *Mountains and Sea* (Figure 72), created in 1952. The canvas stretches almost 10 feet across. In-

FIGURE 72. HELEN FRANKENTHALER. *Mountains and Sea.* 1952. 86⅜″ × 117¼″ (7′ 2⅜″ × 9′ ¼″). Collection of the artist (on extended loan to the National Gallery of Art, Washington, D.C.).

spired by Pollock's murals, which he placed on the floor and worked from all four sides, Frankenthaler used the same method. Edges were defined after the canvas was painted. However, Pollock's drip technique retained the thick texture of the paint, whereas Frankenthaler found a new luminous quality in oil paint by thinning the paint with turpentine. The colors soaked into the white canvas ground, decreasing the saturation of the hues and achieving an effect similar to the brightness of watercolors.

Unlike the single all-over texture that Pollock's drip method yields, Frankenthaler retains specific hues and shapes that float in an undefined space across the picture surface. While the viewer cannot actually identify water and mountains, one can sense both the color and light of a landscape. These qualities, combined with the sheer scale of the piece, make the viewer feel immersed in a watery natural environment. Frankenthaler painted this work in New York after spending the summer in Nova Scotia. She recalled: "I came back and did *Mountains and Sea* and I know the landscapes were in my arms as I did it."[14]

The drips and splatters that occur all over the canvas indicate that the painting of the work was a highly spontaneous, almost uncontrolled act made visible in the finished work. However, there is a clear centering of the main mass, a controlled balance that belies the apparent spontaneity of the technique. The potentialities for the "soak-stain" technique were appreciated by two major artists, Morris Louis and Kenneth Noland, who proceeded to develop their own staining techniques in the late 1950s.

In 1963 Frankenthaler switched from oil paint to acrylics, which do not soak into the canvas as quickly as oils and therefore can be pushed or "flooded" over the surface. This method is apparent in *Flood* (Figure 73), painted in 1967, in which large areas of color sweep in irregular bands across almost 12 feet of canvas. Moving up from the bottom, there is a band of deep blue, then green, which continues up the right side. The "sky" is filled with swirling bands of mustard-yellow and hot pink. One can hardly help but read this image in terms of landscape, seeing a strip of water, land, and then an active sky, which rolls across the canvas. In the upper left, there is a dark area that seems to be an approaching storm. These associations are conveyed through the most minimal means available—colored shapes. But the colors and their shapes are so powerful and so precisely controlled that one reads them as forces of nature. The viewer is absorbed by the splendor of this scene, created on an immense scale, rivaling the scale of nature. Like Pollock and other painters of the 1950s and 1960s, Frankenthaler exploited the expressive possibilities of large-scale paintings.

Frankenthaler's contribution to the history of contemporary painting has long been recognized. In 1969 she was given a major retrospective at the Whitney Museum in New York. Her works reveal a unique color sensibility, an innovative method of paint application, and a personal imagery that con-

FIGURE 73. HELEN FRANKENTHALER. *Flood.* 1967. Synthetic polymer. 124 × 140″. Collection of the Whitney Museum of American Art, New York. Gift of the Friends of the Whitney Museum of American Art.

veys the beauty and vastness of nature in an abstract and nondescriptive, yet evocative, style.

AGNES MARTIN (1912–)

Agnes Martin's mature works, for example, *Untitled* (Figure 74), concentrate on the use of a grid drawn in pencil on a luminous ground. Her paintings are early and characteristic examples of Minimalism, a movement that affected a number of artists in the 1960s. Reacting against the painterly emotionalism of Abstract Expressionism, Martin's extremely delicate, humble paintings are conceptually crystalline, eliminating any elements of chance or spontaneity in their execution. Her works are holistic because the entire surface is created through the repetition of module units. Martin's works were seminal influences for the next generation of artists, including Eva Hesse, who frequently employed grids.

Martin was born on a wheat farm in Saskatchewan, Canada. Her father

FIGURE 74. AGNES MARTIN. *Untitled.* 1961. Ink and pencil on paper. 8 × 8¼ ″. Courtesy of Margo Leavin Gallery, Los Angeles.

died when she was still very young, and the family moved to Vancouver. In 1941 Martin began attending Columbia University's Teachers College. By 1954 she had earned a B.S. and an M.A. degree in fine arts and arts administration at Columbia and was determined to become a painter. She was living in New York during the most active and formative era of Abstract Expressionism. After graduation from Columbia she moved to New Mexico, settling in Taos in 1956.

Martin's paintings of the early 1950s reveal the influence of Abstract Expressionist painters, such as Arshile Gorky and William Baziotes, through her use of biomorphic, abstract forms, which convey a symbolic or narrative content. By 1955 she was using geometric shapes placed on pale, luminous backgrounds. In 1957, with the support of the gallery owner Betty Parsons, Martin returned to New York. From this time onward, her works developed in the direction of increasing simplicity of structure and uniformity of surface. Her paintings either employ the repetition of a single form or the depiction of one large form.

By 1961 Martin was using the format of the grid on a square canvas. Her horizontal and vertical units created the effect of a veil suspended within the canvas edges. Her grids eventually expanded to cover the entire surface of the canvas, creating a total unity between the picture surface and the module. Martin's grids are usually subdivided into rectangular units. She explained her use of the rectangle in the following way:

My formats are square, but the grids never are absolutely square, they are rec-
tangles, a little bit off the square, making a sort of contradiction, a dissonance,
though I didn't set out to do it that way. When I cover the square surface with
rectangles, it lightens the weight of the square, destroys its power.[15]

Martin's characteristic use of pencil creates "channels of nuance stretched
on a rack of linear tensions . . . "[16] As opposed to paint or ink, a pencil does
not respond readily to the artist's hand pressure. Therefore, the selection of
pencil as a medium is a reaction against the gestural painters of Abstract
Expressionism.

Although Martin has confined her art within a narrow set of limitations,
there is great variety within the self-imposed confines of the grid. Her grids are
never identical, but vary in proportions, size, and color. Furthermore, as
Lawrence Alloway has noted, the selection of a conceptual order is just as
personal as autographic tracks of the brush.[17]

The physical size of a work is irrelevant in Martin's systems. Whether on
the small scale of Figure 74 or the much larger size of many of her canvases,
Martin's images evoke the sense of the sublimely infinite in their accumulation
of small, identical units. They seem as if they could be extended indefinitely to
infinity. "A collection of similar bits, beyond easy counting, implies infinity;
that is why the internal area of a Martin painting can seem highly expan-
sive."[18] They are intended to evoke a mystical, meditative response in the
viewer.

Martin's images, then, are deceptively simple. While one can grasp her
system almost instantly, the implications of her images are complex. It is
paradoxical but accurate to see in Martin's highly structured and impersonal
surfaces a visual metaphor for the vastness of the universe and the multiplicity
existing within nature.

BRIDGET RILEY (1931–)

Bridget Riley has received international recognition as one of the innovators in
the Op Art movement. Her works concentrate on the dynamics of visual
perception, the physiological core of the visual arts. Riley's paintings challenge
the viewer to see in unaccustomed ways.

Born in London, Riley received her early training at Goldsmith's School
of Art and at the Painting School of the Royal College of Art. She left school
with no personal sense of direction and did very little painting until 1959.
During that year she became interested in Georges Seurat, the theories of
Pointillism, and the art of the Italian Futurists. By 1961 Riley had focused her
energies on the creation of images in black and white in which basic units are
altered to create a visual effect of motion. Unlike Martin, who maintains a

uniformity in her grids, Riley's painting explores the effects of variations in regular patterning. In 1961 she saw works by Victor Vasarely for the first time. Encouraged by this artist's example, she pursued her interests in the optical "tricks" that can be achieved through the manipulation of geometric shapes.

Fall (Figure 75) is a square canvas in which black and white lines of equal width undulate from top to bottom. Toward the bottom, the "visual frequency" (Riley's term) changes from the slow, even curves of the upper two-thirds of the canvas to shorter, more rapid undulations. The eye tries to mix the black and white lines unsuccessfully and perceives pulsations of gray. An almost painfully intense visual vibration results. As William Seitz observed: "The eyes seem to be bombarded with pure energy."[19] The image creates an illusion of movement. We feel as if these lines are actually moving through space. There is also a sense of sound waves, and the analogy to musical rhythms is unavoidable.

Riley's *Fall* and other Op Art paintings sacrifice narrative content and the entire Western tradition of optical illusion. There are few precedents for images that focus so exclusively on the way we see. Riley's creative input for this

FIGURE 75. BRIDGET RILEY. *Fall.* 1963. Emulsion on board. 55½ × 55½". The Tate Gallery, London. Reproduced by permission of the artist.

work resides in the selection of the unit sizes and in the changes in those units to alter the visual rhythm of the painting. As opposed to Frankenthaler's paintings, which reveal the technical skill and manual expertise of the artist, Riley's surfaces, like Martin's, are smooth and immaculate.

Riley participated in the seminal exhibition that defined and illustrated the artistic movement since named Op Art. "The Responsive Eye" opened at New York's Museum of Modern Art in 1965 with a reproduction of Riley's *Current* (1964) on the cover of the catalogue. Her paintings, then limited to black and white, elicited wide critical and popular success.

In the late 1960s Riley incorporated color into her systemic images. Retaining the use of repeating geometric units, her subtle color variations create beautiful and intriguing effects of movement. Her formative contribution to Op Art has long been recognized, and in 1971 she was given a major retrospective exhibition at the Hayward Gallery in London.

ALICE NEEL (1900–1984)

With total indifference to the trends in the art world since World War II, ignoring fluctuations of taste and the pervasive abstraction of the 1950s and 1960s, Alice Neel created a body of works, almost all portraits, of supreme individuality and psychological intensity. After forty years of painting, it was only in 1974 with a major retrospective at the Whitney Museum in New York that her oeuvre became recognized outside of a small circle of cognoscenti. Neel's gifts spring from her unique ability to pierce the "protective strategies" which people assume, revealing the soul beneath the surface.[20]

With deceptive modesty, Neel has said, "I usually know why people look the way they look."[21]

Born in 1900 in a suburb of Philadelphia, Neel recalls always knowing she would become a painter. Avoiding the Impressionist-dominated Pennsylvania Academy of Fine Arts, she received her training in the more traditional academic curriculum of the Philadelphia School of Design for Women between 1921 and 1925. That year she married an artist from a wealthy Cuban family, Carlos Enriquez. The death of her first daughter, the disintegration of her marriage, and the impoverishment of the Depression led to a suicide attempt and total nervous breakdown in the early 1930s. From these painful experiences, Neel emerged to settle in New York City and eventually receive a small stipend from the WPA. Neel only began to receive some recognition in the art world when she won a prize for one of her portraits in 1962.

As Ann Sutherland Harris has observed, Neel has turned the conventions of portraiture inside out by operating outside of the confines of the commissioned work.[22] Without catering to the tastes or desires of her patrons, the artist selects her sitters, positioning them, in her own studio, rather than integrating the sitter into his or her environment. This absence of conventional

portrait patronage has permitted Neel to paint some segments of humanity rarely, if ever, recorded in paint. Neel's sitters are drawn from the broadest range of social and economic classes. They include art world celebrities, such as Andy Warhol, members of the intelligensia, such as Linda Nochlin, and ordinary working–class minority persons, such as her Haitian housekeeper, Carmen, portrayed nursing her developmentally damaged child.

Between 1930 and 1978 Neel executed a series of nude portraits of pregnant women, sometimes reclining as in *Pregnant Maria* (Figure 76), at other times upright. Neel has justified her attention to pregnancy by noting its importance in life and its neglect by other artists.[23]

One of the most marked characteristics of Neel's images is their specificity. They never descend into stereotypes or generalizations. Even in the subcategory of nude pregnant portraiture, which Neel practiced sporadically throughout her career, the individual retains her own unique identity. This is clearly apparent in *Pregnant Maria*.

Like Manet's *Olympia, Pregnant Maria* presents an image of a whole person, unashamed by her nudity or obvious pregnancy, confronting the viewer with dignity and apparent lack of self-consciousness. No female fertility goddess or archetypal earth mother, this very real individual does not symbolize "Maternity," but embodies the physical human fact of childbearing.

FIGURE 76. ALICE NEEL. *Pregnant Maria.* 1964. Oil on canvas. 32 × 47″. Collection of the family. Photo courtesy of the Robert Miller Gallery, New York.

Characteristically, Maria is positioned very close to the viewer in the extreme foreground, with little depth indicated. This forces a direct interaction between portrait subject and viewer. Also in a typical fashion, some portions of the canvas are treated with a great deal more detail and modeling than others. Maria's face, breasts, and distended belly are fully modeled, giving them a tangible presence, while the receding foot and background are undetailed and unmodeled. Clearly defined contour lines and visible brushwork also characterize the style of the painting.

Neel's talent lies in her unique ability to present the essence of her sitter, not merely his or her surface ornamentation. She calls this "telling the truth:"

> I do not know if the truth that I have told will benefit the world in any way. I managed to do it at great cost to myself and perhaps to others. It is hard to go against the tide of one's time, milieu, and position. But at least I tried to reflect innocently the twentieth century and my feelings and perceptions as a girl and a woman. Not that I felt they were all that different from men's.
>
> I did this at the expense of untold humiliations, but at least after my fashion I told the truth as I perceived it, and, considering the way one is bombarded by reality, did the best and most honest art of which I was capable.[24]

Nochlin identifies this ability of telling the truth about an individual's personality as a characteristic most appropriate to the socialization processes of women:

> In the field of portraiture, women have been active among the subverters of the natural laws of modernism. This hardly seems accidental: women have, after all, been encouraged if not coerced, into making responsiveness to the moods, attentiveness to the character-traits . . . of others into a lifetime's occupation. What more natural than that they should put their subtle talents as seismographic recorders of social position, as quivering reactors to the most minimal subsurface psychological tremors to good use in their art?[25]

Alice Neel, more than any other contemporary artist, has exploited this female trait of insight to generate a large body of extraordinarily powerful images.

EVA HESSE (1936–1970)

Eva Hesse's mature and significant career as an artist is concentrated within the brief span of five years, 1966 through 1970, the year she died from a brain tumor at the age of thirty-four. During this time, she created a number of sculptures that differ in many ways from the prevailing contemporary aesthetic of Minimalism. As a post-Minimalist, Hesse's works were formally, technically and conceptually innovative and influential for the direction of sculp-

ture during the 1970s. Her oeuvre is well documented, and her contribution to the history of contemporary art is widely recognized.

Hesse was born in Hamburg into a German Jewish family. She and her sister escaped extermination in the Holocaust by leaving Germany on a children's train bound for neutral Holland. Her parents rejoined them several months later, and the family settled in New York City in 1939. New traumas came when her parents were divorced and when, the following year, her mother committed suicide. By age sixteen, Hesse had decided to become an artist. She studied at several New York art schools: Pratt Institute, the Art Students League, and Cooper Union. From 1957 to 1959 Hesse attended Yale University's School of Art and Architecture. Returning to New York City, she integrated herself into the avant-garde art community. In 1961 she married the artist Tom Doyle, and in 1964 the couple spent a year in Germany. During this stay abroad, Hesse abandoned painting and started making three-dimensional, biomorphic reliefs, related in form and spirit to Surrealism.

In 1966 two emotionally traumatic events occurred in Hesse's life: Her marriage ended and her father died. She emerged from these crises a mature sculptor with a personal style and direction. That same year she participated, along with Louise Bourgeois, in a group show called "Eccentric Abstraction," curated by Lucy Lippard. This exhibition first defined the post-Minimal process-oriented attitude of a group of contemporary sculptors.

Hesse shared with Claus Oldenburg, Robert Smithson, Lucas Samaras, and Louise Bourgeois an aversion to the architectural and "serious" sculptural ambitions of Minimalism. Hesse was one of the first artists to use a wide range of nontraditional materials to make her objects. Her earliest works were made from limp and pliable materials, such as cord, rubber tubing, or wire, emerging from boards mounted on a wall. Hesse's works often employed the repetition of similar units. She was very aware and deliberate about her intentions. In the last year of her life she told an interviewer:

> If something is meaningful, maybe it's more meaningful said ten times. It's not just an esthetic choice. If something is absurd, it's much more absurd if it's repeated . . . repetition does enlarge or increase or exaggerate an idea or purpose in a statement.[26]

In 1967 Hesse made *Repetition Nineteen,* in which nineteen nearly identical buckets are scattered about the floor. That same year she discovered latex rubber, a sensuous and flexible but impermanent material. The following year she also began working with fiberglass.

These interests are all apparent in *Vinculum I* (Figure 77), created in the last year of her life, when she was quite ill. This piece consists of two ladders made of irregularly shaped fiberglass units. The two forms are joined by rubber tubing strung horizontally between them and tumbling down loosely on the floor. A "vinculum" is defined as a connecting bond or tie. In mathematics, it is a horizontal line placed over two or more members of a compound

FIGURE 77. EVA HESSE.
Vinculum I. 1969. Fiberglass,
rubber tubing, metal screen. 8′
× 8″ × 2′. Collection of Mr.
and Mrs. Victor W. Ganz.

quantity to show that they are to be treated together. Thus, the rubber tubing in this work forms a vinculum between the grid units, both formally and in the literal sense of tying or binding the two units together.

Vinculum I is typical of Hesse's creations in that it incorporates formal opposites: the hard fiberglass units contrasting with the soft and pliable rubber tubes. Hesse had this to say about her use of opposites:

> . . . absurdity is the key word. . . . It has to do with contradictions and opposi-
> tions. In the forms I use in my work, the contradictions are certainly there. I was
> always aware that I should take order versus chaos, stringy versus mass, huge
> versus small, and I would try to find the most absurd opposites or extreme
> opposites. . . . I was always aware of their absurdity and also their formal con-
> tradictions, and it was always more interesting than making something average,
> normal, right size, right proportion. . . .[27]

The use of rubber tubing and fiberglass materials for the creation of sculpture is extremely innovative. Another innovation is the way this work simply leans against the wall. Hesse's objects often hover ambiguously between two-di-mensional painting and three-dimensional sculpture. This work is quite flat and the tubing is very linear. It cannot stand by itself—it must lean against the wall, yet it is neither a painting nor a relief, artistic forms which are usually hung on a wall.

The sculpture of Eva Hesse challenges many traditional attitudes concerning our expectations of the appearance of a piece of sculpture and the materials used in its construction. In a witty and understated way, Hesse's works are revolutionary, transforming the medium and the intellectual approach to the creation of a work of "art."

LOUISE BOURGEOIS (1911–)

Since the late 1940s Louise Bourgeois has created works of sculpture that express a highly personal symbolic system. Unaffected by the successive art movements that have dominated the art world since World War II, she has pursued personal goals, tenaciously seeking formal equivalents for the constants underlying the human condition. Working in a wide variety of media, ranging from traditional sculptural materials, such as marble, wood, and bronze, to impermanent latex, Bourgeois's works explore the relationship between man and woman and the concept of androgyny, as well as seeking equivalents for emotional states.

Bourgeois was born in France into a family in which her artistic talents were not only recognized but put to use. Her parents restored Aubusson tapestries, and her job as a child was to draw in the missing parts to guide the weavers. She received a classical education at the Sorbonne, where she studied philosophy and geometry. She also studied art history at the Ecole du Louvre. She acquired academic training in the fine arts at the Ecole des Beaux-Arts, which she attended from 1936 to 1938. She moved to New York in 1938 and has lived there ever since.

In the late 1940s Bourgeois created simple wooden structures that convey a powerful and eerie presence. *The Blind Leading the Blind* consists of a double row of upright wooden posts that taper to pointed "feet." The posts are connected by an irregularly shaped lintel. The almost uniform uprights are easily interpreted as anonymous, unindividualized persons. The lintel binds them together, turning the separate posts into an architectural structure. Painted black, like Nevelson's later constructions, the work conveys a sense of monotonous menace. It is interesting and relevant that this work was created during the McCarthy Era, around the time when Bourgeois, Duchamp, and other artists were being investigated by the House Committee on Un-American Activities. It reflects the paranoia about communism that had temporarily seized the government machinery of the United States.

The use of a group of regular units is also seen in Bourgeois's "Cumulus" series from the late 1960s (Figure 78). In these works, most of which are carved in marble, rounded forms seem to be bursting through or growing out of undifferentiated matter. Like spores emerging from a sac, or a penis becoming erect, these rounded forms, which also could be interpreted as

FIGURE 78. LOUISE BOURGEOIS. *Cumul I.* 1969. Marble. 22⅜ × 50 × 48″. Photo courtesy of the artist and the Musée National d'art Moderne, Centre Georges Pompidou, Paris.

breast shapes, are symbols of a life force. They evoke a sense of eclosion and androgynous generation.

Bourgeois's works do not fit within a stylistic movement or a neatly defined category. She has worked in a wide variety of media and in a range of different styles, adjusting her formal means to fit her expressive intent. She deals with the most fascinating questions of the human spirit—the relationship between the sexes and the relationship of the individual and the society in which he or she lives. Honored with a major retrospective of her works at the Museum of Modern Art in 1982, Bourgeois's contribution to the history of sculpture has only recently been ully appreciated.

12

1970 to the Present

The energy and force of the women's liberation movement in America in the early 1970s generated new subjects, techniques, and energy for women artists. Largely bypassed by the coolly rational and ironic aesthetics of Pop Art and Minimalism, women artists began impacting very directly on the art world as a whole. In 1980, one critic looking back on the decade confidently proclaimed: "For the first time women are leading, not following."[1] That leadership role occurred in a number of different media and directions exemplified by the artists included in this chapter.

Women artists first began incorporating subject matter derived from personal experience into the work of art. This inaugurated a shift from Minimalism to the recent era, known as "Pluralism" or "Post-Modernism." Frequently subjects were autobiographical and focused on the specific experiences of being female. In an effort to integrate the private realm with the public activity of the art work, women artists adopted the slogan "The personal is the political." As one male artist succinctly observed: "Women have made subject matter legitimate again."[2]

Women artists employed a wide range of media for the expression of content. Whether it appeared in the traditional forms of painting or sculpture or in the rituals of performance art, the validity of using material summoned from the artist's life as a woman had immense consequences for the entire art world.

Some women used their own faces or bodies in their art works, pioneering a new category of art known as "body art."[3] Body art works usually involve an examination of female sexuality or a satirical comment on stereotypically female roles. As developed by both European and American artists, women's body art was very different from that created by men. While

male artists, such as Vito Acconci, Bruce Nauman, or Dennis Oppenheim, often enacted some form of self-mutilation in their "body art" works, women artists, such as **Carolee Schneeman** and **Mary Beth Edelson,** used their nude bodies in a more positive manner to proclaim the power of female sexuality.

Some women artists used their feminist consciousness to generate works of specific political intent. **Judy Chicago** channeled her knowledge of women's history into the monumental installation work *The Dinner Party.* Her close colleague and collaborator from the early 1970s, **Miriam Schapiro** combined sensitivities to the decorative potential of fabrics and the history of women's culture to become one of the leaders of "pattern painting." For artists of both sexes, renewed interest in the "decorative arts" and the formal potentials of patterning was allied with the exploration of craft media often practiced by women and generally devalued by comparison with the "fine arts" of painting, sculpture, and architecture.

Simultaneously, several African-American artists created styles and subjects identifiable with the special concerns of American black women. The works of **Bettye Saar** and **Faith Ringgold** examined the double oppression of being both black and female. Their works express attitudes toward racial discrimination and sexism from a specifically feminist viewpoint.

A search for sources of inspiration outside the traditional materials and subjects of sculpture led to the revitalization of the craft technique of weaving in the works of the Polish artist **Magdalena Abakanowicz.** Recognized as the foremost fiber artist in the world, Abakanowicz has created an extensive oeuvre of monumental sculptured objects from natural fibers. The early sculpture of **Nancy Graves** also springs from a rejection of the premises of modern technological society in favor of the exploration of an ahistorical, natural world. Like Abakanowicz's art, Graves's camels and sculptures based on fossil remains restore a connection between the art object and the continuity of nature.

A similar rejection of technological society characterizes the Earthworks of **Alice Aycock** and **Nancy Holt.** Both artists moved outside the gallery spaces of the art world to design site sculpture which required the viewer's interaction with geological and cosmic forces.

The search for personal identity and a heightened feminist awareness of the power of media-manipulated imagery unifies the art activities of performance artists **Carolee Schneeman, Eleanor Antin, Suzanne Lacy,** and **Leslie Labowitz,** active in the 1970s and the second-generation feminist concerns of **Cindy Sherman** and **Barbara Krugar.** Performance artists invented an entirely new art form to explore autobiographical aspects of woman's condition, invent neoprimitivist rituals connecting contemporary women to a mythological, matriarchal past, or highly self-conscious political happenings designed to change the immediate conditions in which women lived. The "deconstruction" of gender roles characterizes the art of Cindy Sherman and Barbara Krugar. Developing out of the concerns of body art of the early 1970s,

Sherman alters her own appearance to become the "actress" in her photos. These psychodramas stress the importance of culturally defined stereotypes of femininity and behavior as generated by the popular media of film, photography, and television. Barbara Krugar manipulates pre-existing media images with self-written texts that pierce the ideology of patriarchy in very agressive ways.

The traditional medium of painting has retained its viability in the works of many women artists from the late 1970s into the 1980s. **Audrey Flack,** like Richard Estes and Don Eddy, is one of the major figures in the 1970s movement known as Photo Realism, Super Realism, or New Realism. These artists use color slides as sources for paintings created with an airbrush and thus related in appearance to large-scale advertisements, such as images on billboards. Rather than selecting a given scene from her environment, like other Photo Realists, Flack's paintings are still lifes that employ a highly personal content, often derived from her sensitivity to the experiences of women.

The prominent leadership role of women in the 1970s experienced a setback in the 1980s. As opposed to Earthworks, conceptual art, and performance art, so prevalent in the 1970s, according to one critic, "the 1980s were about the re-instatement of painting as a dominant mode of expression and, with it, the tradition of the heroic male artist."[4] Neo-Expressionism was the first major painting movement to attract critical attention and achieve commercial success in the 1980s. **Susan Rothenberg** is the only woman who has received recognition in this movement. The neoexpressionist canvases of Rothenberg containing a generalized form, most often a horse, have elevated her to superstar status in the art world. Her very individual canvases satisfy formalist concerns for richly painted surfaces and the desire for content of the "New Image" painting, using personal, though not specifically feminist, imagery.

Another painter who emerged in the 1980s is **Elizabeth Murray.** Her artistic vocabulary is abstract, employing biomorphic forms often paired with a witty personal content.

This chapter closes with the outstanding achievement of the *Vietnam War Memorial* designed by **Maya Ying Lin,** then an undergraduate at Yale University. Perhaps no other work of art has impacted so directly on so many people as this very special monument to those who died in the Vietnam War.

While critical consensus identifies the 1970s as an extremely active and fruitful epoch for women artists, this situation began to change in the early 1980s.Coinciding with the political rise of Reagan and the Moral Majority, coupled with the defeat of the ERA amendment, the cultural backlash against women artists was in full force by 1984, the year of the enormous inaugural exhibition of the newly refurbished Museum of Modern Art in New York. In that international survey of trends in the arts, only 14 of 150 works were by women. The underrepresentation of women in that major show stimulated the formation of the "Guerrilla Girls," an anonymous activist group who appear

in public wearing gorilla masks. They are the self-proclaimed "conscience of the art world." The Guerilla Girls are the latest chapter in the struggle of women artists for recognition and equality in the most prestigious institutions of the art community. The abysmal record of the Whitney Museum in showcasing women artists has been a specific target of their attacks.

The declining fortunes of women artists in the 1980s can be measured economically. Funding by the National Endowment for the Arts for women artists' organizations such as cooperative galleries, declined 35 percent between 1982 and 1985.[5] According to a recent NEA report, women artists make an average annual income of less that half that of men. While 38 percent of practicing artists are women, only a very tiny minority have been able to maintain public careers as artists.

In the spring of 1987 the National Museum of Women in the Arts opened to the public in Washington, D.C., with a major historical exhibition of American women artists.[7] The establishment of this institution has reopened the debate over the role of women artists and feminism in the art world.[8] Many people feel that the "ghettoization" of work by women in a separate museum is not a positive move. Others feel that the concept is valid only if the museum functions on a feminist agenda, working to improve the situation of living artists. The politically conservative founder, Mrs. Willamina Cole Holladay, whose private collection forms the core of the museum's permanent collection, has publicly refused to use the museum as a feminist forum.

Whatever the 1990s have in store for women artists, it is clear that women will no longer passively await the rewards of recognition in the art world. New times demand new strategies, and this author is confident that women artists will make themselves heard and seen, in future decades both within and outside of the systems and institutions of the art world.

Finally, the author wishes to remind the reader that the artists discussed in this chapter are not the only women creators to make important contributions to contemporary art. They have been selected for detailed discussion because each figure is an outstanding representative of a major avant-garde movement in contemporary art history. The achievements of these few artists do not represent the total contribution of women to the visual arts. There are many other women artists working today whose works are also worthy of attention and recognition.

THE FEMINIST ART MOVEMENT OF THE 1970s

The history of a contemporary feminist art movement is generally traced back to 1970, the year Judy Chicago founded the first feminist studio art course at Fresno State College in northern California. It is also the year that Judy Gerowitz abandoned the patriarchal association of her father's name and se-

lected the surname "Chicago" from the city of her birth and initial formal education at the Chicago Art Institute. That same year she showed the first images characterized by the central openings of vaginal imagery, which would dominate her art for the next decade. The following year, in 1971, she teamed up with Miriam Schapiro, who had been living in California since 1967. Together they developed a feminist art program at the California Institute of the Arts in Valencia.

The energy generated from these pedagogical experiments led to the communal art installation known as *Womanhouse*. Working with a team of students from the University of California, Schapiro and Chicago supervised the renovation of a run-down building in Hollywood designing installation works in each of the rooms. The walls and ceiling of the "Kitchen" (by Robin Weltsch) were covered in breast-shaped eggs. Schapiro, in collaboration with Sherry Brody, created a dollhouse whose forms and fabric elements would influence the course of her art for the next few years, while Chicago created the more aggressive "Menstruation Bathroom." Set into the sterile white environment of the typical American bathroom, a garbage can contained the evidence of female menstruation cycles.

These artists' distinct contributions to *Womanhouse* are illustrative of the diverse directions their feminist art would take during the 1970s. *Womanhouse* was a catalytic force for Los Angeles's women artists' community and led directly to the founding in the following year, 1973, of the Los Angeles Woman's Building, still in operation, although in a different locale.

JUDY CHICAGO (1934–)

Chicago's collaborative activities culminated in the design and execution of the most monumental and well-publicized individual work to emerge out of this ferment of feminist activism in California. *The Dinner Party* (Figure 79) was conceived in 1974–75, exhibited at the San Francisco Museum in 1978, and travelled around the country, finally arriving at the Brooklyn Museum, New York, in 1980.

This major installation work is composed of a large triangular table, stretching 48 feet on each side. The triangle was selected as the earliest symbol of female power and the sign of the goddess. Each arm of the equilateral triangle supports thirteen place settings. The thirty-nine women selected for this homage range from the early series of goddesses, through Eleanor of Aquitaine, Christine De Pisan, the noted feminist of the early fifteenth century, Artemisia Gentileschi and Sojourner Truth to the diverse achievements in the twentieth century of Margaret Sanger and Georgia O'Keeffe. Each of these place settings consists of a porcelain plate, 14 inches in diameter, de-

FIGURE 79. JUDY CHICAGO. *The Dinner Party.* Thirty-nine porcelain place settings on embroidered fabric runners. 48′ × 48′ × 48′. © Judy Chicago, 1979. Photo by Michael Alexander.

signed by Chicago to reflect the specific achievements and experiences of these historic figures. The designs of all the plates are based on the central, vaginal imagery so critical to Chicago's aesthetic.

One of the most remarkable aspects of *The Dinner Party* was the complex and beautiful needlework runners that form a major part of the ensemble and were executed by over one-hundred skilled needleworkers. The use of China plate painting and needlework as the key components of this piece form a self-conscious reevaluation of "craft" media, most often practiced by women and barred from consideration as "fine art."

The monumental table is set on a raised platform, covered with 2,300 hand-cast tiles, on which are written the names of an additional 999 significant women in history.

Chicago's ambitious goal for this work was didactic and, in turn, political. By educating women about their unique contributions to history, she hoped to spark social change in today's world.

> So my *Dinner Party* would also be a people's history—the history of women in Western civilization. . . . I had been personally strengthened by discovering my rich heritage as a woman and the enormous amount of information that existed about women's contributions to society. This information, however, was totally outside the mainstream of historical thought and was certainly unknown to most people. And as long as women's achievements were excluded from our understanding of the past, we would continue to feel as if we had never done anything

worthwhile. This absence of any sense of our tradition as women seemed to cripple us psychologically. I wanted to change that, and I wanted to do it through art.[9]

Whatever reservations one might have concerning the obsessive repetition of vaginal imagery and difficulties in viewing the needlework runners caused by the closed triangular form of the table, *The Dinner Party* fulfilled Chicago's expectations. Shown around the country, it impacted on a very large number of viewers, demonstrating the potential of a work of art, if it was large and clear and strong in its message, to touch the lives of many people in a very direct, immediate way.

MIRIAM SCHAPIRO (1923–)

Miriam Schapiro's contributions to the feminist art movement and the entire school of painting known as "pattern painting" or "decorative art" is well established. Her monumental compositions, which deal directly with the objects and life experiences of women, have received regular and consistently positive critical appraisals. Her ability to generate symbols based on historically grounded artifacts of women's life experiences provides the most convincing case for the existence of a woman's culture that has survived and flourished through the centuries of patriarchy.

Formally trained at Hunter College, Schapiro received her M.A. in fine arts from the University of Iowa in the early 1950s. Throughout that decade, she worked in an Abstract Expressionist style that contained very veiled references to the human figure. Despite the execution of a large series of paintings in 1960 and 1961, which incorporated the personal symbol of the egg and the house as confining structure, by 1965 the artist had succeeded in erasing all personal metaphor and iconography from her abstractions.[10]

A turning point in her development occurred with the creation of the mural scaled *Big OX #1* in 1968. The painting is dominated by an orange structure, hexagonal in shape, whose orifice is edged in a modeled pink. Four orange arms stretch to the corners of the composition, forming the "X" to the hexagon's "O" of the title. Despite the hard-edged style, the coloration and central imagery identify this transitional work as one loaded with female body imagery.

Her collaboration with Judy Chicago was a catalyst for Schapiro. After executing the dollhouse in 1972 (with Sherry Brody), which was exhibited in *Womanhouse,* Schapiro began to explore and exploit the potential of patterned fabric to carry beauty and significance in a high art context. By 1973–74 she had developed a style that combined fabric collage and painting, structured within an architectural framework. She named her new formal interest "Fem-

mage": collages developed from materials and themes of concern to the lives of women. Bridging her return to New York in 1976, Schapiro worked on a series known as "Collaborations," which incorporated reproductions of works of art by women artists of the past.

Between 1976 and 1979 Schapiro exhibited a series of monumental works based on the form of the kimono, the fan, and the robe (i.e., the "Vestiture" series). These magnificent, impressive, and monumentally scaled works break down any meaningful distinction between the concerns of abstraction and the "merely" decorative use of patterning in craft objects or fabric design. Like the nineteenth-century American quilts, these works set new standards as complex abstract statements. Schapiro was now one of the leading figures in the postmodernist movement known as "pattern painting," defined by John Perrault in the following way:

> Pattern painting is non-Minimalist, non-sexist, historically conscious, sensuous, romantic, rational, decorative. Its methods, motifs, and referents cross cultural and class lines. Virtually everyone takes some delight in patterning, the modernist taboo against the decorative notwithstanding. As a new painting style, pattern painting, like patterning itself, is two dimensional, non hierarchical, all over, a-centric, and aniconic. It has its roots in modernist art, but contradicts some of the basic tenets of the faith, attempting to assimilate aspects of Western and non-Western culture not previously allowed into the realms of high art.[11]

Schapiro's role as a key generator of this new interest in pattern, which became widespread among a number of artists in the second half of the 1970s, cannot be overestimated.

An outstanding example of a fully developed "pattern painting" is the *Barcelona Fan* (Figure 80). Stretching twelve feet across and six feet high, this enormous work is composed of alternating light and dark bands, which generate a continuous and rhythmic movement across the surface. The semicircular shape is divided into four major sections, each composed of alternating strips of fabric. Unity from the core to the outer edges is maintained by the continuity of linear elements from the "handle" to the edge. The *Barcelona Fan* is dazzling in its red and gold richness of flowered brocade. The form of the fan metaphorically reveals the unfolding of woman's consciousness, and was exhibited with the "Vestiture" series which presents "ceremonial robes to celebrate the new meaning of womanhood."[12] These works presented the artworld with a new use of fabric and a new definition of the "decorative" and its inescapable significance as "high art," as well as symbolic images suffused with feminist relevance.

Since 1984, Schapiro has restored a more specific human imagery to her art, creating brilliantly colored and patterned images of the "creative woman." Based on the theme of the artist as performer, often set on a stage, these works open a new chapter in Schapiro's career, retaining the sense of personal imagery and formal decorative power developed through the 1970s.

FIGURE 80. MIRIAM SCHAPIRO. *Barcelona Fan.* 1979. Fabric and acrylic on canvas. 6 × 12″. Photo courtesy of Miriam Schapiro.

FEMINISM, POLITICS, AND THE AFRICAN-AMERICAN ARTIST

Bettye Saar (1926–)

Bettye Saar is one noted African-American artist who developed a personal style to convey her distinctive vision outside the realm of the "fine arts" and the traditions of Western art. Born in Los Angeles, she studied art at Pasadena City College, graduating in 1949. During the 1950s she raised a family, but in the 1960s she began making constructions in boxes. Inspired by the works of Joseph Cornell, Saar gathered together objects, fabrics, and other bits and pieces with which she composed her imaginative tableaux. Using this assemblage technique, Saar discovered the formal means by which she could best express a personal content. In the mid-1960s and early 1970s Saar focused on the ready-made stereotypes of black people promoted by white society to make her political statements. In some works she used "Uncle Tom" or "Little Black Sambo" or "Aunt Jemima." In *The Liberation of Aunt Jemima* (Figure 81), Saar explodes the myth of the "good house nigger."[13] Aunt Jemima holds a broom in one hand and a rifle in the other. The anger and violence of the black revolution is here given a forceful symbol.

Faith Ringgold (1930–)

Faith Ringgold is an artist of impressive talents who also developed her personal style outside the Western Renaissance tradition. Born in Harlem,

FIGURE 81. BETTYE SAAR. *The Liberation of Aunt Jemima.* 1972. Mixed media. 11¾ × 8 × 2¾" (29.8 × 20.2 × 6.8 cm). University Art Museum, University of California, Berkeley, CA. Purchased with the aid of funds from the National Endowment for the Arts (Selected by the Committee for the Acquisition of Afro-American Art). (UAM 1972.84)

Ringgold studied art at the City College of New York. Like Saar, Ringgold's education was acquired through the subsidized public schools for higher education. In the mid-1960s, inspired by the political upheavals of the civil rights movement, Ringgold painted a 12-foot-wide mural entitled *Die* (Figure 82). Using flat, unmodulated colors, Ringgold achieves a decorative and original style for a vision of interracial violence. While black and white adults attack each other, two children huddle together in the center of the composition hoping to survive the massacre.

Ringgold recalls that she became a feminist in 1970, when she launched a protest against an all-male exhibition at the School of Visual Arts in New York, in itself designed to protest war, racism, and sexism. Ringgold's feminism became incorporated into her art in 1973, when she abandoned oil painting and began making soft sculpture using sewing and other craft techniques. Her mother had been a fashion designer, and Ringgold recalls that when she was young her mother was always sewing. However, it was the feminist movement that sanctioned her use of these techniques for the creation of art. "If I'd been left alone, I'd have done my own kind of thing earlier, based on sewing. As it was, it wasn't until the Women's Movement that I got the go-ahead to do that kind of work."[14] During this time she had been teaching

FIGURE 82. FAITH RINGGOLD. *Die.* 1967. Oil on canvas. 72 × 144″. Photo by Malcolm Varon, New York City. Reproduced by permission of the artist.

African crafts, such as beadwork, appliqué, and mask-making, at the Bank Street College in New York. Combining this interest in African crafts with her feminist consciousness of traditional women's art, she decided to make soft sculptures based on her memory images of black people. The results are the group of works known collectively as the "Family of Women" (Figure 83). Using a variety of techniques, needlepoint, braided ribbon, beading, and sewn fabric, these images are imaginative presences with foam bodies. They are dressed in African-inspired clothing, and the sewn faces are derived from African masks.

Drawing on her heritage as both an African-American and a woman, Ringgold has evolved a set of original images that speak directly of her personal experiences.

POST-MINIMALISM: NEW DIRECTIONS
FOR SCULPTURE

Magdalena Abakanowicz (1930–)

The works of Magdalena Abakanowicz are one of the most persuasive reasons to abandon any inherent devaluation of craft from the "fine art" of sculpture. The Polish artist is today widely recognized as the foremost artist working with fiber. She has built an international reputation since the 1960s, moving from her initial medium of weaving to sculpture in fiber and wood.

Born into an aristocratic family of the Polish landed gentry,

FIGURE 83. FAITH RINGGOLD. *Mama Jones, Andrew, Barbara, and Faith.* 1973. Mixed media, life size. From the "Family of Women," series. Photo by Faith Ringgold. Reproduced by permission of the artist.

Abakanowicz's youth was spent in the upheavals of World War II and its aftermath in Poland. She studied from 1950 to 1954 at the Academy of Fine Arts of Warsaw without finding a clear direction as an artist. It was only in the early 1960s, on a borrowed loom, that her original vision found its means of expression. Exhibiting regularly in the Lausanne Biennial of Tapestry from 1962 through 1979, she began to receive international recognition for her extraordinary creations.

Her first major works were the huge woven structures known as *Abakans*. These enormous, freely hanging objects, full of slits and negative spaces, exist in three dimensions and transform the medium of tapestry into the realm of monumental sculpture. They signaled a new set of possibilities for the use of fiber. Beginning in 1973, Abakanowicz abandoned the loom and the weaving process while maintaining the use of natural organic fibers, now pressed into molds. The "Seated Figures" and "Backs" series are evocative symbols of community and anonymity, individuality and similarity.

Mary Jane Jacob, curator of the major retrospective exhibition that traveled about the United States and Montreal from 1982 to 1984, identifies *Embryology* (1978–80) (Figure 84) as Abakanowicz's masterpiece.[15] Composed

FIGURE 84. MAGDALENA ABAKANOWICZ. *Embryology.* 1978–80. Collection of the artist. Photo by Jan Nordahl, Sodertalje, Sweden.

of hundreds of rounded forms of various sizes, the shapes are cut and stitched. Some are closed opaque shapes covered in rough burlap. Others are semi-transparent gauze covered forms that reveal their interior stuffing. Composed of hand-made thread that the artist soaked, dyed, rinsed, and dried in a complex process, "the cycle is about the process of birth and growth in human beings and in nature and the changes that bodies or earth undergo when cut or altered."[16]

Abakanowicz has described her associations connected with her chosen medium in the following statement:

> I see fiber as the basic element constructing the
> organic world on our planet,
> as the greatest mystery of our environment.
> It is from fiber that all living organisms are built—
> the tissues of plants, and ourselves.
> Our nerves, our genetic code,
> the canals of our veins, our muscles.
>
> We are fibrous structures.
> Our heart is surrounded by the coronary plexus,
> the plexus of most vital threads.
>
> Handling fiber, we handle mystery.[17]

Although Abakanowicz has used the fibrous, natural material of wood in some sculptural pieces created in the 1980s, her reputation and artistic identity is rooted in her sensitivity to the sculptural possibilities and expressive potential of fibers.

Nancy Graves (1940–)

Nancy Graves made her first appearance in the art world with the exhibition of life-sized camels, frozen in midmotion, in 1968. While living in Florence, Italy, in 1965, Graves was inspired by the wax sculptures of an eighteenth-century anatomist, Clemente Susini. Sensing the sculptural possibilities of a recreation of the world of natural forms, she began her exploration of the camel, which would result by 1970 in the fabrication of twenty-five full-scale beasts.

Graves pursued an intensive study of the anatomy of these animals and constructed them on wooden armatures, using sheep and goat skins. Although the artist was quite conscious that these sculptures were not exact replicas, their scale, pose, and naturalistic components made them appear as effigies of the awesome beasts.[18] In the rarified atmosphere of the New York art world, then dominated by Minimalism, the camels brought sculpture back in touch with the vital world of organic nature in the most direct way possible.

Between 1969 and 1971 Graves made a number of works based on the forms of camel bones. Investigation of the camel skeleton led, in turn, to an interest in the fossilized prehistoric camel skeleton in the collection of the Natural History Museum in Los Angeles. After making two films in Morocco, which focused on the movements of camels, Graves created *Variability of Similar Forms*. This work combined her interest in fossilized skeletons with the illusion of motion. Originally fabricated in wax over a steel armature and painted white, the piece was reworked several years later and then cast into bronze with a white patina developed by Ron Young of the Johnson atelier in Princeton, New Jersey. *Variability and Repetition of Similar Forms II* (Figure 85) is the resulting work, which now can function as an outdoor sculpture. This piece is composed of thirty-six camel legs, which both retain her desire for a close connection with the natural world and become isolated linear forms of pure motion. The clear intent to create an illusion of motion was inspired, according to Graves, by the nineteenth-century time-lapse studies of animal and human locomotion of Muybridge.[19] Each leg is subdivided into thirds by two joints. While the bottom portion of each is identical, the upper sections are taken from both front and back legs of the prehistoric beast. The legs are positioned in a variety of different angles, so the effect of motion is inescapable.

Since 1979 Graves's desire to utilize objects and forms from the real world of living nature has found expression in over two-hundred sculptures cast directly from objects selected from the plant and animal world. Her

FIGURE 85. NANCY GRAVES. *Variability and Repetition of Similar Forms II.* 1979. Bronze with white patina and corten steel base. 72 × 144 × 192″. Collection Akron Art Museum, purchased with the aid of the Museum Acquisition Fund, the Mary and Louis S. Myers Foundation, the Firestone Foundation, and the National Endowment for the Arts. Photo by Rick Zaidan.

extraordinarily vitalistic sculptures employ plant leaves, vines, carob beans, sardines, and oyster shells among many other selected objects, which are then brightly colored.

The sculpture of Nancy Graves has been appreciated by a wide audience and received positive critical evaluation, culminating in a major traveling exhibition of her works in 1987 and the simultaneous publication of a catalogue raisonné. Her sculptures seem to satisfy a need for renewal with nature while exploring the full range of the formal possibilities of welding implicit in the works of David Smith. Graves has developed an oeuvre that constantly surprises and seems endlessly inventive, yet springs from the multiplicity of forms in the natural world itself. These works translate the childlike awe and sense of wonder at the organic world into sophisticated sculptures of wide appeal, communicating a sense of a vitalistic life force.

Earthworks and Site Sculpture

Women artists have been important participants in the movement, which began in the late 1960s and early 1970s to connect the work of art with a direct experience of the earth itself, outside of the gallery space. Rejecting the high-

tech look and focus of Minimalism, earth sculptors introduced a new sense of geological and prehistoric time into their art. In the key works of both Nancy Holt and Alice Aycock, the direct participation of the viewer is absolutely essential for completion of the work of art.

Alice Aycock (1946–)

Alice Aycock's first large outdoor sculpture was the *Maze* (1972), a twelve-sided wooden structure thirty-two feet in diameter and six feet high. This work was specifically intended to evoke the panic of entrapment in the viewer. The following year, Aycock designed the first structure in which the viewer had to crawl along the ground to experience the work. The viewer entered *Low Building Made with Dirt Roof (for Mary)* through a doorway only 30 inches high, which was the tallest point of the structure, whose other dimensions were 20 by 12 feet. Like the *Maze,* the panic of claustrophobia was part of the intended result. But as Lippard has noted, Aycock's low buildings evoke both the fearful and hopeful aspects of the cave: fear in terms of claustrophobia, entrapment, and absorption and hopeful in the prehistoric sense in which caves were magical precincts located within the body of the Earth Mother. It is believed that in prehistoric times, caves were viewed as protective environments. They were the sites of fertility and childbirth rituals.[20]

Nancy Holt (1938–)

Nancy Holt's most famous and seminal site sculpture, *Sun Tunnels* (Figures 86 and 87) shares an isolated, barren desert setting with works by Smithson, Heizer, and de Maria. Its form is determined by a precise interaction with the environment to a much greater extent than most other works in this category. Like Aycock's site sculptures, *Sun Tunnels* and Holt's other works require a level of human interaction far beyond that of most other site sculptures.

Born in Massachusetts, Nancy Holt lived and worked on the East Coast until 1968, when, in the company of Robert Smithson and Michael Heizer, she traveled west to the Salt Lake deserts of Utah. According to her own recollection, "As soon as I got to the desert, I connected with the place."[21] Five years later she began a search for a site to install a set of four monumental concrete tubes, which would become the *Sun Tunnels.*

Sun Tunnels evolved naturally out of Holt's earlier invention of the concept of "locators." Not sculpture in the traditional sense of an object to be looked at, Holt's locators are meant to be looked *through.* The artist thus provides a means of controlling the viewer's perceptions of a given view or space. In 1972 she positioned eight locators at Missola Ranch in Montana and one at Narragansett Beach, Rhode Island.

Sun Tunnels consists of four huge concrete pipes 18 feet long and slightly over 9 feet in diameter. Each pipe rests on a buried concrete foundation. The

FIGURE 86. NANCY HOLT. *Sun Tunnels.* 1973–76. Overall length 86′. Tunnel lengths 18 × 9′. Photo courtesy of the artist.

four pipes are arranged in an X configuration which, at its longest point, reaches 86 feet. The positioning of these pipes was determined with the help of an astrophysicist using the position of the sun at its most extreme points from the earth—the summer and winter solstices. Like a modern Stonehenge, giant

FIGURE 87. NANCY HOLT. *Sun Tunnels,* (interior view). Photo courtesy of the artist.

shapes brought from a different place were erected to assist the primordial human need to comprehend the cycles of the universe.

The complexity of *Sun Tunnels* is increased when one becomes aware of the configuration of holes 7 to 10 inches in diameter drilled through concrete pipes that are 7 inches thick. The positions of these holes were determined by the location of stars forming four constellations. By day, the drilled holes permit sunlight to penetrate the tubes, casting elliptical forms on the inner surface (see Figure 87). At night, when the moon is over a quarter, paler light forms may also be observed in the tubes. Like Monet's complex inversions of air and sky in the *Waterlilies* murals, Holt has "turned the world upside down" in an innovative way. She also transforms sunlit day into darkened night inside the protective shelter of the pipes.

Thus, *Sun Tunnels* is not a sculpture positioned in the desert but an observatory, which requires the participation of the viewer to function. According to the artist, one of the major goals of *Sun Tunnels* is the desire to bring "the vast landscape back to human proportion."[22] The larger openings at the ends of the pipes and the smaller drilled holes frame and limit the landscape vistas, defining a new relationship between the viewer and the vastness of the earth. Another way that Holt reconciles the imposition of these large, commercially fabricated objects into this uninhabited desert vastness is through the materials employed. She notes, "The color and substance of the tunnels is the same as the land that they are a part of. . . . "[23]

In her account of the creation of *Sun Tunnels,* Holt details the complex process and collaboration with technicians necessary for the creation of the Earthwork. She harnessed modern technology to achieve a goal that stretches back into prehistory. This compression of time is another factor of relevance to the conception of this work. In her account, Holt notes the way time is made visible in the desert: "The rocks in the distance are ageless: they have been deposited in layers over hundreds of thousands of years. 'Time' takes on a physical presence."[24]

More recently, Holt created an observatory monument in a much more urbanized location. *Dark Star Park* in Rosslyn, Virginia, a suburb of Washington, D.C., is sited on a ⅔-acre plot amid high-rise office buildings. Here the artist has positioned large concrete spheres, posts, and tunnels, creating another environment that mediates between roads, buildings, and the cosmic forces of the universe.

PERFORMANCE ART

During the 1970s, women artists interested in both exploring their gender-defined identities and in changing society's attitudes and behavior towards women turned to a totally new art form known as "performance art." As

Moira Roth, the historian of this movement, defines it, performance art is "a hybrid form which combines visual art, theater, dance, music, poetry and ritual."[25] The presence of one or more performers, an audience, and the execution of the work in real time and space provides the performance artist with an immediacy and concrete reality appropriate for the communication of feelings, beliefs, and concepts that would receive much more highly abstracted representation in the traditional media of painting or sculpture.

Roth has identified three major trends in performance art of the 1970s. This "Amazing Decade" for women saw performance artists exploring autobiographical sources, the "personal clutter" of everyday lives as valid material for a work of art. The belief that the "personal is the political" lent a broadened significance to these performance pieces. A second trend focused on the developing interest in prehistoric matriarchies, goddess worship, and other forms of women's spirituality via the staging of rituals. The third trend involved highly structured events with a well-defined feminist political intent. Such events are intended in Lacy and Labowitz's term to serve as "models for feminist action."

By 1972 there were active centers of performance art on both the east and west coasts. Many performance events focused on the expression of personal feelings and experiences about the performers' lives as women. Such works have no equivalent in the aggressive "Body Art" of male artists such as Vito Acconci or Chris Burden. As precedents to concerns later explored by Cindy Sherman, "Women performers made attempts to study, expose, mock, and challenge stereotyped images of women."[26] Carolee Schneeman, a filmmaker, and Eleanor Antin are among the leading performance artists in this trend. In 1975 Schneeman performed "Interior Scroll." Standing in the nude, she extracted a text from her vagina and defended and explained the need for the exposure of the personal in art. Eleanor Antin's art involves the development of a series of alter-ego personae, most notably a nurse and Eleanora Antinova, a black ballerina in Diaghilev's Ballet Russes. Primarily through the medium of performance, Antin explores these aspects of herself by playing out the lives of these fictional people.

Mary Beth Edelson is the most noted performance artist concerned with myths of female power in prepatriarchal, prehistorical cultures. The primary form in which she expresses these concerns is ritual. One of Edelson's most noted ritual pieces was staged in 1977 at the AIR gallery (a woman's cooperative gallery) in New York. The artist created a *Gate of Horn,* composed of photos of women's hands making the sign of the horn, the symbol of the Minoan great goddess, found at the Palace at Knosses (Figure 88). Participants in this ritual passed through this *Gate of Horn* to an interior space defined by a flaming ladder to perform the ritual piece *Proposals for: Memorials to 9,000,000 Women Burned as Witches in the Christian Era.* Edelson connected the persecution of women as witches with the patriarchal, Christian need to eliminate goddess worship. On Halloween women reenacted the medieval meetings of

FIGURE 88. MARY BETH EDELSON. *Gate of Horn/Fig of Tri-
umph.* 1977. Installation from *Proposals for: Memorials to the
9,000,000 Women Burned as Witches in the Christian Era.* Photo
courtesy of Mary Beth Edelson. Photo by Eric Pollitzer. © Mary
Beth Edelson, 1977.

witches and marched in procession, carrying long sticks holding candlelit
pumpkins.

Other rituals were created to be performed in isolation, made public only
through subsequent documentation. These private rituals often had more au-
tobiographical significance to the performers and sought a transformation of
personal circumstances into mythic dimensions.

The third trend, more overtly and directly political, was perfected by the
collaborative activity of Suzanne Lacy and Leslie Labowitz in Southern Cal-
ifornia. Labowitz spent five years in Germany during the 1970s, studying with

Joseph Beuys and developing a consciousness and experience in the pos-
sibilities of carefully staged events to force political, media, and popular atten-
tion on issues of key concern to women. Lacy had been involved in Judy
Chicago's feminist art program in Fresno in 1970 and also brought many years
of involvement with feminist issues to their collaboration. Spurred by the
crimes of the Hillside Strangler and the climate of fear being generated by the
news media, Lacy and Labowitz staged *In Mourning and In Rage* on the steps of
Los Angeles City Hall in 1977. A funeral procession first circled City Hall.
Then, nine seven-foot-tall women, veiled in black, emerged from the hearse.
Each of the nine black mourners read a statement that explicitly connected the
murders of the Hillside Strangler with the entire range of crimes against wom-
en perpetrated by our society. As each mourner read her statement, a tenth
figure, clothed in red, draped a red scarf around the black figure. The sur-
rounding chorus chanted, "In memory of our sisters, we fight back!" The
press was given a defined statement of the purpose of the event, and a list of
demands for women's self-defense was presented to members of the City
Council. In their explanation of the event, Labowitz and Lacy express their
concern about the images as well as the condition of women in our culture.[27]
They state three primary reasons for *In Mourning and In Rage*: first, to provide a
public ritual for women to share their grief and rage over the recent tragedies;
second, to provide a means for women's organizations and city government to
share in a collective expression against this violence; and third, to create a
media event controlled by the artists to permit a wider audience to learn of
their concerns. The political artists here harnessed the power of television,
radio, and written news media to communicate their viewpoint.

Breaking out of the confines and limitations of the traditional forms of
the visual arts, performance artists invented a new genre of art, one which
focused on the specific experience of women and spoke to those needs in a very
direct form of communication.

PHOTOGRAPHY

Cindy Sherman (1954–)

Using the medium of photography paired with the life-sized or larger
scale and color of painting, Cindy Sherman employs carefully staged pictures
to expose the artifices of imagery and the power of that constructed imagery to
manipulate the reality of women's lives. Since she began her career in 1977, her
works have received consistent critical appreciation, culminating in a retro-
spective exhibition organized by the Akron Art Museum and shown at the
Whitney Museum in New York in 1987. Part of the second generation of
feminists, her true subject is a deconstruction of film, magazine, and all forms
of popular imagery. As Lisa Phillips observed: "For Sherman the camera is a

tool with which to explore the condition of representation and the myth that the photograph is an index of reality."[28] Her most recent works explore the appearances of a loss of sanity and the deterioration of the human into first animal then vegetable decay, rot, and defilement.

Born in New Jersey and raised on Long Island, Sherman emerged in the art world in the late 1970s with a series of "film stills." In these black and white, 8 × 10 inch photos, carefully staged, and using herself as actress, Sherman changes her own appearance to create a frozen moment out of a fictitious, but implied, continuous film narrative. Borrowing from the imagery of *film noir* movies of the late 1950s and early 1960s, these works aggressively appropriate content and imagery in a postmodernist stance. Her art is meant to engage the viewer, forcing him or her into an involvement with the self-consciously ambiguous scenario only hinted at in the single image. As Ken Johnson has noted, these "anachronistic female role models" are given significance and potency as part of everyone's formative consciousness. "Through satire, she can admit to herself how compelling she finds the ultra-feminity of the 1950s—the image of women derived from her mother and her own psychological makeup."[29]

In 1980 Sherman began to use color, simultaneously enlarging the scale of the image. Her first fully mature series, the horizontal works of 1981, were inspired by pornographic centerfolds. Sparked by a request from *Artforum* to design a portfolio, these life-sized figures are "psychologically charged, unset-

FIGURE 89. CINDY SHERMAN. *Untitled #92.* 1981. Color photo. 2 × 4'. Photo courtesy of Metro Pictures, New York.

tling, and disturbing."[30] For example, in *Untitled #92* (Figure 89), an adolescent girl in dated clothing crouches anxiously on the floor gazing up at an unidentified, looming presence. Spotlighting isolates Sherman, the actress, and the looming black shadows rob the viewer of any clear sense of context. This work is characteristic of Sherman's production in its implied narrative and self-conscious ambiguity. It is an exciting, yet supremely frustrating, task for the viewer, forcing a personal projection, like a Rorschach inkblot, onto the image.

Following the highly theatrical and idiosyncratically colored scenes of the 1983 "Costume Dramas," Sherman's work begins a descent into a hellish world of madness and loss of rational control. Her images, still using herself as actress, are bizarre, distressing, and at times veering into the animal world. Her works from 1987 present a rotting landscape of death, decay, and waste. Here her presence has all but disappeared, in one work indicated only by a reflection in a pair of sunglasses. If Ken Johnson is accurate, Sherman's work "therapeutically releases the contents of psychic disturbance through the clarifying sanity of a prolifically inventive and witty theatrical, photographical and artistic practice."[31] This artist is just in midcareer, and one eagerly awaits the next phase in Sherman's creative development.

Barbara Krugar (1945–)

Like Cindy Sherman, Barbara Krugar's work deals with the power, sexual politics, and hidden meanings of images inherited from the popular media of films, television, and magazines. Unlike Sherman, Krugar does not assume the role of actress in constructed scenarios, but manipulates her "found" imagery. She combines these pictures with brief, pithy texts that she has written. This appropriation of images is an important trend in works by second-generation, postmodernist artists with well-developed feminist consciousness.

Born in Newark, New Jersey, Krugar studied with the photographer Diane Arbus for a short time at the Parsons School of Design. Encouraged by Marvin Israels, another teacher at Parsons, she secured a job as a graphic designer at Condé Nast publications, working on *Mademoiselle* magazine, which she designed between 1968 and 1972. This crucial experience gave Krugar the familiarity with media layout formulas that she employs directly in her characteristic photomontages.

Inspired by a massive wall hanging by Abakanowicz, Kruger began making works in the late 1960s that incorporated yarn and cloth. When she began combining her own photos with short written texts, she discovered a new, very personal direction in her art.

In 1981 she developed the form she uses today. An image appropriated from a source in popular culture is manipulated through enlargement or cropping and juxtaposed with a text, set in boldface type. Her large-scale works,

often 4 feet tall and 6 feet wide, are fitted into bright red frames for exhibition. They announce their identity as art objects, commodities on the market.[32]

A characteristic example of Krugar's work is shown in Figure 90. Appropriating an antedated photograph of a movie marquee advertising a film from the 1950s, Krugar's superimposed text declares, "We don't need another hero." The text thus deconstructs the mythology of sexual stereotypes and female subservience promoted by such mass media instruments as "The Naked Spur." It is through the juxtaposition of text and image that a contemporary feminist message is communicated, clearly and unequivocally.

Krugar works with the specific intent of including women in her audience. She recognizes the distinct experiences women have in the culture. "I want to address difference that leads to gender distinctions. I'm not a separatist, I'm not a utopian."[33]

Krugar's works have received wide recognition in the art world since their appearance in the early 1980s. Considered among the most important postmodernists, Krugar creates work that is "contentious, aggressive, and explosive."[34] In its power to communicate concepts directly and expose manipulative meanings of imagery, it points in the direction of a widened role for art to effect significant social change.

FIGURE 90. BARBARA KRUGER. *Untitled (We don't need another hero).* 1987. Photographic silkscreen/vinyl. 108¾× 157¾". Photo courtesy of Mary Boone Gallery. Photo credit: Zindman/Fremont.

TRENDS IN PAINTING

Audrey Flack (1931–)

Audrey Flack is one of the originators and most prominent artists in the 1970s movement known as Photo Realism. Like Don Eddy and Richard Estes, Flack uses photographic reproductions, i.e., color slides, projected onto the canvas to create her paintings. However, while Eddy and Estes merely select their subjects from the urban environment, Flack's paintings are wholly artificial still life arrangements. Her choice of objects and their juxtapositions and relative sizes are totally controlled by the artist. Her paintings always convey a precise message, sometimes with a biographical content, at other times with public or political significance.

Flack, like Frankenthaler and Ringgold, was born in New York. She studied at the High School of Music and Art, where she was trained in the Cubist idiom. At Cooper Union, where the prevailing style was Abstract Expressionism, Flack absorbed the lessons of the gesture painters. She attended Yale University's Graduate School and continued her studies of the figure at the Art Students League. In the mid-1950s, Flack was one of the very few artists who displayed paintings of the human figure. Abstraction so dominated the art world at that time that her realistic art was little appreciated. Nevertheless, she persisted in retaining recognizable subjects in her art through the 1960s. The *Kennedy Motorcade* (1964) was the first painting in which she used a color photograph as a reference.[35] Thereafter, she continued to use photographs as sources for her paintings and in the early 1970s discovered the advantages of using a color slide projected directly on the canvas. In this way, she could increase the scale and achieve greater brilliance of color in her canvases.

Flack's characteristic paintings from the 1970s use an airbrush to create an immaculate surface that can imitate the textures of objects. She layers the three primary hues in transparent glazes so the colors are mixed optically. In this way, she eliminates line and brushstrokes but retains a precision useful for the description of a variety of reflective surfaces.

One of her most impressive and famous paintings is *World War II, April 1945* (Figure 91), referring to the liberation of the Nazi concentration camp at Buchenwald. As a source for her painting, Flack employs Bourke-White's photo *The Living Dead of Buchenwald*. She combines Bourke-White's document with other still life objects to create an image that is both a tribute to the survivors and a memorial to the six million Jews who died in the Holocaust. The single rose, burning candle, and black border are readily recognized symbols for commemorating the dead. The watch, butterfly, and overripe pear are additional references to mortality. The printed statement in the lower right-hand corner is a rabbinical quotation affirming faith in God: "You can take everything from me—the pillow from under my head, my house—but you

FIGURE 91. AUDREY FLACK. *World War II, April 1945.* 1976–77. Acrylic and oil on canvas. 96 × 96″, incorporating a portion of the Margaret Bourke-White photograph *The Living Dead of Buchenwald, April 1945* copyright Time Inc. Photograph courtesy Louis K. Meisel Gallery.

cannot take God from my heart." The dripping red wax from the candle looks like blood staining the photo. The cakes are almost obscene sensual indulgences compared with the deprivation the concentration camp victims endured. Thus, each carefully selected object adds another layer of meaning to the image.

The airbrushed surface of the painting conveys the variety of textures of the objects. Like other realists, Flack is interested in surfaces that reflect light, such as the silver tray and candlestick, the teacup, and the blue glass chalice. Each object is so large, however, that one does not truly recognize them as "real." Like O'Keeffe, Flack understands the power of a close-up vision. Seeing a small object very enlarged, the viewer is compelled to look carefully at that object. In this work, Flack has adapted the heroic scale of Abstract Expressionism and color field painting to her still life composition.

There is no table surface and no defined perspective space. The high viewpoint flattens the space, bringing each object close to us. The colors are harsh, dominated by highly saturated primaries, red, blue, and yellow. They

are uncomfortable to look at, reinforcing the unpleasant content of the image. One critic has summed up the impact of *World War II, April 1945* as "a painting that is difficult to forget."[36]

Since the revived appreciation in the 1970s for paintings with recognizable subjects, Flack's originality and talent have received critical and popular attention. One of her paintings was the first Photo Realist work purchased by the Museum of Modern Art in New York.

Susan Rothenberg (1945–)

Susan Rothenberg's densely worked, often encrusted canvases combine abstract expressionist sensitivity to painted surface and gesture with a neoexpressionist desire to communicate emotions through references to recognizable objects. Her works have received wide critical praise since her first one-person gallery show in New York in 1976, culminating in a major traveling exhibition originated by the Los Angeles County Museum of Art in 1983. Her large-scale, generalized images can be powerful and haunting.[37]

Rothenberg began painting as a child and studied art at Cornell University in the 1960s. After some travel abroad and a few years spent in Washington, D.C., she arrived in New York in 1969, when her real life as an artist began. Rothenberg ignored the art world's emphasis on site sculptures, process art, and conceptualism of the early 1970s and focused instead on painting as her medium. In 1973 she made her first horse paintings, finding the theme that would occupy her steadily for the next six years. Rothenberg's early horse paintings showed the animal in profile, set against a roughly brushed-in surface and pinned to the two-dimensional canvas by diagonal lines or other linear elements. Soon the horse began to be shown facing forward and, in the late horse paintings, such as *Hulk* (Figure 92), the animal form is both dismembered and multiplied. This composition is dominated by a white horse's head and two leg shapes galloping toward the viewer head on in the center of the very large canvas. The negative space between the head and legs of this frontal horse is bridged by a black shadowy form, part of a leaping horse shape set in profile. Balancing the weight of this black horse's head on the left is a crisply defined inverted leg with a shadow embedded in the olive green "landscape." The upper "corners" painted a bright white become light and air as opposed to the dense, dark green "earth" of the ground.

Characteristically, the entire surface is dominated by roughly brushed-in paint and speckled with touches of white. It is a rich, dense surface worked with apparent determination and forceful energy. *Hulk* is characteristic of the artist's work in its avoidance of the sensuous evocativeness of color in favor of the more intellectual and calligraphic qualities of a highly limited palette. Although accents of red and blue do occasionally appear in her works, the general avoidance of color identifies those very large-scale works as depictions of ideas of things, rather than illusions of forms in nature. Like the prehistoric

FIGURE 92. SUSAN ROTHENBERG. *The Hulk.* Acrylic and flashe on canvas. 89 × 132¼″. Collection of the Museum of Contemporary Art, Los Angeles. The Barry Lowen Collection. Photo credit: Squidds & Nunns.

cave painting of bulls, Rothenberg captures the powerful essense of the beast rather than a precise, naturalistic rendering of its appearance.

Exhausting the formal and expressive possibilities of the horse, Rothenberg turned to the simplified signs for hand and head. Since 1981 a variety of images have emerged in her art ranging from trees to the human form.

Rothenberg's paintings have a quality of honesty and seriousness. They satisfy formalist concerns for maintaining the integrity of the picture surface with the Neoexpressionst need for emotional content. Her recognition in the 1980s is consistent with the trend in the art world to reward a few women artists of exceptional talent whose art does not have overtly feminist content.

Elizabeth Murray (1940–)

Elizabeth Murray's witty, inventive paintings of the 1980s demonstrate the survival of abstraction as a viable mode in contemporary painting. However, Murray's style of abstraction is filled with organic forms, references to content, narrative, and synthetic Cubist still life objects and could not be further removed from the reductivist geometry of 1960s Minimalism or other formalist aesthetic systems.

Murray was born in Chicago but received her masters in fine arts in 1964 from Mills College, in the San Francisco Bay area. Moving to New York in 1967, her development proceeded slowly through the 1970s. From an early interest in narrative and cartooning, Murray spent much of the 1970s experimenting with the formal possibilities of oil paint, enlarged scale, shaped can-

vases, and highly saturated color. Only in the early 1980s did Murray's paint-ing acquire the self-assurance and control of means that make them fascinating and unique artistic statements. Murray's paintings generate multiple and am-biguous associations that avoid programed or specific narrative content.

Sail Baby (Figure 93) is characteristic of Murray's mature paintings on a number of levels. First, it is composed of three individual canvases. Murray's 1980s paintings most frequently employ multiple canvases, which echo or contradict the forms depicted on them. Often, as in this example, painted shapes are continued from one canvas to the other, generating an obvious tension between the physical facts of the painting, i.e., the separate canvases and the painted illusion that unifies those physically distinct canvases. Another characteristic of Murray's art is the presence of large areas of highly saturated colors. The frequently depicted coffee cup, here in a brilliantly saturated yellow with a sky-blue interior edge, is "supported" by a magenta saucer shape underneath.

Also, *Sail Baby* has a narrative meaning. Murray notes that this painting is "about my family. It's about myself and my brother and my sister, and I think, its also about my own three children, even though Daisy wasn't born yet."[38] This painting expresses the tension between individual identity and the emotional bonding within families. In fact, every form in this painting helps to unify this image and work against the physical separation of the three can-vases. The shape of the cup and saucer most obviously bridges the three canvases. A serpentine emerald-green linear element weaves about in a contin-ous counterclockwise motion from the "hole" in the handle of the cup to its disappearance into the sky-blue interior of the cup. The whole form is set against a wine-red ground, which on its lower edges reveals a dripped paint

FIGURE 93. ELIZABETH MURRAY. *Sail Baby.* 1983. Oil on canvas. 26 × 135″. Collec-tion Walker Art Center, Minne-apolis, Walker Special Pur-chase Fund, 1984.

surface of yellows and blue. Therefore, in terms of method of paint application, *Sail Baby* contains a range from gestural definition to hard edge, from evenly painted surfaces to dripping, residually Abstract Expressionist spontaneity.

The green serpentine is the most obvious element in *Sail Baby,* that reveals Murray's obsession with movement. "Elizabeth Murray's art has always been in motion and about motion. . . . Everything is in flux, is undergoing a process of change and distortion that is visually strange and abstract, but also psychologically real. . . ."[39]

It is exciting to see an artist find ways of using the traditional medium of oil painting in a very innovative and also very personal way. Murray's paintings are full of formal surprises that remain engrossing because they resonate with human implications.

Both Murray and Rothenberg demonstrate the ability of women artists to invent new formal means and content in the 1980s and each has been recognized for her achievements. The paintings of both artists can surprise, delight, and move jaded late-twentieth-century viewers through the traditional medium of painting. Finally, both artists stand at midcareer. One can only await the new directions their paintings will take as they move through their life spans.

MAYA YING LIN, THE *VIETNAM WAR MEMORIAL* (1981–83)

It is hard to conceive of a greater challenge to America's artists than the design for a memorial to those who died in Vietnam.[40] For a war in which winning and losing lost their significance, a war in which there were no heroes but only survivors, the task of finding a form that would honor and commemorate the dead without glorifying this inglorious war might seem an impossible task. The achievement of Maya Ying Lin, an undergraduate architecture student at Yale, in inventing the design of the memorial seems all the more remarkable.

The *Vietnam War Memorial* owes its existence to the Vietnam Veterans Memorial Fund (VVMF) founded by Jan C. Scruggs in 1979. The VVMF lobbied for a site in Washington and succeeded in this goal in 1980, when President Carter authorized the establishment of the monument on two acres of the Mall of the U.S. Capitol. With the securing of the site, an enormous open competition took place in which over 1400 final entries were submitted. Lin's winning design was announced on May 1, 1981. The Memorial was finished in 1983.

This powerfully simple work is neither sculpture nor architecture, but a hybrid form derived in its essential utterly simple formal vocabulary from the tenets of Minimalism. The memorial consists of two triangular walls that form an arc, meeting at about 125°. The viewer moves along a 247-foot-long path

on either end, constantly descending into the earth, to a depth of over 10 feet at the point of intersection. The visitor then makes his or her ascent. The walls create a structure without enclosing space. The descent into the earth is an extremely powerful aspect of the experience of the Memorial and one with an ancient history in funerary monuments. From the buried tombs of the Pharoahs to the tholos tombs of Mycenae, burial in the life-giving body of Mother Earth has provided solace for survivors and signified respect for the dead.

The cool simplicity of a Minimalist vocabulary seen in the identical triangular walls appears as a necessary form of intellectual control given the immense emotional power of the experience. As our national "wailing wall" with the ability to evoke such depths of mourning, the need for a spare language with an intellectually or rationally clear form seems appropriate.

The material for the walls, a very highly polished granite, was another important component of the overall design of the Memorial. A total of seventy granite slabs compose the two walls. Engraved into the slabs are the individual names of every person killed in Vietnam, listed chronologically by date of death. The years encompassing the conflict, 1959 and 1975, are inscribed in the center angle. This most modern war memorial turns upside down the concept of the "tomb of the unknown soldier." One dead body does not abstractly symbolize all casualties. Every individual who died is evoked, one by one, by name. No trite generalizations are permitted to relieve the awareness of individual sacrifice.

The granite surface both contains the names of the dead and functions as a mirror reflecting the image of each visitor. Thus, no matter how agressively one might wish to distance oneself from the consciousness of the human cost of Vietnam, every visitor is by definition a part of the memorial by the unremitting presence of one's own image reflected in the wall every step of the way. There is no way to remain "outside" the experience of the monument once one has initiated the descent.

The beauty, power, and immense originality of the *Vietnam War Memorial* has penetrated into America's consciousness. This great work has redefined the form of a fitting monument to the dead and proven to be a cathartic magnet for an entire nation that lived and suffered through those terrible years. The *Vietnam War Memorial* exists for everyone, not only the comrades and families of the slain.

NOTES

INTRODUCTION

1. Ann Sutherland Harris and Linda Nochlin, *Women Artists: 1550–1950* (New York: Alfred A. Knopf, 1977), p. 29.
2. Rozsika Parker and Griselda Pollack, *Old Mistresses: Women, Art, and Ideology* (New York: Pantheon Books, 1981), pp. 44–45.
3. Thalia Gouma-Peterson and Patricia Mathews, "The Feminist Critique of Art History" *Art Bulletin,* (1987), pp. 326–57. Also of interest is Norma Broude and Mary D. Garrard's response published in *Art Bulletin,* March 1989, pp. 124–26.
4. Lucy Lippard, "Why Separate Women's Art?" (1973) reprinted in *From the Center, Feminist Essays on Woman's Art* (New York: E.P. Dutton, and Co., Inc., 1976), p. 42.
5. Charles F. Stuckey and William P. Scott, *Berthe Morisot, Impressionist* (New York: Hudson Hills Press, in association with the Mount Holyoke College Art Museum and the National Gallery of Art, 1987), p. 26.
6. Norma Broude and Mary D. Garrard, "Feminist Art History and the Academy: Where Are We Now?" *Women's Studies Quarterly* XV; nos. 1 and 2 (1987), p. 15.

CHAPTER 1

1. Vincent Scully, *The Earth, the Temple, and the Gods: Greek Sacred Architecture,* rev. ed. (New York: Frederick A. Praeger, 1969), p. 11.
2. Joseph Campbell, *The Masks of God: Primitive Mythology* (New York: Viking Press, 1959), p. 313.
3. Paula Webster, "Matriarchy: A Vision of Power," in Rayna R. Reiter, *Toward an Anthropology of Women* (New York and London: Monthly Review Press, 1975), p. 143.

4. Ann Oakley, *Sex, Gender and Society* (New York: Harper and Row, 1972), p. 165.
5. Eleanor Leacock, "Women in Egalitarian Societies," in Renate Bridenthal and Claudia Koonz (eds.), *Becoming Visible: Women in European History* (Boston: Houghton Mifflin, 1977), p. 17.
6. Stephanie Coontz and Peta Henderson, (eds.), *Women's Work, Men's Property: The Origins of Gender and Class* (London: Verso, 1986).
7. Coontz and Henderson, "Introduction," p. 37.
8. Ruby Rohrlich-Leavitt, "Women in Transition: Crete and Sumer," in *Becoming Visible*, p. 40.
9. For general comments about Egyptian women, see Steffen Wenig, *The Woman in Egyptian Art* (New York: McGraw-Hill, 1969).
10. Nancy Luomala, "Matrilineal Reinterpretation of Some Egyptian Sacred Cows," in Norma Broude and Mary D. Garrard, (eds.), *Feminism and Art History: Questioning the Litany* (New York: Harper and Row, 1982), pp. 19–32.
11. For the following discussion I am indebted to the detailed, excellent study by Gerda Lerner, *The Creation of Patriarchy* (New York and Oxford: Oxford University Press, 1986) and the briefer essay by Ilse Seibert, *Women in the Ancient Near East*, trans. Marianne Herzfeld (New York: Abner Schram, 1974).
12. The seal is reproduced in Seibert, *Women in the Ancient Near East*, p. 22.
13. Scully, *The Earth, the Temple, and the Gods*, pp. 11–24. Sections of this discussion are reprinted in Broude and Garrard (eds.), *Feminism and Art History*, 1982), pp. 33–43.
14. Sarah B. Pomeroy, *Goddesses, Whores, Wives and Slaves: Women in Classical Antiquity* (New York: Schocken Books, 1975), p. 227.
15. Sarah B. Pomeroy, "A Classical Scholar's Perspective on Matriarchy," in Berenice A. Carroll (ed.), *Liberating Women's History: Theoretical and Critical Essays* (Urbana: University of Illinois Press, 1976), p. 220, 223.
16. Pomeroy, *Goddesses, Whores, Wives and Slaves*, pp. 64–78.
17. Kate McK. Elderkin, "The Contribution of Women to Ornament in Antiquity," in *Classical Studies Presented to Edward Capps on His Seventieth Birthday* (Princeton: Princeton University Press, 1936), p. 125.
18. Pomeroy, *Goddesses, Whores, Wives and Slaves*, p. 125.
19. Elderkin, "The Contribution of Women to Ornament," pp. 125–26.
20. Giovanni Boccaccio, *Concerning Famous Women*, trans. with an introduction by Guido A. Guarino (New Brunswick, N.J.: Rutgers University Press, 1963), p. 131.
21. Robert Rosenblum, "The Origin of Painting: A Problem in the Iconography of Romantic Classicism," *Art Bulletin* 39 (1957), pp. 279–82.
22. These histories include: Ernest Guhl, *Die Frauen in der Kunstgeschichte* (Berlin, 1858); Elizabeth Fries Lummis Ellet, *Women Artists in All Ages and Countries* (New York, 1859); Octave Fidière, *Les Femmes artistes à l' Académie royale de peinture et de sculpture* (Paris, 1885); Walter Sparrow, *Women Painters of the World* (London, 1905).
23. Verena Zinserling, *Women in Greece and Rome*, trans. L. A. Jones (New York: Abner Schram, 1973), p. 64.
24. Herlihy notes that there were fewer girls reaching adulthood than boys, but he does not attribute this directly to female infanticide. David Herlihy, "Life Expectancies for Women in Medieval Society," in Rosemarie Thee Morewedge (ed.), *The Role of Women in the Middle Ages* (Albany: The State University of New York Press, 1975), pp. 4–5.
25. JoAnn McNamara and Suzanne Wemple, "The Power of Women Through the Family in Medieval Europe: 500–1100," in Mary Hartman and Louise Banner (eds.), *Clio's Consciousness Raised* (New York: Harper Colophon Books, 1974), pp. 103–4.
26. Pomeroy, *Goddesses, Whores, Wives and Slaves*, pp. 199–200.

27. Zinserling, *Women in Greece and Rome,* p. 58.

28. Pliny, the Elder, *Naturalis Historia,* 147, trans. K. Jex-Black and E. Sellers, *The Elder Pliny's Chapters on the History of Art* (Chicago: Argonaut, 1968, photocopy of 1896 edition), p. 171.

CHAPTER 2

1. Susan Mosher Stuard (ed.), *Women in Medieval Society* (Philadelphia: The University of Pennsylvania Press, 1977), p. 9.

2. JoAnn McNamara and Suzanne F. Wemple, "Sanctity and Power," in *Women in Medieval Society,* p. 108.

3. Eileen Power, *Medieval Women,* ed. M. M. Postan (London: Cambridge University Press, 1975), p. 20.

4. F. Heer, *The Medieval World: Europe 1100–1350* (London: Weidenfeld and Nicolson, 1962), p. 265.

5. Brenda M. Bolton, "Mulieres Sanctae," in *Women in Medieval Society,* pp. 45–47.

6. Dorothy Miner, *Anastaise and Her Sisters* (Baltimore: Walters Art Gallery, 1974), pp. 10–11.

7. Ibid., p. 10.

8. Annemarie Weyl Carr, "Women Artists in the Middle Ages," *Feminist Art Journal* V, no. 1 (1976), p. 6.

9. Power, *Medieval Women,* p. 38.

10. Ibid., pp. 87–88.

11. Sibylle Harksen, *Women in the Middle Ages,* trans. Marianne Herzfeld (New York: Abner Schram, 1975), p. 28.

12. Kathleen Casey, "The Cheshire Cat: Reconstructing the Experience of Medieval Women," in *Liberating Women's History,* p. 247, note 7.

13. Joan Kelly, "Early Feminist Theory and the *Querelle des Femmes,* 1400–1789," *Signs* VIII, no. 1 (Autumn 1982), pp. 4–28.

14. Millard Meiss, *French Painting in the Time of Jean de Berry* (London: Phaidon, 1967–68), I, p. 3.

15. Dorothy Miner believes that Le Noir is identical with the artist identified by Meiss as the "Passion Master" (see *Anastaise and Her Sisters,* p. 19). While Meiss accepts the possibility that Le Noir might be the name of the artist whose works form a stylistic group, he uses the name "Passion Master" for this figure, stopping short of attributing these works to Jean Le Noir (*French Painting,* pp. 167–68).

16. Miner, *Anastaise and Her Sisters,* pp. 18–19.

17. A. G. I. Christie, *English Medieval Embroidery* (Oxford: Clarendon Press, 1938), p. 1.

18. Christie, *English Medieval Embroidery,* Appendix I.

19. The most complete discussion of the Bayeux Tapestry is in F. Stenton (ed.), *The Bayeux Tapestry* (London: Phaidon, 1957).

20. Harris and Nochlin, *Women Artists: 1550–1950,* pp. 16–17.

21. For a detailed description of the Syon Cope, see Christie, *English Medieval Embroidery,* pp. 142–48.

CHAPTER 3

1. E. William Monter, "The Pedestal and the Stake: Courtly Love and Witchcraft," in *Becoming Visible,* p. 133.

2. Louise A. Tilly and Joan W. Scott, *"Women, Work, and Family* (New York: Holt, Rinehart and Winston, 1978), p. 60.
3. Joan Kelly-Gadol, "Did Women Have a Renaissance?" in *Becoming Visible*, pp. 160–61.
4. J. O'Faolain and L. Martines, *Not in God's Image* (New York: Harper and Row, 1973), p. 145.
5. Hannelore Sachs, *The Renaissance Woman*, trans. Marianne Herzfeld (New York: McGraw-Hill, 1971), p. 9.
6. Ruth Kelso, *Doctrine for the Lady of the Renaissance* (Urbana: University of Illinois Press, 1956), pp. 59, 77.
7. Monter, "The Pedestal and the Stake," p. 127.
8. Sherrin Marshall Wyntjes, "Women in the Reformation Era," in *Becoming Visible*, p. 186.

CHAPTER 4

1. Charles de Tolnay, "Sofonisba Anguissola and Her Relations with Michelangelo," *Journal of the Walters Art Gallery* IV (1941), pp. 115–19.
2. Eleanor Tufts, *Our Hidden Heritage: Five Centuries of Women Artists* (New York and London: Paddington Press, 1974), p. 21.
3. Mario Praz, *Conversation Pieces: A Survey of the Informal Group Portrait in Europe and America* (University Park and London: Pennsylvania State University Press, 1971), p. 149.
4. A complete transcript, translated into English, is published in Mary D. Garrard, *Artemisia Gentileschi: The Image of the Female Hero in Italian Baroque Art* (Princeton, N. J.: Princeton University Press, 1989).
5. See Garrard, *Artemisia Gentileschi,* chapter 2, for a detailed discussion of the intellectual tradition of "Women Worthies" and *Querelle des Femmes* as background for the iconographic innovations of Gentileschi.
6. Ibid., p. 358.

CHAPTER 5

1. Madlyn Millner Kahr, *Dutch Painting in the Seventeenth Century* (New York: Harper and Row, Icon Editions, 1978), p. ix.
2. Ibid., pp. 79–82.
3. For a complete discussion of this painting, see Frima Fox Hofrichter, "Judith Leyster's *Proposition*—Between Vice and Virtue," *Feminist Art Journal* (1975), pp. 22–26. This essay is reprinted in Norma Broude and Mary Garrard, *Feminism and Art History: Questioning the Litany* (New York: Harper and Row, Icon Editions, 1982), pp. 173–83.
4. Harris and Nochlin, *Women Artists: 1550–1959,* p. 154.
5. Wilfred Blunt, *The Art of Botanical Illustration* (London: Collins, 1950), p. 128.

CHAPTER 6

1. Harris and Nochlin, *Women Artists: 1550–1950,* p. 161.
2. Tufts, *Our Hidden Heritage,* p. 110.

3. For a thorough discussion of this painting, see Joseph Baillio, *"Marie-Antoinette et ses enfants* par Mme. Vigée-Lebrun," *L'Oeil* (March–April 1981).
4. The discussion of Labille-Guiard is based on the detailed, authoritative study of the artist by Anne-Marie Passez, *Biographie et Catalogue raisonné des oeuvres de Mme. Labille-Guiard* (Paris: Arts et Metiers Graphiques, 1973).

CHAPTER 7

1. Renate Bridenthal, "Something Old, Something New: Women Between the Two World Wars," in *Becoming Visible* pp. 440–41.
2. Tilly and Scott, *Women, Work, and Family,* p. 77.
3. Ibid., p. 161.
4. Alice Kessler-Harris, "Women, Work, and the Social Order," in *Liberating Women's History,* pp. 339–40.
5. For a discussion of Enlightenment ideas on women's equality, see Katherine B. Clinton, *"Femme et philosophe:* Enlightenment Origins of Feminism," *Eighteenth-Century Studies* VIII, no. 3 (1975), 295ff. See also Abby R. Kleinbaum, "Women in the Age of Light," in *Becoming Visible,* pp. 217–35.
6. Marilyn J. Boxer and Jean H. Quataert (eds.), *Connecting Spheres: Women in the Western World, 1500 to the Present* (New York and Oxford: Oxford University Press, 1987), pp. 102–9.
7. Theodore Zeldin, *Oxford History of Modern Europe: France: 1848–1945* (Oxford: Clarendon Press, 1973) I, pp. 343–44.

CHAPTER 8

1. Christine Jones Huber, *The Pennsylvania Academy and Its Women* (Philadelphia: The Pennsylvania Academy of Fine Arts, 1974).
2. Jane Mayo Roos, "Another Look at Henry James and the 'White Marmorean Flock'," *Woman's Art Journal* vol. 4 (Summer 1983), p. 32.
3. Eleanor Tufts, *American Women Artists: 1830–1930* (Washington, D.C.: The National Museum of Women in the Arts, 1987), catalogue entry number 5.
4. Robin Bolton-Smith and William H. Truettner, *Lilly Martin Spencer: The Joys of Sentiment* (Washington, D.C.: Smithsonian Institution Press for the National Collection of Fine Arts, 1973), p. 11. The following discussion of Lilly Martin Spencer is indebted to this detailed, excellent catalogue.
5. Ibid., p. 69.
6. William H. Gerdts, *American Neoclassical Sculpture: The Marble Resurrection* (New York: Viking Press, 1973), p. 47.
7. Susan Waller, "The Artist, the Writer, and the Queen: Hosmer, Jameson, and Zenobia," *Woman's Art Journal* vol. 4 (Summer 1983), pp. 21–28.
8. For a complete discussion of this work, see Tufts, *American Women Artists: 1830–1930,* catalogue entry number 107.

CHAPTER 9

1. Wendy Slatkin, "Women Artists and the Ecole des Beaux-Arts: A Study of Institutional Change in Late Nineteenth-Century France" (unpublished). See also J. Diane Radycki, "The Life of Lady Art Students: Changing Art Education at the Turn of

the Century," *Art Journal* vol. 42, no. 1 (Spring 1982), pp. 9–13. For a recent interesting discussion of the activities of the *Union des Femmes Peintres et Sculpteurs* in its socio-economic context, see Tamar Garb, "Revising the Revisionists: The Formation of the *Union des Femmes Peintres et Sculpteurs,*" *Art Journal* vol. 48 (Spring 1989), pp. 63–70.

2. Gabriel Weisberg, *The Realist Tradition: French Painting and Drawing, 1830–1900* (Cleveland: Cleveland Museum of Art, 1980), p. 1.
3. Theodore Stanton (ed.), Reminiscences of Rosa Bonheur (London, 1910; reprint ed. New York: Hacker Art Books, 1976), p. 72.
4. Anna Elizabeth Klumpke, *Rosa Bonheur, sa vie, son oeuvre* (Paris: Flammarion, 1908), pp. 311–12 (author's translation).
5. For the discussion of Bonheur, I am strongly indebted to the excellent essay by Albert Boime, "The Case of Rosa Bonheur: Why Should a Woman Want to Be More Like a Man?" *Art History* vol. 4 (December 1981), pp. 384.
6. Denis Rouart, *The Correspondence of Berthe Morisot* (London: Lund Humphries, 1957), p. 14.
7. Charles F. Stuckey and William P. Scott, *Berthe Morisot: Impressionist* (New York: Hudson Hills Press, Mount Holyoke College Art Museum in Association with the National Gallery of Art, 1987), p. 136.
8. Griselda Pollock, *Vision and Difference: Femininity, Feminism and the Histories of Art* (London: Routledge, 1988) p. 63.
9. Stuckey, *Berthe Morisot*, pp. 130–36.
10. Adylyn Breeskin, *Mary Cassatt: A Catalogue Raisonné of the Oils, Pastels, Watercolors and Drawings* (Washington, D.C.: Smithsonian Institution Press, 1970), p. 9.
11. Gillian Perry, *Paula Modersohn-Becker: Her Life and Work* (London: The Woman's Press, 1979), p. 115.

CHAPTER 10

1. Radycki, "The Life of Lady Art Students," p. 11.
2. Martha Kearns, *Käthe Kollwitz: Woman and Artist* (Old Westbury, N.Y.: The Feminist Press, 1976), p. 192.
3. Margit Rowell and Angelica Zander Rudenstine, *Art of the Avant-Garde in Russia: Selections from the George Costakis Collection* (New York: The Solomon R. Guggenheim Museum, 1981), p. 23.
4. Camilla Gray, *The Russian Experiment in Art: 1863–1922* (New York: Abrams, 1972), p. 224.
5. Arthur A. Cohen, *Sonia Delaunay* (New York: Abrams, 1975), p. 61.
6. Ibid., p. 83.
7. For a discussion of this issue, see Clare Rendell, "Sonia Delaunay and the Expanding Definition of Art," *Woman's Art Journal* vol. 4, no. 1 (Summer 1983), pp. 35–38.
8. The following section on the Women of Surrealism was written by Janet Kaplan, Moore College of Art, Philadelphia, PA.
9. Andre Breton, *Arcane 17,* quoted in Whitney Chadwick, "Eros or Thanatos—The Surrealist Cult of Love Reexamined," *Artforum,* 14 (November 1975), p. 50.
10. Gloria F. Orenstein, "Art History and the Case for the Women of Surrealism," *The Journal of General Education* XXVII, no. 1 (Spring 1975); reprinted in *Feminist Collage: Educating Women in the Visual Arts,* Judy Loeb (ed.) (New York: Teacher's College Press, Columbia University, 1979), pp. 35–59. This situation receives expanded treatment in Whitney Chadwick, *Women Artists and the Surrealist Movement* (Boston: Little, Brown and Co., 1985).

11. Josephine Withers, "The Famous Fur-Lined Teacup and the Anonymous Meret Oppenheim," *ARTS Magazine* vol. 52, no. 3 (November 1977), p. 88.
12. From *Chronicle* (1958), quoted in Withers, "The Famous Fur-lined Teacup," p. 93.
13. For a discussion of the journey as a major theme in Varo's work, see Janet Kaplan, "Remedios Varo: Voyages and Visions," *Woman's Art Journal* vol. 1, no. 2 (Fall 1980/Winter 1981), pp. 13–18.
14. Quoted in Walter Gruen, "Index of Illustrations," *Remedios Varo*, with texts by Octavio Paz, Roger Cailliois, and Juliana Gonzalez (Mexico City: ERA Ediciones, 1966), p. 173.
15. Dorothea Tanning, in *XXᵉSiècle* (September 1976), reprinted in the exhibition catalogue, *Dorothea Tanning: 10 Recent Paintings and a Biography* (New York: Gimpel-Weitzenhoffer Gallery, 1979), no page number.
16. Georgia O'Keeffe exhibition catalogue, *An American Place, 1939,* reprinted in *Georgia O'Keeffe,* (New York: Viking Press, 1976), no page number.
17. Lloyd Goodrich and Doris Bry, *Georgia O'Keeffe* (New York: Whitney Museum of American Art, 1970), p. 18.
18. O'Keeffe exhibition catalogue, *An American Place, 1939,* in *Georgia O'Keeffe,* no page number.
19. Ibid.
20. Roger Fry, quoted in *The Cameron Collection/Julia Margaret Cameron,* introduction by Colin Ford (New York: Van Nostrand Reinhold, 1975), p. 136.
21. William Innes Homer, *A Pictorial Heritage: The Photographs of Gertrude Käsebier* (Wilmington: Delaware Art Museum, 1979), p. 6.
22. *Imogen Cunningham: Photographs,* with an introduction by Margery Mann (Seattle and London: University of Washington Press, 1970).
23. Karin Becker Ohrn, *Dorothea Lange and the Documentary Tradition* (Baton Rouge: Louisiana State University Press, 1980), p. 79.
24. Margaret Bourke-White, *Dear Fatherland, Rest Quietly* (New York: Simon and Schuster, 1946), p. 73.

CHAPTER 11

1. Paul Guth, "Encounter with Germaine Richier," *Yale French Studies* vols. 19–20 (Spring 1957–Winter 1958), p. 80.
2. Ibid., p. 82.
3. Erich Neumann, *The Great Mother: An Analysis of the Archetype,* trans. Ralph Manheim (New York: Pantheon Books, Bollingen Series XLVII, 1955), p. 127.
4. Guth, "Encounter with Germaine Richier," p. 83.
5. Barbara Hepworth, *A Pictorial Autobiography* (London: A. Zwemmer, 1959), p. 9.
6. Herbert Read, *Barbara Hepworth, Carvings and Drawings* (London: Lund Humphries, 1952), no page number.
7. Claire Falkenstein, recorded conversation in *Los Angeles Art Community Group Portrait* (University of California, Los Angeles Oral History Program, 1982), p. 189.
8. Ibid., pp. 191–92.
9. Quoted in Laurie Wilson, "Bride of the Black Moon: An Iconographic Study of the Work of Louise Nevelson," *ARTS Magazine* 54 (May 1980), p. 144.
10. Louise Nevelson, *Louise Nevelson: Atmospheres and Environments* (New York: C. N. Potter in association with the Whitney Museum of American Art, 1980), p. 77.
11. Wilson, "Bride of the Black Moon," p. 145.
12. Arnold B. Glimcher, *Louise Nevelson* (New York: Praeger, 1972), pp. 22–23.
13. Barbara Rose, *Lee Krasner: A Retrospective* (New York: Museum of Modern Art, 1983). My discussion of Krasner is indebted to Rose's excellent, detailed essay.

14. Barbara Rose, *Helen Frankenthaler* (New York: Abrams, 1971), p. 54.

15. Lucy Lippard, "Hommage to the Square," *Art in America* (July–August 1987), p. 55; quoted in *Agnes Martin* exhibition catalogue (Institute of Contemporary Art, University of Pennsylvania, 1973), p. 9.

16. Lucy Lippard, *From the Center: Feminist Essays of Women's Art* (New York: E. P. Dutton, 1976), p. 65.

17. Lawrence Alloway, "Systemic Painting," in Gregory Battcock (ed.), *Minimal Art: A Critical Anthology* (New York: E. P. Dutton, 1968), p. 55.

18. Lawrence Alloway, *Agnes Martin* exhibition catalogue (Philadelphia: Institute of Contemporary Art, 1973), p. 10.

19. William C. Seitz, *The Responsive Eye* (New York: Museum of Modern Art, 1965), p. 31.

20. Linda Nochlin, "Some Women Realists: Painters of the Figure," *ARTS Magazine* vol. 48 (May 1974), p. 30.

21. Ann Sutherland Harris, *Alice Neel: 1930–1980* exhibition catalogue (Los Angeles: Loyola Marymount University, 1983), p. 3.

22. Ibid., p. 6.

23. Patricia Hills, *Alice Neel* (New York: Abrams, 1983), p. 162.

24. Ibid., p. 185.

25. Nochlin, "Some Women Realists," p. 29.

26. Cindy Nemser, "An Interview with Eva Hesse," *Artforum* (May 1970), p. 62.

27. Ibid., p. 60.

CHAPTER 12

1. Kay Larson, "For the First Time Women Are Leading, Not Following," *Art News* vol. 79 (October 1980), pp. 64–72.

2. Ibid., p. 68.

3. See Lucy R. Lippard, "The Pains and Pleasures of Rebirth: European and American Women's Body Art," *Art in America* vol. 64 (May–June 1976), reprinted in *From the Center: Feminist Essays on Women's Art* (New York: E.P. Dutton, 1976), pp. 121–38.

4. Eleanor Heartney, "How Wide Is the Gender Gap?" *Art News* vol. 86 (Summer 1987), p. 140.

5. Ibid., p. 141.

6. Ibid., p. 145.

7. The exhibition catalogue was written by Eleanor Tufts, *American Women Artists: 1830–1930,* with essays by Gail Levin, Alessandra Comini, and Wanda M. Corn (Washington, D.C.: The National Museum of Women in the Arts, 1987).

8. John Loughery, "Mrs. Holladay and the Guerrilla Girls," *ARTS Magazine* vol. 62 (October 1987), pp. 61–65.

9. Judy Chicago, *The Dinner Party: A Symbol of Our Heritage* (Garden City, N.Y.: Anchor Books, 1979), p. 12.

10. The most detailed discussion of Schapiro's work before 1980 is Thalia Gouma-Peterson, *Miriam Schapiro: A Retrospective: 1953–1980* exhibition catalogue (Wooster, Ohio: The College of Wooster, 1980). This catalogue was prepared for a major traveling exhibition of Schapiro's works.

11. John Perrault, "Issues in Pattern Painting," *Artforum* (December 1977), reprinted in Richard Hertz, *Theories of Contemporary Art* (Englewood Cliffs, N.J.: Prentice-Hall, 1985).

12. Paula Bradley, "Placing Women in History: Miriam Schapiro's Fan and Vestiture Series," *ARTS Magazine* vol. 56 (February 1979), p. 148.
13. Elaine Hedges and Ingrid Wendt, *In Her Own Image: Women Working in the Arts* (Old Westbury, N.Y.: The Feminist Press, 1980), p. 289.
14. Eleanor Munro, *The Originals: American Women Artists* (New York: Simon and Schuster, 1979), p. 410.
15. *Magdalena Abakanowicz,* intro. by Mary Jane Jacobs (New York: Abbeville Press, 1982), catalogue organized by the Museum of Contemporary Art, Chicago, for traveling exhibition, p. 14.
16. Ibid., p. 15.
17. Ibid., p. 94.
18. *Nancy Graves: A Survey 1969/1980,* essay by Linda L. Cathcart (Buffalo, N.Y.: Albright-Knox Art Gallery, 1980), p. 13.
19. *The Sculpture of Nancy Graves: A Catalogue Raisonné* (New York: Hudson Hills Press, in association with the Fort Worth Art Museum, 1987), catalogue entry no. 23.
20. Lucy R. Lippard, *Overlay: Contemporary Art and the Art of Prehistory* (New York: Pantheon Books, 1983), p. 198.
21. Nancy Holt, "Sun Tunnels," *Artforum* vol. 15 (April 1977), p. 34.
22. Ibid.
23. Ibid., p. 35.
24. Ibid., p. 34.
25. Moira Roth (ed.), *The Amazing Decade: Women and Performance Art in America: 1970–1980* (Los Angeles: Astro Artz, 1983), p. 8. For the following discussion of performance art, I am indebted to Roth's excellent essay.
26. Ibid., p. 20.
27. Leslie Labowitz-Starus and Suzanne Lacy, "In Mourning and In Rage . . ." *Frontiers: A Journal of Women's Studies* vol. 1 (Spring 1978), pp. 52–55.
28. *Cindy Sherman,* essays by Peter Schjeldahl and Lisa Phillips, (New York: Whitney Museum of Art, 1987), p. 13.
29. Ken Johnson, "Cindy Sherman and the Anti-Self: An Interpretation of her Imagery," *ARTS Magazine* vol. 62 (November 1987), p. 49.
30. Phillips, p. 15.
31. Johnson, p. 53.
32. Carol Squiers, "Diversionary (Syn)tactics: Barbara Krugar Has Her Way with Words," *Art News* vol. 86 (February 1987), p. 84.
33. Ibid., p. 80.
34. Ibid., p. 75.
35. Cindy Nemser, "Conversation with Audrey Flack," *ARTS Magazine* vol. 48 (February 1974), p. 34.
36. John Perrault, "A Painting That Is Difficult to Forget," *Art News* 77 (April 1978), pp. 150–51.
37. For the following discussion of Rothenberg, see Lisbet Nilson, "Susan Rothenberg: Every Brushstroke Is a Surprise," *Art News* vol. 83 (February 1984), pp. 47–54.
38. *Elizabeth Murray: Paintings and Drawings,* exhibition catalogue organized by Sue Graze and Kathy Halbreich, essay by Roberta Smith (New York: Abrams, in association with the Dallas Museum of Art and the MIT Committee on the Visual Arts, 1987), p. 64.
39. Ibid., p. 8.
40. For this discussion of the Vietnam War Memorial, I am indebted to Shirley Neilsen Blum, "The National Vietnam War Memorial," *ARTS Magazine* vol. 59 (December 1984), pp. 124–28.

Annotated Bibliography

GENERAL WORKS ON
THE HISTORY OF WOMEN ARTISTS

Recent widespread interest in women artists has stimulated the publication of a number of books in English about this topic. However, writings on the history of women artists date back to the nineteenth century, so three early treatments of the topic are included here. I strongly recommend all of the following for further reading:

BACHMANN, D., AND S. PILAND, EDS. *Women Artists: An Historical, Contemporary and Feminist Bibliography*. New Jersey and London: Scarecrow Press, 1978. A thorough listing of references on this subject.

BROUDE, NORMA, AND MARY D. GARRARD, EDS. *Feminism and Art History: Questioning the Litany*. New York: Harper and Row, 1982. A collection of scholarly articles that employs various methodological approaches, including analyses of works by women artists, to correct male-biased views of mainstream art history.

CLEMENT, CLARA ERSKINE. *Women in Fine Arts from the Seventh Century B.C. to the Twentieth Century*. Boston: Houghton Mifflin, 1904; reissued by Hacker Art Books, 1974. Provides interesting historical perspective.

ELLET, ELIZABETH FRIES LUMMIS. *Women Artists In All Ages and Countries*. New York: Harper and Co., 1859. An important early treatment of the subject.

FINE, ELSA HONIG. *Women and Art: A History of Women Painters and Sculptors from the Renaissance to the 20th Century*. Montclair, N.J.: Abner Schram, 1978. Includes brief, interesting discussions of many artists. Each chapter is introduced with a concise, useful summary of women's social history. Useful bibliography.

GREER, GERMAINE. *The Obstacle Race: The Fortunes of Women Painters and Their Work*. New York: Farrar, Straus, Giroux, 1979. Contains useful information mixed with some distorted conclusions about a vast number of women artists. More important, Greer arranges the factors that prevented more women from achiev-

ing greater success in the visual arts into a series of obstacles and supports them with specific examples.

HARRIS, ANN SUTHERLAND, AND LINDA NOCHLIN. *Women Artists: 1550–1950.* New York: Alfred A. Knopf, 1976. A major source for the subject. Written as a catalogue for a traveling exhibition, the introductory essays provide informative overviews, and the catalogue entries contain pertinent data on individual creators. Useful bibliography.

HELLER, NANCY G. *Women Artists: An Illustrated History.* New York: Abbeville Press, 1987. An adequate nonpolemic survey text loaded with quality illustrations and details.

LOEB, JUDY, ED. *Feminist Collage: Educating Women in the Visual Arts.* New York: Columbia University Press, 1982. Collection of essays on both specific women artists and broader feminist topics.

MUNSTERBERG, HUGO. *The History of Women Artists.* New York: Clarkson N. Potter, 1975. Includes discussions of women artists in prehistoric, antique, and primitive civilizations, as well as chapters on graphic artists and photographers.

NOCHLIN, LINDA. "Why Have There Been No Great Women Artists?" in *Art and Sexual Politics,* ed. Thomas B. Hess and Elizabeth C. Baker. New York: Collier, 1971. Pioneer essay analyzing the theoretical reasons for the smaller absolute number of women artists and the absence of recognition of their achievements in the mainstream of contemporary art history.

PARKER, ROZSIKA, AND GRISELDA POLLACK. *Old Mistresses: Women, Art and Ideology.* New York: Pantheon Books, 1981. A thorough discussion of the stereotyping of women's art, ideological preconceptions of the discipline of art history, and women's relation to artistic and social structures. Avoiding biographical discussions, these English feminists present the first serious analysis of the relationship between the historical evaluation of women's art and the underlying criteria of the academic discipline of art history.

PETERSEN, KAREN, AND J. J. WILSON. *Women Artists: Recognition and Reappraisal From the Early Middle Ages to the Twentieth Century.* New York: Harper Colophon Books, 1976. Contains a chapter on Chinese artists and many black and white reproductions. The text, however, tends to be superficial and is not consistently reliable. Useful bibliography.

RUBENSTEIN, CHARLOTTE STREIFFER. *American Women Artists: From Early Indian Times to the Present.* Boston: G.K. Hall, 1982. Employs an encyclopedic approach and contains brief discussions of hundreds of artists.

SPARROW, WALTER. *Women Painters of the World.* London: Hodder and Stoughton, 1905. Contemporary with Clement's volume, Sparrow's work is equally extensive.

TUFTS, ELEANOR. *Our Hidden Heritage: Five Centuries of Women Artists.* New York: Paddington Press, 1974. Lively biographical essays of twenty-two major women artists.

GENERAL WORKS ON WOMEN'S HISTORY

The following collections of essays contain useful and reliable scholarship on women's history.

BOXER, MARILYN J., AND JEAN H. QUATAERT, EDS. *Connecting Spheres: Women in the Western World, 1500 to the Present.* New York and Oxford: Oxford University

Press, 1987. The editors' introductory remarks to the more specific essays provide a useful overview of women's history since the Renaissance.

BRIDENTHAL, RENATE, AND CLAUDIA KOONZ, EDS. *Becoming Visible: Women in European History*. Boston: Houghton Mifflin, 1977.

CARROLL, BERENICE A. *Liberating Women's History*. Urbana: University of Illinois Press, 1976.

HARTMAN, MARY, AND LOUISE BANNER, EDS. *Clio's Consciousness Raised*. New York: Harper Colophon Books, 1974.

ROSALDO, MICHELLE ZIMBALIST, AND LOUISE LAMPHERE, EDS. *Woman, Culture and Society*. Stanford, Calif.: Stanford University Press, 1974.

CHAPTER 1

BOCCACCIO, GIOVANNI. *Concerning Famous Women*, trans. and ed. G. A. Guarino. New Brunswick, N.J.: Rutgers University Press, 1963. Renaissance source for information contained in Pliny.

COONTZ, STEPHANIE, AND PETA HENDERSON, EDS. *Women's Work, Men's Property: The Origins of Gender and Class*. London: Verso, 1986. Well-argued collection of essays by French and American scholars on the economic roots of the origins of male dominance.

ELDERKIN, KATE McK. "The Contribution of Women to Ornament in Antiquity," in *Classical Studies Presented to Edward Capps*. Princeton, N.J.: Princeton University Press, 1936. The only extant essay focusing exclusively on the role of women artists in antiquity.

JEX-BLACK, K., AND E. SELLERS, TRANS. *The Elder Pliny's Chapters on the History of Art*. Chicago: Argonaut, 1968; photocopy of the 1896 original. What we know of women artists in antiquity rests exclusively on the Roman historian Pliny's brief mention of a few individuals, reprinted in this text.

LERNER, GERDA. *The Creation of Patriarchy*. New York and Oxford: Oxford University Press, 1986. Important contribution to our understanding of women's lives in the ancient Near East. Contains thorough discussions of the legal positions of women in Mesopotamian, Babylonian, and Judaic law.

LUOMALA, NANCY. "Matrilineal Reinterpretation of Some Egyptian Sacred Cows," in *Feminism and Art History: Questioning the Litany*, eds., Normal Broude and Mary D. Garrard. New York: Harper and Row, Icon Editions, 1982. Concise, informative article on the position of royal women in Pharonic Egypt and its relevance for interpreting the visual arts.

POMEROY, SARAH B. *Goddesses, Whores, Wives and Slaves: Women in Classical Antiquity*. New York: Schocken Books, 1975. The most reliable and readable source of information concerning women in ancient Greece and Rome.

REITER, RAYNA R., ED. *Toward an Anthropology of Women*. New York and London: Monthly Review Press, 1975. Collection of essays exploring the roles of women in prehistoric and primitive societies, pertinent to the issue of matriarchies.

SEIBERT, ILSE. *Women in the Ancient Near East*, trans. Marianne Herzfeld. New York: Abner Schram, 1974. Clear, concise analysis of the position of women in the ancient Near East.

WENIG, STEFFEN. *The Woman in Egyptian Art*. New York: McGraw-Hill, 1969. An overview of the topic, which deals with the roles and positions of Egyptian women of all classes, as well as imagery.

ZINSERLING, VERENA. *Women in Greece and Rome,* trans. L. A. Jones. New York: Abner Schram, 1973. More concise than the Pomeroy book, this text deals with the same subject.

CHAPTER 2

CARR, ANNEMARIE WEYL. "Women Artists in the Middle Ages," *Feminist Art Journal* V, no. 1, 1976. Summary of available information on women artists of the Middle Ages.

CHRISTIE, A. G. I. *English Medieval Embroidery.* Oxford: Clarendon Press, 1938. Still the basic reference tool for *opus anglicanum.*

HARKSEN, SIBYLLE. *Women in the Middle Ages,* trans. Marianne Herzfeld. New York: Abner Schram, 1975. Reliable source addressing the role and position of women in medieval society.

MINER, DOROTHY. *Anastaise and Her Sisters.* Baltimore, Md.: Walters Art Gallery, 1974. Brief but thoroughly documented source of information on women artists in the Middle Ages.

MOREWEDGE, ROSEMARIE THEE, ED. *The Role of Women in the Middle Ages.* Albany: The State University of New York Press, 1975. Collection of authoritative essays on the topic.

POWER, EILEEN. *Medieval Women,* ed. M. M. Postan. London: Cambridge University Press, 1975. Reliable source addressing the role and position of women in medieval society.

STENTON, F., ED. *The Bayeux Tapestry.* London: Phaidon Press, 1957. Standard source for the study of this art work.

STUARD, SUSAN MOSHER, ED. *Women in Medieval Society.* Philadelphia: The University of Pennsylvania Press, 1977. Collection of authoritative essays on the topic.

CHAPTER 3

KELSO, RUTH. *Doctrine for the Lady of the Renaissance.* Urbana: University of Illinois Press, 1956. The fundamental scholarly source for information regarding the position and socially approved roles of women during the Italian Renaissance.

SACHS, HANNELORE. *The Renaissance Woman,* trans. Marianne Herzfeld. New York: McGraw-Hill, 1971. A concise discussion of the position of women in northern Europe during this epoch.

CHAPTER 4

BISSELL, R. WARD. "Artemisia Gentileschi: A New Documented Chronology," *Art Bulletin* L, 1968, pp. 153–68. The first authoritative modern study. Contains valuable information and a number of black and white illustrations of less familiar paintings by the artist.

GARRARD, MARY D. *Artemisia Gentileschi: The Image of the Female Hero in Italian Baroque Art.* Princeton, N.J.: Princeton University Press, 1989. Long-awaited comprehensive study of this major figure. Fascinating, necessary reading.

MOIR, ALFRED. *The Italian Followers of Caravaggio*. Cambridge, Mass.: Harvard University Press, 1967. Sets the oeuvre of Artemisia Gentileschi into a historical context.

CHAPTER 5

GRANT, MAURICE H. *Rachel Ruysch: 1664–1750*. Leigh-on-Sea: F. Lewis, 1956. Short biographical essay with a substantial number of black and white illustrations.

GREINDL, E. *Les Peintres flamands de nature morte au XVII siecle*. Brussels: Elsevier, 1956. Study of Flemish still life and flower painting. (French)

HOFRICHTER, FRIMA FOX. "Judith Leyster's *Proposition*," *Feminist Art Journal,* 1975; reprinted in *Feminism and Art History,* ed. Broude and Garrard. Scholarly article about a specific painting by this artist, written by an author who has done extensive research on Leyster.

MITCHELL, PETER. *European Flower Painters*. London: Adam and Charles Black, 1973. Study of Flemish still life and flower painting.

RUCKER, ELIZABETH. *Maria Sibylla Merian: 1647–1717*. A catalogue for an exhibition at the Germanisches Nationalmuseum in Nuremburg in 1967, this is the most recent and authoritative study of Merian's work. (German)

CHAPTER 6

Angelika Kauffman und ihre Zeitgenossen. Bregenz: Vorarlberger Landesmuseum, 1968. Exhibition catalogue of her works in their historical context. (German)

BAILLIO, JOSEPH. "*Marie-Antoinette et ses enfants* par Mme. Vigée Le Brun," *L'Oeil,* March and May 1981. In addition to this scholarly article about a specific painting by the artist, Baillio is the author of the recent catalogue published concurrently with an important exhibition of Vigée-Librun's paintings, held at the Kimball Art Museum, Fort Worth, Texas, in 1982.

COLDING, TORBEN HOLCH. *Aspects of Miniature Painting: Its Origins and Development*. Copenhagen: Ejnar Munksgaard, 1953. Authoritative work that discusses Rosalba Carriera's contribution to the history of miniature painting.

GATTO, GABRIELLE. "Per la cronologia di Rosalba Carriera," *Arte veneta* XXV, 1971, pp. 182–93. Recent research on the dating of Carriera's works. (Italian)

HELM, WILLIAM H. *Vigée-Lebrun: Her Life and Friendships*. London: Hutchinson and Co., 1916. Biographical monograph.

MANNERS, LADY VICTORIA, AND G. C. WILLIAMSON. *Angelica Kauffman, R.A. Her Life and Works*. London: The Bodley Head, 1924. Best modern biography of the artist.

PASSEZ, ANNE-MARIE. *Biographié et Catalogue Raisonné des Oeuvres de Mme. Labille-Guiard*. Paris: Arts et Métiers Graphiques, 1973. Excellent, authoritative study of this artist. (French)

ROLAND-MICHEL, MARIANNE. *Anne Vallayer-Coster*. Paris, 1970. A thorough and reliable monograph about the artist containing valuable information not only on Vallayer-Coster, but also on her immediate artistic environment and her relationships with contemporary French still life painters. (French)

CHAPTER 7

Carroll, Berenice A., ed. *Liberating Women's History.* Urbana: University of Illinois Press, 1976. Interesting essays focused on the social history of American women.

Flexner, Eleanor. *Century of Struggle: The Women's Rights Movement in the United States.* New York: Atheneum, 1973. Standard and most readable history of the women's suffrage movement.

Tilly, Louise A., and Joan W. Scott. *Women, Work and Family.* New York: Holt, Rinehart, and Winston, 1978. The most complete analysis of the impact of industrialization on women's lives. Using data from France and England, this study pinpoints the economic and demographic factors that affected women's work and categorizes the types of work women performed between 1700 and 1950.

Zeldin, Theodore. *France: 1848–1945.* Oxford: Clarendon Press, 1973. For readers especially interested in the position of women in France during this period, volume I contains a concise overview of the political, economic, and cultural situations of French women during this epoch.

CHAPTER 8

Bolton-Smith, Robin, and William Truettner. *Lilly Martin Spencer: The Joys of Sentiment.* Washington, D.C.: Smithsonian Institution Press, 1973. Thorough, scholarly, and informative study of this artist, published in conjunction with a major exhibition of her works.

Carr, Cornelia, ed. *Harriet Hosmer, Letters and Memories,* New York, 1912.

Cikovsky, Nicolai. *The White Marmorean Flock: 19th Century American Women Neoclassical Sculptors.* Poughkeepsie, N.Y.: Vassar College Art Gallery, 1972. An exhibition catalogue, this is the only published work focusing specifically on the women neoclassical sculptors of the nineteenth century. Introductory essay by William Gerdts.

Gerdts, William H. *American Neoclassical Sculpture: The Marble Resurrection.* New York: Viking Press, 1973. Includes discussions about the White Marmorean Flock, but is an overall treatment of the movement rather than a specific discussion of these women.

Holstein, Jonathan. *Abstract Design in American Quilts.* Published for an exhibition at the Whitney Museum of American Art, New York, 1971. Discusses the relationship between the aesthetics of the quilt and abstract art of the twentieth century.

Holstein, Jonathan. *The Pieced Quilt: An American Design Tradition.* Greenwich, Conn.: New York Graphic Society, 1973. Focuses specifically on the art of quilt making—the techniques and the relationship to American folk arts.

Leach, Joseph. "Harriet Hosmer: Feminist in Bronze and Marble," *Feminist Art Journal,* Summer 1976.

Mainardi, Patricia. "Quilts, The Great American Art," in *Feminism and Art History: Questioning the Litany,* ed. Norma Broude and Mary D. Garrard. New York: Harper and Row, Icon Editions, 1982. A discussion of the aesthetics of the quilt and the roles these works played in the lives of the women who made them.

Roos, Jane Mayo. "Another Look at Henry James and the 'White Marmorean

Flock'," *Woman's Art Journal* vol. 4, no. 1 (Summer 1983). Fascinating article, which investigates the attitude of James towards these sculptors and the negative connotations of the group name.

Tufts, Eleanor. *American Women Artists: 1830–1930.* Washington, D.C.: The National Museum of Women in the Arts, 1987. Exhibition catalogue for the inauguration of the new museum. Informative catalogue entries on a wide range of artists, paired with good color reproductions of works included in the show. Brief introductory essays by Gail Levin, Alessandra Comini, and Wanda M. Corn, as well as Tufts, the curator.

Waller, Susan. "The Artist, the Writer, and the Queen: Hosmer, Jameson, and Zenobia," *Woman's Art Journal* vol. 4, no. 1 (Summer 1983). Scholarly article on the collaboration between Jameson and Hosmer, leading to a more authoritative interpretation of the feminist significance of *Zenobia.*

CHAPTER 9

Ashton, Dore, and Denise Browne Hare. *Rosa Bonheur: A Life and Legend.* New York: Viking, 1981. A recently published biography, this work examines Bonheur's life not only for its artistic impact, but also within the context of the society in which she lived.

Bataille, M. L., and G. Wildenstein. *Berthe Morisot—Catalogue des peintures, pastels, et aquarelles.* Paris: Les Beaux Arts, 1961. A catalogue raisonné of Berthe Morisot's oeuvre. (French)

Boime, Albert. "The Case of Rosa Bonheur: Why Should A Woman Want to Be More Like a Man?" *Art History* vol. 4, no. 4 (December 1981). Brilliant interpretation of Bonheur's intellectual makeup. Essential reading for an understanding of the artist.

Busch, Gunter, and Liselotte von Reinken, eds. *Paula Modersohn-Becker: The Letters and Journals,* translated by Arthur S. Wensinger and Carole Clew Hoey. New York: Taplinger Publishing, 1983. Greatly expanded, authoritative volume of the artist's writings, containing much previously unpublished material.

Breeskin, Adylyn. *The Graphic Work of Mary Cassatt.* New York: Bittner, 1948. Catalogue.

Breeskin, Adylyn. *Mary Cassatt: A Catalogue Raisonné of the Oils, Pastels, Watercolors and Drawings.* Washington, D.C.: Smithsonian Institution Press, 1970. Fundamental research tool for any student interested in the work of Mary Cassatt.

Hale, Nancy. *Mary Cassatt.* Garden City, N.Y.: Doubleday, 1975. Biography.

Mathews, Nancy Mowll. *Cassatt and Her Circle: Selected Letters.* New York: Abbeville Press, 1984. An important addition to the Cassatt literature, the letters of the artist and her family provide great insight into the works of this major figure.

Mathews, Nancy Mowll. *Mary Cassatt.* New York: Abrams, in association with the National Museum of American Art, Smithsonian Institution, 1987. Well-illustrated, informative monograph on the artist.

Paula Modersohn-Becker: zum hundertsten Geburtsdag. Bremen Kunsthalle, 1976. Exhibition catalogue with valuable essays by Gunter Busch and others. (German)

Perry, Gillian. *Paula Modersohn-Becker: Her Life and Work.* London: The Woman's Press, 1979. Informative and readable biography.

Radycki, J. Diane, trans. and ed. *The Letters and Journals of Paula Modersohn-Becker.*

Metuchen, N.J.: Scarecrow Press. 1980. Although based on the 1920 compilation of Modersohn-Becker's writings, a sensitive and accurately colloquial translation of a key group of documents.

ROUART, DENIS, ED. *The Correspondence of Berthe Morisot.* London: Lund Humphries, 1957, republished 1986.

STANTON, THEODORE, *Reminiscences of Rosa Bonheur.* London, 1910; reprinted by Hacker Art Books, 1976. The son of the great suffrage leader Elizabeth Cady Stanton is an interesting, sympathetic, contemporary biographer of the artist.

STUCKEY, CHARLES F., AND WILLIAM P. SCOTT. *Berthe Morisot: Impressionist.* New York: Hudson Hills Press, Mount Holyoke College Art Museum in Association with the National Gallery of Art, 1987. Detailed, scholarly study of the professional career of this artist. Excellent color reproductions of many of her works. Published in conjunction with the major exhibition organized by Mount Holyoke College Art Museum, and shown at the National Gallery in Washington. An important additon to the Morisot literature.

CHAPTER 10

BOSQUET, A. *Le Peinture de Dorothea Tanning.* Paris: Jean-Jacques Pauvert, 1966. Monograph. (French)

BOURKE-WHITE, MARGARET. *Dear Fatherland, Rest Quietly.* New York: Simon and Schuster, 1946. Exciting eye-witness account of history in the making.

The Cameron Collection/Julia Margaret Cameron, introduction by Colin Ford. New York: Van Nostrand Reinhold, 1975. Focuses specifically on a major group of her photographs.

CHADWICK, WHITNEY. *Women Artists and the Surrealist Movement.* Boston, Little, Brown and Co., 1985. Detailed thematic study of the contribution of women artists to Surrealism, and the attitudes towards women by their male colleagues. Fascinating, necessary reading for an understanding of the topic.

CHAMOT, M. *Goncharova.* Paris, 1972. Monograph. (French)

COHEN, ARTHUR A. *Sonia Delaunay.* New York: Abrams, 1975. Monograph containing information on the artist's life and art, as well as many color reproductions.

COWART, JACK, AND JUAN HAMILTON. *Georgia O'Keeffe, Art and Letters.* (Letters selected and annotated by Sarah Greenough.) Washington, D.C.: National Gallery of Art, and Boston: New York Graphic Society, 1987. Catalogue of a traveling exhibition of the artist's works. Reprints letters for the first time.

DAMASE, J. *Sonia Delaunay, Rhythms and Colors.* Greenwich, Conn.: New York Graphic Society, 1972. Another extensive monograph, with numerous color reproductions.

DATER, JUDY. *Imogen Cunningham: A Portrait.* Boston: New York Graphic Society, 1979. Contains many reproductions of Cunningham's photos and interviews with people who knew her well.

DELAUNAY, SONIA. *Sonia Delaunay: Art into Fashion.* New York: G. Braziller, 1986. Reproductions of the artist's designs, with brief introductory essay.

GERNSHEIM, HELMUT. *Julia Margaret Cameron: Her Life and Photographic Work.* Millerton, N.Y.: Aperture, 1975. A detailed overview of this artist's career.

GOODRICH, LLOYD, AND DORIS BRY. *Georgia O'Keeffe.* New York: Whitney Museum of American Art, 1970. Catalogue; valuable reference source.

GRAY, CAMILLA. *The Russian Experiment in Art: 1863–1922.* New York: Abrams, 1972. Standard study of the Russian avant-garde.

HINZ, RENATE, ED. *Käthe Kollwitz, Graphics, Posters, Drawings,* trans. Rita and Robert Kimber. New York: Pantheon Books, 1981. Monograph in which a substantial number of the artist's works are reproduced.

HOMER, WILLIAM, I. *A Pictorial Heritage: The Photographs of Gertrude Käsebier.* Wilmington: Delaware Art Museum, 1979. This exhibition catalogue is the only reliable study available on this photographer.

Imogen Cunningham: Photographs. Seattle and London: University of Washington Press, 1970. Good selection of photographs, reproduced with a brief biographical essay by Margery Mann.

KAPLAN, JANET. *Unexpected Journeys: The Art and Life of Remedios Varo.* New York: Abbeville Press, 1988. Authoritative monograph, loaded with information on this still little-known Surrealist.

KEARNS, MARTHA. *Käthe Kollwitz: Woman and Artist.* Old Westbury, N.Y.: Feminist Press, 1976. A sensitively written biography with a distinctly feminist viewpoint, Kearns quotes extensively from Kollwitz's letters and journal entries.

LISLE, LAURIE. *Portrait of an Artist: A Biography of Georgia O'Keeffe.* Albuquerque: University of New Mexico, 1986; New York, Pocketbooks, 1987. An overdue biography based on the author's personal acquaintance with O'Keeffe.

MELTZER, MILTON. *Dorothea Lange: A Photographer's Life.* New York: Farrar, Straus and Giroux, 1978. Monograph documenting Lange's career.

NOCHLIN, LINDA. Review of retrospective exhibition of Dorothea Tanning's work at the Centre National d'Art Contemporain, Paris. *Art in America* LXII, November/December 1974, p. 128.

OHRN, KARIN BECKER. *Dorothea Lange and the Documentary Tradition.* Baton Rouge: Louisiana State University Press, 1980. Monograph documenting Lange's career.

O'KEEFFE, GEORGIA. *Georgia O'Keeffe.* New York: Viking, 1976. Monograph containing many fine color reproductions of the artist's paintings, accompanied by texts written by the artist.

ORENSTEIN, GLORIA F. "Art History and the Case for Women of Surrealism," in *Feminist Collage,* ed. Judy Loeb. New York: Teacher's College Press, 1979. An introduction to the major women artists of the Surrealist movement.

The Photos of Margaret Bourke-White, ed. Sean Callahan. Greenwich, Conn.: New York Graphic Society, 1972. Extensive collection of photographs.

PLAZY, GILLES. *Dorothea Tanning.* Paris: E.P.I. Editions Filipacchi, 1976. Monograph. (French)

RENDELL, CLARE. "Sonia Delaunay and the Expanding Definition of Art," *Woman's Art Journal* vol. 4, no. 1, Summer 1983. Examination of the artist's attitude to design activities other than easel painting and the range of her works in a wide variety of media.

ROWELL, MARGIT, AND ANGELICA ZANDER RUDENSTEIN. *Art of the Avant-Garde in Russia: Selections from the George Costakis Collection.* New York: The Solomon R. Guggenheim Museum, 1981. Exhibition catalogue: contains useful information about Liubov Popova and other women active in this movement.

Russian Women Artists of the Avant Garde, 1910–1930. Cologne: Galerie Gmurzynska, 1979. Exhibition catalogue focusing specifically on the contribution of women to this movement.

Sonia Delaunay: A Retrospective. Catalogue for the recent traveling exhibition; a well-

documented source for information about the artist. Contains essays by Sherry A. Buckberrough and others.

WITHERS, JOSEPHINE. "The Famous Fur-Lined Teacup and the Anonymous Meret Oppenheim," *ARTS Magazine* vol. 52, no. 3, November 1977. A useufl essay on this artist.

ZIGROSSER, CARL. *Prints and Drawings of Käthe Kollwitz.* New York: Dover Press, 1951; rpt. 1969. Contains a substantial number of reproductions of Kollwitz's work.

CHAPTER 11

ALLOWAY, LAWRENCE. *Agnes Martin,* essay in exhibition catalogue for show held at the Institute of Contemporary Art, University of Pennsylvania, 1973. A detailed intellectual analysis of Agnes Martin's paintings.

BOWNESS, ALAN, ED. *The Complete Sculpture of Barbara Hepworth: 1960–69.* London: Lund Humphries, 1971. A complete catalogue raisonné of her oeuvre.

BRIDGET RILEY. *Paintings and Drawings, 1951–71.* Arts Council of Great Britain, 1971. Extensive documentation is included in this catalogue of a retrospective exhibition held at the Hayward Gallery in London.

DE SAUSMAREZ, MAURICE. *Bridget Riley.* Greenwich, Conn.: New York Graphic Society, 1970. A valuable reference for readers interested in Riley's career.

GLIMCHER, ARNOLD. *Louise Nevelson.* New York: Praeger, 1972. Documents the life and career of this artist.

GOOSEN, E. C. *Helen Frankenthaler.* New York: Praeger, 1969. Catalogue for the artist's major retrospective held at the Whitney Museum of American Art.

GUTH, PAUL. "Encounter with Germaine Richier," *Yale French Studies* vol. 19–20, Spring 1957/Winter 1958, pp. 78–85. Rare source in English based on an interview with the artist.

HAMMACHER, A. M. *The Sculpture of Barbara Hepworth.* New York: Abrams, 1968. Reliable monograph.

HARRIS, ANN SUTHERLAND. *Alice Neel: 1930–1980.* Los Angeles: Loyola Marymount University, 1983. Brief but interesting essay by Harris, with appropriate commentary on exhibited works.

HEPWORTH, BARBARA. *A Pictorial Autobiography.* London: A. Zwemmer, 1959; Bradford on Avon, England: Moonraker Press, 1978. A valuable source for understanding the artist. A paperback edition is still in print.

HILLS, PATRICIA. *Alice Neel.* New York: Abrams, 1983. A primary source since the text is culled from extensive conversations with the artist. Informative essay by Hills adds insights on this creator.

HODIN, J. P. *Barbara Hepworth.* London: Lund Humphries, 1961. A complete catalogue raisonné of her oeuvre.

LIPPARD, LUCY. *Eva Hesse.* New York: New York University Press, 1976. An extremely thorough treatment of both the life and work of this artist, interwoven in a clever manner so neither psychology nor formalism dominates. Lippard was a personal friend of Hesse's; this book benefits from their intimacy.

MUNRO, ELEANOR. *Originals: American Women Artists.* New York: Simon and Schuster, 1979. Contains biographies of many important artists, based mainly on interviews conducted by the author.

NEMSER, CINDY. "An Interview with Eva Hesse," *Artforum,* May 1970. This article reveals much about Hesse's attitude toward her art shortly before her premature death.

NEMSER, CINDY. "Conversation with Audrey Flack," *ARTS Magazine* vol. 48, February 1974, pp. 34–37.

NEVELSON, LOUISE. *Atmospheres and Environments.* New York: Clarkson N. Potter in association with the Whitney Museum of American Art, 1980. Includes text by the artist and reproductions of many of her works.

READ, HERBERT. *Barbara Hepworth. Carvings and Drawings.* London: Lund Humphries, 1952. Insightful introductory essay and many reproductions of Hepworth's works.

ROSE, BARBARA. *Helen Frankenthaler.* New York: Abrams, 1971. The main source for information about this artist; includes lengthy text and many color and black and white reproductions.

ROSE, BARBARA. *Lee Krasner: A Retrospective.* New York: Museum of Modern Art, 1983. Scholarly, detailed study of the career of this artist. Basic reading for an understanding of her development. Published in conjunction with a major exhibition of her works.

SWENSON, LYNN F., AND SALLY SWENSON. *Lives and Work: Talks with Women Artists.* Metuchen, N.J.: Scarecrow Press, 1981. A group of recorded conversations with living American artists.

WILSON, LAURIE. "Bride of the Black Moon: An Iconograhic Study of the Work of Louise Nevelson," *ARTS Magazine* 54, May 1980, pp. 140–48. Article containing valuable insights into the meaning of Nevelson's imagery and the development of her style from the point of view of her content.

WYE, DEBORAH. *Louise Bourgeois.* New York: Museum of Modern Art, 1982. A catalogue for the recent retrospective exhibition, this valuable resource contains numerous reproductions, an introductory essay by William Rubin, and a complete bibliography for this artist.

CHAPTER 12

BLUM, SHIRLEY NEILSEN. "The National Vietnam War Memorial," *ARTS Magazine* vol. 59, no. 4, December 1984, pp. 124–28. Sensitive, detailed analysis of the monument.

CHICAGO, JUDY. *The Dinner Party: A Symbol of Our Heritage.* New York: Doubleday; and Garden City, N.Y.: Anchor Books, 1979. Includes a lengthy essay documenting the creation of *The Dinner Party* and biographical information about the women honored by the work.

CHICAGO, JUDY. *Through the Flower: My Struggle as a Woman Artist.* New York: Doubleday; and Garden City, N.Y.: Anchor Books, 1975. Autobiography.

FLACK, AUDREY. *Audrey Flack.* New York: Abrams, 1981. Contains an essay written by the artist and color reproductions of her works.

GRAVES, NANCY. *The Sculpture of Nancy Graves: A Catalogue Raisonné.* New York: Hudson Hills Press, in association with the Fort Worth Art Museum, 1987. Essays by E.A. Carmean, Jr., Linda L. Cathcart, Robert Hughes, and Michael Edward Shapiro. Catalogue by Ruth J. Hazel. Published in conjunction with a major traveling exhibition of her works. Important source for the artist, with informative interpretative essays.

GRAZE, SUE, AND KATHY HALBRIECH. *Elizabeth Murray: Paintings and Drawings*. New York: Abrams, in association with the Dallas Museum of Art and the MIT committee on the Visual Arts, 1987. Essay by Roberta Smith. Interesting introductory essay and comments by the artist for works reproduced in good quality color plates. Published in conjunction with a major traveling retrospective exhibition.

GOUMA-PETERSON, THALIA. *Miriam Schapiro: A Retrospective: 1953–1980*. Wooster, Ohio: The College of Wooster, 1980. Most complete source on this artist up to the date of the exhibition.

HEARTNEY, ELEANOR. "How Wide Is the Gender Gap?" *Art News* vol. 86 Summer 1987, pp. 139-45. Important recent article assessing the position of women artists in the art world of the 1980s.

HOLT, NANCY. "Sun Tunnels," *Artforum* vol. 15, April 1977, pp. 33–37. Primary source for an understanding of this seminal earthwork.

JACOBS, MARY JANE. *Magdalena Abakanowicz*. New York: Abbeville Press, 1982. Lavishly illustrated catalogue for a major traveling exhibition. Sensitive introductory essay by Jacobs.

LARSON, KAY. "For the First Time Women Are Leading Not Following," *Art News* vol. 79, October 1980, pp. 64–72. Important article acnowledging and discussing the contributions of women artists for the art movements of the 1970s.

LIPPARD, LUCY R. *From the Center: Feminist Essays on Women's Art*. New York: E. P. Dutton, 1976. A collection of critical writings on contemporary women's art by the most important feminist critic of the era.

LIPPARD, LUCY R. *Overlay: Contemporary Art and the Art of Prehistory*. New York: Pantheon Books, 1983. Fascinating study of the interrelationships between art by both male and female artists and prehistoric monuments. Contains an important chapter on "Feminism and Prehistory."

NEMSER, CINDY. "Conversation with Audrey Flack," *ARTS Magazine* vol. 48, February 1974, pp. 34–37. Early, primary source on the artist.

NILSON, LISBET. "Susan Rothenberg: Every Brushstroke Is a Surprise," *Art News* vol. 83, February 1980, pp. 47–54. Interesting interview and background information on the artist.

POLLOCK, GRISELDA. *Framing Feminism: Art and the Women's Movement, 1970–1985*. Pandora, 1987. Anthology of articles by and about feminist art in England.

RAVEN, ARLENE, CASSANDRA L. LANGER, AND JOANNA FRUEH, EDS. *Feminist Art Criticism: An Anthology*. Ann Arbor: UMI Research Press, 1988. A stimulating collection of essays both theoretical and directed at specific works, written since the early 1970s.

ROBINS, CORINNE. *The Pluralist Era: American Art, 1968–1981*. New York: Harper and Row, Icon Editions, 1984. Best overview of the major trends of the art of the designated period.

ROBINSON, HILARY, ED. *Visibly Female: Feminism and Art Today*. New York: Universe Books, 1988. Compiled by an English scholar, this volume contains statements and reviews of works by contemporary feminist artists. Most valuable is the inclusion of a lively exchange between Pollock, Sutherland Harris, and Alloway on the validity of the theoretical positions of *Old Mistresses*.

ROSEN, RANDY ET AL. *Making Their Mark: Women Artists Move into the Mainstream, 1970–1985*. New York: Abbeville Press, 1989. A well illustrated catalogue accompanying a traveling exhibition that surveys women artists' contributions in recent years. Informative essays on the range of women's creativity make this a welcome addition to the literature of contemporary art.

ROTH, MOIRA, ED. *The Amazing Decade: Women and Performance Art in America: 1970–1980; A Source Book.* Los Angeles: Astro Artz, 1983. Best text for this movement. Contains an informative introductory essay by Roth and biographical entries on many artists.

SHERMAN, CINDY. *Cindy Sherman.* New York: Whitney Museum of Art, 1987. Catalogue of a major retrospective exhibition, with perceptive essays by Peter Schjeldahl and Lisa Phillips.

SIEGLE, JEANNE. "Audrey Flack's Object," *ARTS Magazine* vol. 50, June 1976, pp. 103–5. Interesting essay about Flack's iconography.

SMAGULA, HOWARD. *Currents: Contemporary Directions in the Visual Arts.* Englewood Cliffs, N.J.: Prentice-Hall, 1983. Informative survey text of movements since the 1960s.

SQUIERS, CAROL. "Diversionary (Syn)tactics: Barbara Krugar Has Her Way with Words," *Art News* vol. 86, February 1987, pp. 74–85. Interview and biographical profile on the artist.

Index